ELECTRICAL WIRE
ELECTRICAL BOXES
Cut wood for WINDOWS
GET GLASS for WINDOWS

Price fAns
Sketch fan
GET TRACKS for Doors
GET Doors

Supply/Exhaust
System

3D Modeling in Silo

BLENDER UnderGround

D1540670

http://booksite.focalpress.com/companion/

WARD

3D Modeling in Silo

The Official Guide

Antony Ward
David Randall
Nevercenter

Amsterdam • Boston • Heidelberg • London • New York • Oxford • Paris
San Diego • San Francisco • Singapore • Sydney • Tokyo
Focal Press is an imprint of Elsevier

Focal Press is an imprint of Elsevier
30 Corporate Drive, Suite 400, Burlington, MA 01803, USA
The Boulevard, Langford Lane, Kidlington, Oxford, OX5 1GB, UK

Notices
Knowledge and best practice in this field are constantly changing. As new research
and experience broaden our understanding, changes in research methods,
professional practices, or medical treatment may become necessary.

Practitioners and researchers must always rely on their own experience and
knowledge in evaluating and using any information, methods, compounds, or
experiments described herein. In using such information or methods they should
be mindful of their own safety and the safety of others, including parties for whom
they have a professional responsibility.

To the fullest extent of the law, neither the Publisher nor the authors, contributors,
or editors, assume any liability for any injury and/or damage to persons or
property as a matter of products liability, negligence or otherwise, or from any
use or operation of any methods, products, instructions, or ideas contained in the
material herein.

Library of Congress Cataloging-in-Publication Data
Application submitted

British Library Cataloguing-in-Publication Data
A catalogue record for this book is available from the British Library.

ISBN: 978-0-240-81481-0

For information on all Focal Press publications
visit our website at www.elsevierdirect.com

10 11 12 13 5 4 3 2 1

Printed in Canada

Working together to grow
libraries in developing countries

www.elsevier.com | www.bookaid.org | www.sabre.org

ELSEVIER BOOK AID
International Sabre Foundation

Contents

Acknowledgments

When first approached to write this book, I was initially skeptical. Yes, Silo is a great application, but my concerns were more about the intended audience, and just how many Silo users were out there. After some investigation, I was pleased to find the user base rapidly growing, with more and more artists being seduced by the "Silo Zen" workflow. I felt it was time to do my part, to help bring Silo to more users while demonstrating what it is capable of, so I eagerly agreed.

Chris Simpson (Associate Acquisitions Editor at Focal Press) and David Randall (Director of Business Development at Nevercenter and co-author) have been the perfect partners for this book, and I doubt I could have done it without them. Their knowledge, patience, and expertise have been invaluable since we kicked off production early this year.

I also want to thank the Silo community; in particular, the people who initially reviewed my idea and helped with tips along the way—Glen Southern and Carsten Lind (who you can find on Twitter as @SouthernGFX and @Cali3D).

About the Authors

Antony Ward

Since the days when stipple was king, Antony Ward has grown with the game development and computer graphics industries, adapting his skills to match the increasing thirst for polygons. During the past 16 years, Antony has led teams, developed workflows, and trained staff in some of today's leading game development studios, all while continuing to share new techniques with people all over the world. During this time, he also wrote two successful technical manuals: *Game Character Development in Maya* (2004) and *Game Character Development* (2008). Both have been popular among the cg community and have since been translated into many different languages, including Chinese.

You can find out more about Antony Ward and follow him online at:

www.ant-online.co.uk
www.facebook.com/AntWardsArt
www.twitter.com/ant_ward

David Randall (Nevercenter)

David is newspaper journalist turned IT professional, and became the main mouthpiece of Nevercenter in 2008, when he joined as the director of marketing and business development. He has also worked on developing the Silo website and Silo education tools (including the Glen Southern Tutorial Series), and has worked closely with Silo's chief developers, Thomas and John Plewe, in crafting the language of the book to help bring out what the Silo tools and commands do, and why.

Nevercenter Ltd. Co. is a private company based near Salt Lake City, UT, with the goal of making 3D graphics more accessible to a wider variety of people by emphasizing speed, appeal, and ease of use.

Introduction

These days, it seems that new 3D applications are released every month. Some claim to be the next best thing and bring a new, fresh perspective on digital art, while older, more established programs simply tick along and bolt on similar new features.

It is sometimes difficult to keep up with current trends, and trying each new application can be time consuming and expensive. I have played around with many programs in the past while trying to nail down the few I would retain as part of my pipeline. Most either did not fit my particular style or my budget. Then, while working at Sumo Digital many years ago, a friend introduced me to Silo and I have been hooked ever since.

After modeling in a package for years with tools that weren't fluid or user friendly, Silo was a breath of fresh air, and I soon adopted it as my main modeling application. Silo does not feature many of the advanced tools of other programs, like animation or advanced shaders, but I have other programs for that. Instead, Silo focuses on modeling, and does it very well.

Because of the great modeling tools, Silo is my starting point on any project. I can quickly block out a rough model to use as a concept, and then take it further by modeling and sculpting details until it is ready for texturing. Every day I hear of a new freelance artist or studio bringing Silo on board, so I was honored when asked to write this book and help bring Silo, and what it is capable of, to the screens of many more digital artists.

I hope you find this book useful, and interesting, and continue to use Silo to develop your skills. We would also love to see what you are using Silo for on the Nevercenter Silo forums (http://silo3d.com/forum/index.php) and the Facebook page (http://www.facebook.com/Silo3D).

Happy modeling!

About Silo

Silo is a focused 3D modeling application for Mac and Windows with the capability to effortlessly switch between organically sculpting high-polygon models and precisely controlling hard-edged angular surfaces. You can use Silo for anything from creating 3D characters for video games and movies to quickly exploring 3D architectural or industrial design ideas.

With a clean interface and high-speed workflow, Silo appeals to professionals and newcomers alike, with top studios worldwide using it as both a

stand-alone design tool and a versatile element of a multi-software 3D graphics workflow.

3D models in Silo are created at their most basic level using polygons. A polygon for our purposes is simply three or more connected points in 3D space that enclose a surface. A complete 3D model can be made from just a couple of polygons or as many as several million. In this book, you will learn more about the basics of working with polygons, and the powerful tools Silo has to aid in creating and manipulating them.

Important features in the Silo toolset include:

- Basic polygon creation, division, and manipulation tools
- Subdivision tools and commands (to create smooth organic forms from angular polygon models)
- Sculpting brushes (to push and mold the surface of an object organically)
- UV tools (to lay out the textures on an object)
- Retopology tools (to create cleaner or lower-polygon-count meshes from an existing model)

We cover all these tools in this book.

If you are a seasoned modeler, you might want to check the Table of Contents and skip to the sections that seem most intriguing, coming back to the earlier chapters as necessary. Experienced modelers coming from other 3D packages often find they are able to pick up the Silo basics very quickly and focus more of their learning time on advanced tools and specialty features.

For the newcomer to 3D: Welcome! We are very happy you have decided to try Silo, and have done our best to guide you along the way. For you, we recommend staying the course from chapter to chapter. Feel free to skip ahead as you feel you can, but keep in mind we will be covering both tools and techniques, which are important in understanding how to model.

Where Is the Companion CD?

Well, there is no CD with this book. We decided it would be better to place what would be the CD content online for you to easily download. This means we can update it as we see fit, with new assets and the latest versions of Silo, so check back frequently to see if there have been any updates.

The bulk of the download will be versions of the project silo file (.sib) saved out at various points. These will serve as a great point of reference should you want to pick the models apart, or pick up the project somewhere in the middle.

You will also be able to download a 30-day trial of Silo to use as you work on your models. If you want to upgrade to the full version, use the code [Can we make this code stand out better?] for a healthy discount (not that Silo is an

expensive application, at the time of writing the professional version will set you back a mere $159.).

In this downloadable content you will also find a few Bonus chapters for you to work with. These add to certain sections of the book, as well as enhance what is already covered in the tutorials to show you how to create a pistol as well as get to grips with Silo's UV mapping and map extraction tools.

All you need to do now is download the files, which you can do from the following location:

http://booksite.focalpress.com/companion/Ward

Getting Started with Silo

In this chapter, we discuss how to view, select, and manipulate models in Silo. If you are not familiar with Silo or polygon modeling, make sure to read the "About Silo" section at the start of the book.

We recommend having Silo open and running as you read, as most of the actual learning will co me as you try things out for yourself. Allow yourself to play, have fun, and make mistakes; you will get comfortable with the software much more quickly. If you do not already have Silo installed, a free 30-day trial is included in the free downloadable content, and you can always find the latest version available at www.nevercenter.com.

Viewing Objects

Working with a 3D model requires seeing the model from all angles. Changing anything on the model to get it looking right from one angle has the potential to negatively affect the way it looks from another. In Silo, you can easily zoom, rotate, and pan the current viewport (i.e., the window used to see the model) to make sure you are getting things right from all angles. It is important to understand that you are not moving the model with these commands, just

3D Modeling in Silo. DOI: 10.1016/B978-0-240-81481-0.00001-7

changing the camera position. Basic viewport controls involve holding the **Alt** key along with different mouse buttons as follows:

- Rotate = *Alt + Left Mouse Button*
- Zoom = *Alt + Right Mouse Button (or scroll with the scroll wheel)*
- Pan = *Alt + Holding Down the Scroll Wheel or Middle Mouse Button*

You can customize all of these controls, but in this book, we will assume you are using the default configuration that ships with Silo.

- To get a feel for manipulating the view in 3D space, create a new Silo file and add a basic model by selecting **Create > Custom Primitive > Base Man With Feet** from the top menu (more on custom primitives in Chapter 2).
- Now try rotating, zooming, and panning to see the model from all angles by holding down the **Alt** key and clicking and dragging with the different mouse buttons or scroll wheel.

Viewport Cameras

So far we've been using the default viewport camera called "Free Perspective," which means it is a camera with perspective correction (i.e., objects further away from the camera appear smaller) that is free to move in all directions. Silo also includes nine additional viewport cameras to make sure you can get a good sense of your model from all angles. The most important of these, besides Free Perspective, are the fixed orthographic camera views, which fix the viewport camera from the top, bottom, left, right, front, and back of your scene. Orthographic views do not use perspective correction, so objects further away from the camera do not appear smaller than objects close to the camera.

Working from the various orthographic views feels more like working with flat blueprints, although the model is of course still 3D. They offer greater technical accuracy, a quick way to see what is going on with the model from

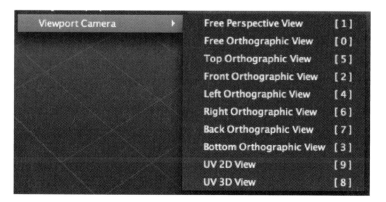

FIG. 1.1 Right-click menu showing the various viewport cameras.

various sides, and (as you'll see when we start modeling our main subject) you can place images in these viewports to exactly match your model to reference material.

The easiest way to switch between viewport cameras is via the right-click menu (under **Viewport Camera**), or use the number keys (**0** through **9** are each assigned to one view). As you try manipulating the view with different cameras, you will notice that panning and zooming in the fixed orthographic views work similarly to the free perspective viewport camera, but using the rotate commands with a fixed camera will just spin your view (like turning the blueprint) rather than rotating in 3D to the far side of the model.

Viewport Layout

To get the most comprehensive view of your model, you also have the option to divide your workspace into multiple viewports, each with its own camera. Depending on the size of your screen and the project, this can be very helpful. You can right click in any viewport to change its camera, or left click to select and start working in that viewport. (Whichever viewport is currently selected is known as the active viewport, and is the one that will respond to your input.)

- Press the **Down Arrow** to switch to a four-viewport layout.
- Use **Spacebar** to quickly expand the selected viewport in a single view layout.
- Press **Spacebar** again to toggle back to the previous multiview layout.

Other viewport layout options are available from **Display > Viewport Layout**.

Take a minute to get a feel for the various cameras and layouts. Don't worry about mastering them all; the important thing is to know they are there to use when you need them.

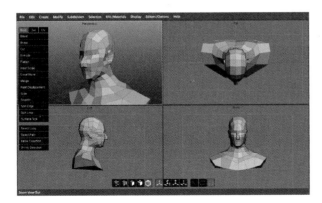

FIG. 1.2 A four-pane viewport layout shows views of the object from the free perspective, top, left, and front viewports.

Selection

As in most 3D graphics software, models in Silo are made up of components known as vertices, edges, and faces. The vertex is the most basic unit of 3D graphics—a point in space with no actual size or shape. An edge is a line created by connecting two of these vertices. Together, a web of these edges and vertices is used to outline the structure of a model, much like scaffolding (often referred to as a wireframe). It defines the shape, but isn't solid. Faces, or polygons, are used to fill in spaces bordered by edges, like pieces of glass in a stained-glass window, and make the model look solid. These components are all interconnected—you can move a vertex directly, or by moving any edges or faces it is part of. 3D modeling is simply the creation and arrangement of these components.

Learning to think of your model in terms of vertices, edges, and faces all at once is essential, as some tasks are impossible with one component type but easy with another. This kind of thinking comes quickly with practice.

Selection Modes

Selection Modes are a way to tell Silo which type of component you want to work with. There is a separate selection mode for faces, edges, and vertices; a **Multi-select Mode**, which lets you see all three at once; and an **Object Mode**, which we will get to in a moment.

Silo's selection modes let you work in terms of these components—in **Face Mode**, you will be manipulating faces; in **Vertex Mode**, vertices; and **Edge Mode**, edges. **Multi-select Mode** is sort of a shorthand that lets you see all three kinds of components at once. Often the key to good modeling is recognizing which selection mode is best for a given task. Many tools are context-sensitive, and change behavior based on the current selection mode.

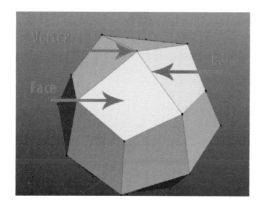

FIG. 1.3 Anatomy of a polygon.

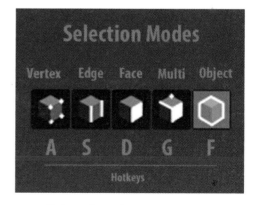

FIG. 1.4 The keys and buttons for selection modes.

Silo contains a fifth selection mode, **Object Mode**. Objects are a useful, if surprisingly complex, concept. For now, it is best to think of each separate part of a model, which is not physically connected (e.g., each of a character's shoes), as a separate object. In Silo, you have to make sure the object is selected in **Object Mode** before trying to edit it in other selection modes. Many models will only contain one object, in which case it will be selected by default.

Selection Styles

Optimizing a modeling working workflow often involves selecting multiple elements with some precision, and to ease the process, Silo has three selection styles: **Paint, Area**, and **Lasso** (Figure 1.5).

- **Paint Style** allows you to hold down the **Left Mouse Button** and paint over additional elements to select anything that comes under the path of the mouse cursor.
- **Area Style** creates a box as you hold down the **Left Mouse Button**, and all visible elements in the box are selected (to select through a model, just hold down the **Middle Mouse Button** or **Scroll Wheel** instead).
- **Lasso Style** works similar to **Area Style**, but allows the user to draw a shape around specific elements while holding down the **Left Mouse Button** (or **Middle Mouse Button** or **Scroll Wheel** to select through and model). Everything within the drawn shape will be selected.

You can also add to a selection regardless of the style by holding down **Shift** and selecting additional elements (**Shift** + **Ctrl** to deselect).

To get a feel for the various selection modes and styles, load a custom primitive (**Create** > **Custom Primitive** > **Base Man With Feet**) and a cube (**Create** > **Cube**) into a scene and try selecting objects, faces, edges, and vertices with each of the selection styles.

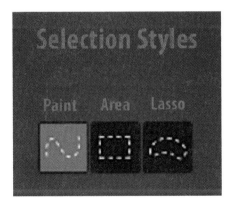

FIG. 1.5 The three selection styles.

Getting comfortable with selection and memorizing the keyboard commands is a very important part of working quickly in Silo.

Manipulating Objects

With a feel for how to see models from all angles and how to select the various elements, you are ready to start some actual modeling using a mainstay of 3D software: the manipulator. In coming chapters we'll learn about more freeform ways to work with polygon elements and objects, so don't get discouraged if working with the manipulator feels a little too technical. Regardless of your workflow, however, knowing how to use the various manipulators is crucial to your 3D modeling success.

A manipulator is a small 3D object with handles that appears next to the current selection and lets you interact with it. The three handles of the basic manipulator point in each of the dimensions of a Silo scene's space. The colors on the manipulator match the red and blue on the Silo grid and represent the X (red) and Z (blue) directions. The green side represents the Y or vertical direction. To start, the manipulator will align with the Silo directions on the grid, but as you work with a model and adjust the manipulator the orientation will likely change.

Three single-function manipulators in Silo allow the user to move, scale, and rotate objects and polygon elements. Each manipulator has outer handles and a center handle that you can click on and drag to perform its functions. There is also a **Multi-use Manipulator** with handles for all move, scale, and rotate operations; and a **Snapping Manipulator** that allows for precise movement and rotation. With the exception of the snapping manipulator, buttons for all the manipulators are in the bottom center of the screen, and hotkeys are on the Q row of the keyboard. You can access the snapping manipulator in the main menu via **Selection** > **Manipulator Tool** > **Snap**. Figure 1.7 is a breakdown of each manipulator and what the various handles do.

Once you have had a chance to review the chart of the various manipulators, it is time to start playing.

- Open a Silo scene and create a primitive base bust (**Create** > **Custom Primitive** > **Base Bust**).
- Try selecting each element type and using each of the handles on the various manipulators to modify the bust.

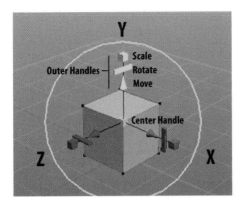

FIG. 1.6 The anatomy of a manipulator.

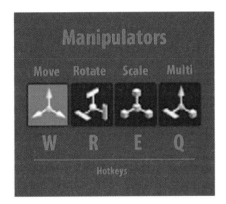

FIG. 1.7 The various manipulators, what the handles do, and the keyboard commands.

For those just starting with 3D, do not be surprised if modifying the bust to look a certain way is harder than you anticipated. We have just started to scratch the surface of what Silo can do and how it works in a real-life modeling situation. In the next few chapters, you will learn about various modeling rules, Silo tools, and workflows that give the modeling process a much more organic feel.

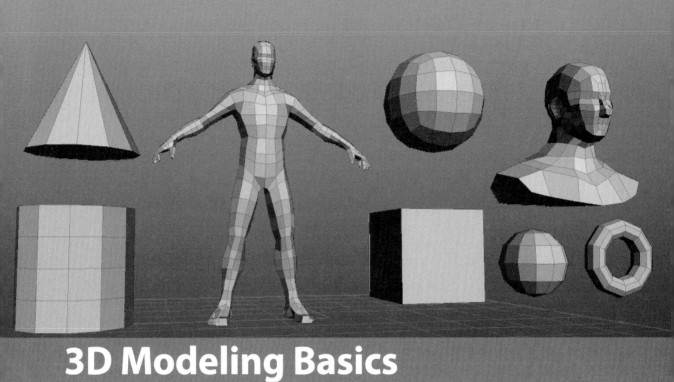

3D Modeling Basics

Learning the Language of 3D

Working in 3D is part art and (unfortunately for many artists) part math. The art elements can be easy to understand and very translatable from other artistic endeavors. The mathematic concepts will, however, likely be new and at first unintuitive. Therefore, before we jump into learning the Silo tools that will help build and define our model, we will pause in this chapter to talk about the important conventions of working in 3D.

This chapter is geared toward the inexperienced modeler. While most of the rest of this book focuses on the "hows" of creating and manipulating geometry, this chapter attempts to cover the "whys." Those familiar with 3D or coming to Silo from another 3D package might want to briefly review this chapter, or just reference it throughout the modeling process if questions arise. The concepts we will cover include subdivision, using quads and face loops, avoiding poles and holes, maintaining appropriate polygon density, and working with references and primitives.

3D Modeling in Silo. DOI: 10.1016/B978-0-240-81481-0.00002-9

While perhaps not strictly a creative endeavor, understanding these technical basics and creating models that look good and are well put together have some valuable benefits, including:

Efficiency. Modeling smart means modeling faster. Following conventions helps to provide standard solutions to common problems, and avoid mistakes that can result in hours of reworking.

Versatility. 3D objects will often have a life in other 3D programs and formats, and subdividing, posing, painting, sculpting, rigging, and animating can become very difficult if the geometry is not done well.

Reusability. Modelers often reference their past work and integrate it into new projects. The cleaner the reference, the easier it will be to use.

Understanding Subdivision

A necessary, powerful complement to working with polygons (and the reason for many of the conventions of polygon modeling) is subdivision. In fact, Silo is often referred to as a "subdivision surfaces modeler." Subdivision tools allow the software to create smooth organic surfaces from a coarse polygonal mesh (see Figure 2.1). For example, if you create a cube and subdivide it multiple times, it will end up looking smooth and spherical (although, for mathematical reasons, not a perfect sphere). This system allows you to create a model using only a few hundred polygons, but then automatically give it a smooth finished look that might take hundreds of thousands or even millions of polygons to achieve. Essentially, subdivision allows you to create high-resolution models without having to create and control all of those tiny polygons individually.

You control subdivision in Silo with the **C** and **V** keys. To get a feel for how it works:

1. Create a new Silo file and add a basic model by selecting **Create** > **Custom Primitive** > **Base Man With Feet** from the top menu.

FIG. 2.1 A character with no subdivision, one level of subdivision, and two levels of subdivision. (Model courtesy of Glen Southern.)

2. Press **C** to subdivide and then **V** to return to the rough polygon mesh. You will notice that while the surface changes, the lines that mark the original polygons do not. In any layer of subdivision within Silo, the base mesh remains editable.

3. Subdivide again and try moving a few edges and points using the manipulator to get a feel for how the subdivided surface responds. You are always selecting and working with the faces, edges, and vertices of the low-resolution original, from which the subdivided version is created.

Subdivision is an iterative command, meaning each time you press **C** you'll get a smoother and smoother mesh, and each time you press **V** you'll step back one level. One temptation for beginning modelers is to use as high a subdivision level as they can. However, because each level quadruples the number of visible polygons from the previous level, going too high can take a toll on your computer processor and dramatically slow modeling. It is best to use low levels of subdivision (typically three or less) and jump up to higher levels only periodically if needed.

Along with all the benefits, subdivision can reveal and magnify certain kinds of modeling flaws. As mentioned earlier, this is why it plays a role in determining the basic rules of polygon modeling—although it is not the only factor. Magnified flaws caused by subdivision are known as subdivision artifacts, and are essentially unexpected bumps, snags, or other types of visual problems. In Figure 2.2, you can see how adding triangles to a model (something we will discuss avoiding in the next section) did not cause a visible problem in the base mesh, but did create a bump in the subdivided version.

Invoking the Holy Quad

One concept you will see reinforced throughout this book is the importance of modeling almost exclusively using four-sided polygons, or "quads." As a new

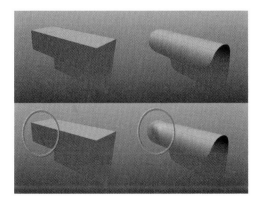

FIG. 2.2 Using non-quads in a mesh is one way to create subdivision artifacts.

11

body part or some new detail is added to the character, you will see non-quads created (either triangles ("tris") or polygons with more than four sides ("n-gons")) and then quickly eliminated using various techniques.

Using quads does not guarantee a clean mesh free of problems. Still, there are some compelling reasons for sticking with quads as much as possible:

Quads subdivide beautifully. Subdivision is really the process of creating quads within polygons, and then dividing those quads into more quads, so starting with quads just makes sense. When starting with a triangle or n-gon, the results can be dramatically less predictable. In Figure 2.3, while the square is neatly and evenly subdivided, the triangle has started to show some pinching, and the nine-sided polygon includes odd pinching and potentially problematic spacing.

Quads make adding detail easier. Subdivision surface modeling, particularly when it comes to what is called "box modeling," is all about roughing out shapes and then adding detail later. The best way to do this is with groups of nicely maintained polygons that can be quickly and cleanly divided. Triangles and n-gons often require individual attention and cannot be worked on as easily in a group.

Cleaner interpretation in other software programs and game engines. Some programs have a hard time dealing with n-gons. They may interpret them a little different from Silo or other software programs, which can cause hiccups when trying to finalize a project. To prevent hassle, it is often just easiest to stick with quads.

Professional projects almost always use quads. Based on the reasons just cited, pros usually stick to quads, which means if you ever want to try your hand at freelance work, or even produce a professional-quality project with fellow amateurs, the expectations will likely be almost all-quads.

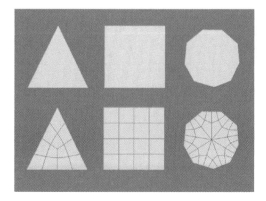

FIG. 2.3 Quads subdivide into a nice, even polygon mesh. The same cannot always be said for triangles or n-gons.

Using Face Loops

As mentioned earlier, just because you stick with quads does not make for a tidy, easy-to-work-with mesh. One key to a well-constructed object is creating well-defined face loops. Face loops are simply strings of quads, which are most useful when they follow the contours of an object.

Face loops that match the contours of an object help avoid subdivision artifacts, and allow artists to easily add detail with commands that can select (**Select Loop**) and split (**Split Loop**) whole loops at a time. A face loop down the back of a human character or around a cheek can easily become two or four loops, and the individual points can be tweaked to add spinal indentation or muscle definition. Throughout the later chapters of this book as we get into the modeling process, you will see repeatedly how we start with, maintain, and create contour-matching face loops, and then use those loops to add detail. Generally speaking, the better your face loops are, the more closely your low-polygon base mesh will resemble the high-resolution subdivided version, because you are more efficiently defining the contours of the shape.

Avoiding Poles

Inevitably, as face loops of polygons collide there will be places on the model where several quads come together in an uncomfortable fashion (i.e., more than four edges converging on a single vertex). These confluences are known as poles, and can cause subdivision artifacts similar to those caused by n-gons and triangles. (Like a face, a vertex will subdivide best when it has four evenly spaced edges coming into it.) A pole can be seen in the center of the subdivided nine-sided polygon in Figure 2.3.

Fig. 2.4 The side of the model is modified so that an edge loop can follow the body contours. This will help when shaping the ribs and abdomen. You will see this again in Chapter 6.

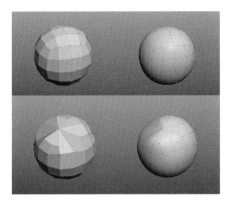

FIG. 2.5 Even in a mesh made of only quads, bringing too many quads together in a single point can cause subdivision problems.

Poles cannot always be avoided, but their effect can often be diminished with appropriate spacing or edge loop rerouting, as you will see throughout the modeling in later chapters.

Avoiding Holes

Silo will allow you to create polygons with holes (sometimes filled with another polygon) embedded in them. Note that this is different from using several regular, solid polygons to carve out a hole in your mesh. Polygons with holes can be useful in the modeling process when you are not working with subdivision, such as in architectural models. However, holes embedded within polygons will not subdivide in a desirable way, and can cause unpredictable problems down the road in rendering packages and game engines. Most 3D software is not built to handle embedded holes in polygons, so you will likely want to eliminate these before subdividing or exporting. You can do this by turning each polygon with a hole in it into multiple solid polygons that surround an opening.

Figure 2.6 shows two objects with holes. The first simply has a missing polygon, and will cause problems in subdivision and when trying to use the object in other programs. The second has a hole all the way through the object connected on all sides by polygons, and won't cause problems.

Maintaining Appropriate Polygon Density

One of the hardest senses to gain as a novice 3D modeler is how much detail to add to a model, and when to do so. Most professionals lean on the side of keeping the polygon density as low and uniform as possible until adding more geometry for specific details becomes necessary. Throughout this book you will see how, when using box modeling techniques, we define all the larger, simpler shapes, such as arms and legs, before going into details like fingers or toes.

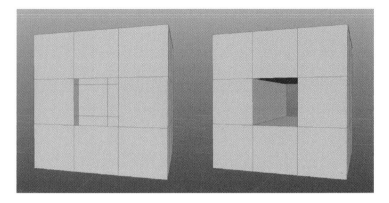

FIG. 2.6 Leaving holes in a model (as on the left) that are not connected all the way through (as on the right) can cause problems when subdividing or trying to use a model in third-party programs.

Working from Reference Images

Nearly all 3D work is done from reference material to some degree or another. Reference material will often be actual front and side views of what you want the model to look like along with photographs or drawings of objects that are similar to the planned finished product. In Silo, you can display these images directly in the viewports while you are working, but you might also just have them on hand to look at.

There are many reasons for using reference material, and a good portion of Chapter 4 is dedicated to the reference material gathering process. Two main reasons are:

1. Even with a clear direction for a model, it is very hard to visualize what the model will look like from all angles and in every nook and cranny. Unlike with 2D art, there is not much you can hide on a 3D model, and often getting a calf muscle right is just as important as a smile. A picture is worth a thousand words, but a model is worth a thousand pictures—it has to look good rendered from any angle.
2. Even the most abstract creatures look best when core structures match something in reality. A 3D model of a dragon, for example, can benefit from referencing a lizard or alligator, or a spaceship might draw on design elements of fighter planes or submarines.

Modeling with Primitives

Hugely important in 3D is the idea of working with premade content that can serve as the starting point for a model. Within the 3D community, there is no sense that you are taking the easy route by doing this; it's all about getting the best result as quickly and efficiently as you can. Silo includes a set of primitive

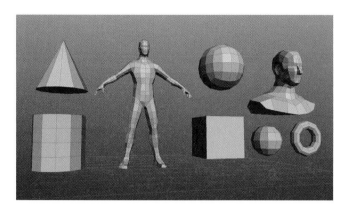

FIG. 2.7 A collection of standard Silo primitives.

shapes—including cubes, cylinders, and spheres, and a "Base Bust" and "Base Man"—that can be used as starting blocks. Experienced modelers often add their own commonly reused models to Silo's custom primitives, such as eyes or teeth, wheels and other mechanical shapes, and various basic characters of different shapes and sizes. They will frequently mine old projects for reusable material.

Bring on the Tools

With a conceptual understanding of these basic 3D conventions, we are ready to move on to the tools of the trade in Chapter 3. Then in Chapter 4, we will begin the process of making our own model.

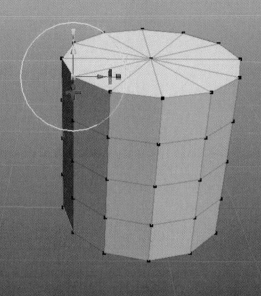

Silo Modeling Tools

This chapter, more than any other in the book, most conceptually matches a user manual for Silo. We will not be covering all of the tools (more will come in Chapter 14), but we will cover the core functions needed for each type of modeling in Silo. Those who are starting to feel comfortable with the software and are coming from another 3D software package might want to skip this chapter for now and reference the commands discussed here as necessary, but for newcomers, we recommend that you work through this chapter before moving on.

Throughout the later modeling chapters, important commands and processes will be called out, and that is a great way to learn them, but those chapters will not provide a background on the tools or a picture for how they fit into the toolset as a whole. That is what this chapter is all about. The following sections discuss keys tools in the context of some of the major modeling workflows.

Box Modeling

Box modeling is perhaps the most popular and freeform method for working with polygons, and it's the approach demonstrated to create the example in

3D Modeling in Silo. DOI: 10.1016/B978-0-240-81481-0.00003-0

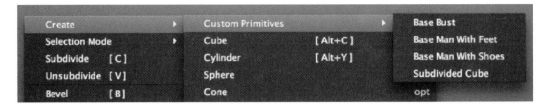

FIG. 3.1 Primitives menu in Silo.

this book. The basic idea is to start with a cube (hence the name), cylinder, or more advanced primitive shape and, using a few very important tools, divide up, extrude from, and mold the shape into a finished object. It is a similar concept to sculpting with clay, where you begin with a lump, rough out the masses by adding, removing, or manipulating the material, and then go over and over it again adding more detail. Box modeling works-in-progress might bear little resemblance to the finished product before the detail is added, and the artist must be careful to add detail methodically to avoid traps that create messy geometry or break from the conventions listed in Chapter 2. The following sections cover primitive creation, mirroring, and important box modeling tools used to divide, expand, and modify primitive shapes.

Primitives

Primitives are the building blocks for box modelers, and are accessible in Silo from the **Right Click** menu or the **Create** drop-down menu (Figure 3.1). The menu gives access to the basic shapes, and to custom primitives such as the **Base Man with Feet** or the **Base Bust** that have already been modeled to a certain point and can serve as an advanced jumping-off point. The most common starting point, the cube, has a keyboard command: **Alt + C**. By selecting **opt** in the menu next to any of the primitives that have it, you will be able to set various parameters such as height, width, and number of sections. You can adjust these parameters before or immediately after creating a primitive.

Mirroring

Often in the modeling process, what you are working on will have some type of symmetry, and rather than trying to make very similar changes to two sides of a model, Silo includes mirroring functionality.

- There are two important types of mirroring. To try them, start by inserting a cylinder into a new Silo scene with **Alt + Y**; the cylinder will insert itself at the XYZ origin of your scene. To see the effect we will be creating, it is best to slide the shape along the X (red) axis a bit (Figure 3.2a).

FIG. 3.2 Mirroring Geometry creates a second side of polygons and enables symmetry so changes are reflected on both sides.

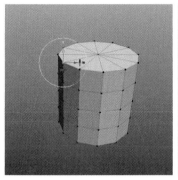
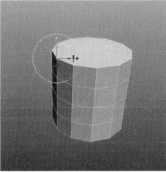
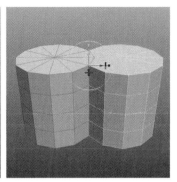

FIG. 3.3 Instance Mirroring shows a seam and a mirrored ghost half of the object that can be disabled and re-enabled.

- Now we are ready to **_Mirror Geometry_**. To try it, select the object and then choose **_Modify_** > **_Mirroring_** > **_Mirror Geometry_** (Figure 3.2b).

This should create a second mirrored side to the model (Figure 3.2c), since it's making the geometry on one side of the blue grid line match the geometry on the other side. This command will also turn on symmetry, so that any changes made to one side of your model will also happen on the other, as in Figure 3.2d.

Mirror Geometry; Modify > Mirroring > Mirror Geometry; Alt + Shift + N

Options under **_Modify_** > **_Mirroring_** > **_Mirror Geometry_** > **_opt_** can control the direction in which the mirroring happens and whether the two mirrored sides will merge vertices along the seam within a certain distance of the axis. Often it is helpful to open this window when performing a mirroring operation. The symmetry of the two sides can be disabled at any time using **_Modify_** > **_Mirroring_** > **_Symmetry Mode Toggle_**.

The other important type of mirroring is **_Instance Mirroring_** (Figure 3.3). As opposed to geometry mirroring, **_Instance Mirroring_** does not actually create new polygons, but simply creates a mirrored "instance" of your model. With an instance mirror, only one side of your model will actually exist as editable

polygons, but this side is drawn twice—once regularly and then once as a mirrored version of itself across whatever axis you choose in the options. This helps you visualize your model as a whole while only actually modeling half. You can then mirror the actual geometry at the end of your modeling process for exporting, so both sides will exist as actual polygons. This type of mirroring is centered on the object's own axis (as indicated by the position of the manipulator when you select it in object selection mode) rather than the location of the model in reference to the grid, so it also often requires the user to move this axis to where the mirroring should occur.

- Try this by selecting a single vertex on the part of your model you want to be the mirroring centerline (Figure 3.3a), and then select **Selection** > **Set Object Axis**.
- Now select **Modify** > **Mirroring** > **Instance Mirror Toggle**.

Instance Mirror; Modify > Mirroring > Instance Mirror Toggle; Shift + I

You'll notice a very similar effect to what we accomplished earlier, with the exception of being able to only edit the original side of the model (Figure 3.3c), and that the instanced side can be removed at any time by selecting the **Instance Mirror Toggle** again. Instance mirroring is often simpler and easier to work with than the symmetry mode described earlier.

Dividing up the Object

Split Loop; Modify > Split Loop; Shift + X (Hold to Slide)

Box modeling commands can be roughly classed into two groups: those that help divide the object, and those that help to expand it out and modify it. Both types of commands add new geometry to the model, which helps you more precisely define its shape. In the next few sections, we cover the three main Silo tools in the box modelers' arsenal for dividing: **Split Loop**, **Cut**, and **Bevel**.

Split Loop

Split Loop is the easiest and most powerful way to dissect a sequence of connected quads. To get an idea of how it works:

- Create a cylinder (**Alt + Y**), enter edge selection mode, and select a single vertical edge (Figure 3.4a).
- Now select **Modify** > **Split Loop** or press **Shift + X**.

You will see a new edge has cut directly through the middle of the selected edge and through all of the quads arranged on a similar track to those on either side of the selected edge (Figure 3.4b).

The quads that have been split are known as a face loop (as discussed in Chapter 2), a sequence of quads laid end-to-end, which, as we'll see later, frequently occur on cylindrical parts of a model (such as arms, legs, fingers, or a torso) and connect back on themselves, forming a loop. We will also be

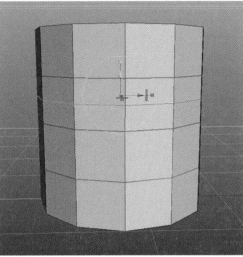

FIG. 3.4 You can easily divide a face loop using Split Loop by selecting a single edge between two faces in the loop and then calling the command.

referring frequently to edge loops, which are sequences of edges connected end-to-end that occur on either side of a face loop.

Select Loop; Selection > Select Loop; Alt + E

In cases like Figure 3.4, the split has gone all the way around the object or the entire distance of the loop, but a split might also only travel a short distance. The direction and length of a loop split can be manually adjusted by selecting the faces you would like to split first. You can select these faces one at a time or automate the process using the **Select Loop** command (**Selection > Select Loop** or **Alt + E**) in the following ways:

- Selecting two consecutive faces or a single edge and calling **Select Loop** will select an entire loop, which can then be split (Figure 3.5a–c).
- Selecting two nonconsecutive faces along a loop will select any faces between the two faces, and then calling **Split Loop** will only split the selection (Figure 3.5d–f).

A split can also go along a manually selected group of faces whether they form a true loop or not as long as Silo can calculate a path through the faces (Figure 3.5g–i).

The **Split Loop** command will allow you to adjust the position of the new edges it creates by automatically opening the **Slide** tool for use on the new edges. This tool lets you slide a sequence of connected edges along the surface of your model as follows:

Slide Tool; Modify > Slide; J

- If you use the keyboard shortcut to call **Split Loop** (**Shift + X**), the Slide tool will open and stay active only as long as you continue to hold these keys down.

Three ways to select and split loops using face selection. Top row: Selecting two consecutive faces and then Select Loop. Middle row: Selecting nonconsecutive faces and then Select Loop. Bottom row: Manual selection.

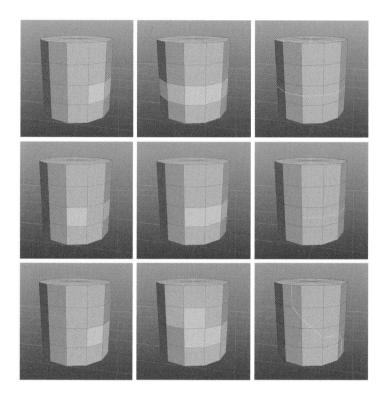

- You can adjust the new edges' position by simply moving your mouse left or right and then releasing the keyboard keys when you are done.
- Otherwise, the Slide tool will open normally after you call **Split Loop** and you can use it by clicking and dragging on the yellow sphere that appears and pressing **Enter** or **Esc** when you are finished adjusting the edges.
- To adjust the placement of these edges later, simply select an edge and press **Alt + E** to select the loop of edges (double-clicking with the **Left Mouse Button** will have the same effect).
- Next, choose **Modify > Slide** or press **J** to enter the Slide tool.

Cut

Cut is a very simple-sounding tool that does many things, depending on what kind of selection you have, but essentially, it lets you divide polygons manually. The important thing to remember about Cut is that it always inserts new edges into the model based on your input and selection mode. Like many tools in Silo, if nothing is selected, Cut will enter an interactive tool mode. If something is already selected, it will act on that selection instead as a command. To get an idea of how it works:

Cut Tool; Modify > Cut; X

- Go to the menu and select **Create > Cube > opt**, and in the options screen set all the values to 3. This will give you a cube with nine faces on each side.

FIG. 3.6 The Cut tool can be used to cut a path across a model.

- Make sure no faces, edges, or vertices are selected, and select **Modify** > **Cut** from the top menu or press **X**.

You will notice the cursor has changed to a two-tone arrow and, regardless of the selection mode you were in before, you are now in multi-select mode. This is the interactive tool we mentioned earlier. It has an entrance (**X**) and an exit (**Esc** or **Right Click**), and the program will function much differently while the tool is in use.

A common usage of **Cut** is to draw out a path for a new edge, so let's try that.

- First, select a vertex on one side of the cube. Once selected, the vertex will turn green, indicating it is the starting point of a cut (Figure 3.6a).
- Next, move the cursor on an edge opposite to the first point (Figure 3.6b). You will notice you can drag along the edge to place a new vertex. Release the mouse button to complete the placement of the new vertex.
- Now click on a face adjacent to the newly created vertex, and again you will see you can drag the new vertex anywhere within the face (Figure 3.6c).
- Finish the cut by clicking on a vertex at the edge of the selected face (Figure 3.6d). Press **Enter** to finalize this cut path and start a new one, or press **Esc** to exit the tool.

It is important to note that a cut cannot jump across an edge between two faces, so to make a continuous cut across multiple faces you must use the tool to cut a new vertex into each edge as you cross it.

As mentioned previously, when vertices, edges, or faces are selected and **Cut** is called, it will behave as a command rather than an interactive tool, with the following results:

- With two or more vertices selected, Cut will connect any selected vertices that share a face, splitting that face with a new edge.
- With an edge selection, Cut will divide each edge with a new vertex and split any polygons containing more than one of the selected edges by connecting the newly created vertices.
- With a face selection, if a face loop is selected, Cut will divide the face loop.

Bevel

Bevel is another key tool for dividing an object, particularly useful in working with hard surface objects. The tool is used for creating a bevel along selected edges or the edges connected to selected faces or vertices. It is akin to slicing off the corner where faces meet, revealing a new face and edges, and is frequently used to add a slight rounding effect along the corners of an object. Bevel is also a handy way, as you will see throughout the book, to quickly add geometry to a mesh.

Bevel Tool; Modify >
Bevel; B

To get a feel for how Bevel works, let's return to the cube with three subdivisions on each side.

- Select an upper edge on one side and double-click to select the whole top edge.
- Select **Modify** > **Bevel** from the top menu or press **B**. A round manipulator will appear that will allow you to adjust the size of the new polygon.
- You can also press and hold **B** when performing the initial bevel to adjust the size with the mouse.

The result should look like Figure 3.7b. It is very important to adjust the Bevel in a noticeable way, or it has the potential to create invisible stacks of polygons that will dramatically change how the model looks when subdivided.

Bevel can also be used with faces and vertices, as seen in Figure 3.7a and c. You will notice one problem with using **Bevel** on faces within a mesh: it creates triangles at each corner (Figure 3.7c). These can be eliminated using the **Merge** tool, which we discuss later in the chapter.

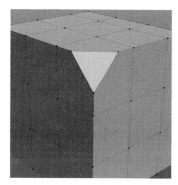
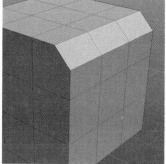
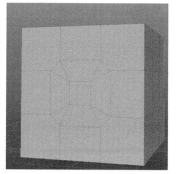

FIG. 3.7 The Bevel tool is akin to slicing off a piece of an object and revealing new faces and edges. These screen shots show beveling a vertex, an edge, and a face.

Expanding and Modifying the Object

In addition to chopping up a cube or a cylinder, box modelers need to easily expand the geometry in various directions and modify it. There is a host of tools and techniques modelers use for this, and we cover some of the most important—**Extrude**, **Tweak**, **Soft Selection**, and **Smooth**—in the following sections.

Extrude

Extrude essentially pulls or extends faces or edges out from the model by creating new adjacent faces. In edge selection mode, Extrude creates a new copy of the selected edges, and connects each new edge to the original with a face. In face selection mode, new faces are similarly created along the boundaries of the selection.

Extrude Tool; Modify > Extrude; Z

After the command is activated using **Modify > Extrude** or **Z**, the new edges or face will then be selected for moving. If an edge is extruded, the previously enabled manipulator will remain in use. If a face is extruded, the **Local Move** tool will be activated, allowing you to move the face perpendicular to its plane. To exit **Local Move** you will have to press **Esc**. However, by pressing and holding **Z** when performing the extrude, you can perform the local move with the mouse, and the Local Move tool will be deactivated when you let go of **Z**. As with Bevel, it is very important to move extruded edges and faces in a noticeable way, or the extra layers of polygons will cause problems with subdivision.

To get a sense of how extrude works, extrude out a chunk of polygons using the following steps:

- Create a cube, this time with just one face on each side (**Create > Cube** or **Alt + C**) (Figure 3.8a). If the standard tool creates something other than one face per side, you can adjust the settings under **Create > Cube > opt**.
- Select one side of the cube and press and hold **Z**, and then slide the mouse until the box has doubled in size (Figure 3.8b). Now select the two faces that make up the bottom of the object and repeat that same kind of

FIG. 3.8 Extrusion can quickly turn a cube into something more.

extrusion twice. You should end up with something like Figure 3.8d. This is how a box modeler might start a torso, the body of a car, or any number of other objects.

Tweak

After extruding out all kinds of polygons, it is the box modeler's job to mold them into something. The manipulators discussed in Chapter 1 are certainly capable of the task, but Silo also includes a great, free-form tool, **Tweak**, to make the process as fast and organic as possible. Tweak was introduced to allow a succession of quick edits without having to select, deselect, and use the manipulator every time. Its function is tied to the current manipulator, and it is most often used with the move manipulator. Since it is shorthand for working with the manipulators, it cannot be listed as a separate menu item; the default way to use Tweak is by holding down the **Control** key.

Tweak has two main uses:

- **Free-form molding without the manipulator**. If nothing is selected, Tweak will select the component or object temporarily, perform the manipulator action while dragging, and then deselect when you release the mouse button. Thus, you can, for instance, move many vertices one at a time without having to painstakingly select and deselect each. Simply hold down the **Control** key, and click and drag on each vertex.
- **Automatically grab the active manipulator**. If you have something selected and the manipulator is visible, clicking and dragging with Tweak will perform the function of the current manipulator in the plane of the screen without having to click on the manipulator itself. This can be helpful when working with intricate meshes or in situations where the manipulator is inside the model or otherwise difficult to access.

Tweak; Control + Mouse

Let's try **Tweak** by going back to the rectangular shape created using the **Extrude** tool and fashion it into a more organic structure, something that might be the building block for the torso of a barrel-chested character. Figure 3.9 shows a sample of how this might turn out. Study the figure and when you're ready, try the following:

- Make sure to enable vertex selection and the move manipulator.
- Using **Tweak**, expand out some of the center polygons, and then shrink those around the top and base.
- Add volume and rounding by pulling out the center vertices.
- Continue to shift your view of the model, tweaking points one at a time to get a rounded look.

Feel free to experiment with this tool. Often, using Tweak can add dramatically to the efficiency and the fun when creating a model.

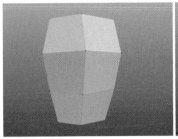

FIG. 3.9 Tweak can quickly transform a rigid shape into something more organic.

 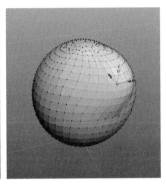

FIG. 3.10 Soft Selection manipulation edits elements around the selection based on Radius and Falloff settings. The effect of Soft Selection is most visible in a dense mesh.

Soft Selection

For sweeping changes on a slightly larger scale, **Soft Selection** is a great tool. Unlike other tools we've looked at, **Soft Selection** has the capability to affect many polygon components at once and tailor the impact to each component individually. When **Soft Selection** is enabled, the effects of the move, scale, and rotate manipulator edits will be as usual on the selected elements, but will also be distributed to adjacent polygons based on a radius and falloff. This causes edits to have a smoothed or softened effect on the model, resulting in an organic, clay-like feel if the geometry is dense enough.

To enable **Soft Selection**, select **Selection > Soft Selection** from the top menu, or press **Alt + Shift + S**. To try it:

- Create a sphere (**Create > Sphere**) (Figure 3.10a).
- Enter vertex selection mode (**A**) and use **Tweak** to drag a few vertices around (Figure 3.10b).

You can tell how much the transformations will affect individual vertices by the coloring of vertices when **Soft Selection** is enabled—the darker the color, the less the effect. The radius (the number of elements selected) can be

Soft Selection; Selection > Soft Selection; Alt + Shift + S

increased or decreased using the **Scroll Wheel**. The "falloff" of the effect (how sharply the effect will stop as it fades out) can be edited by holding **Control** and using the **Scroll Wheel**.

To see the impact on a denser mesh, subdivide twice (**C**) and then select **Subdivision** > **Refine Control Mesh**. **Tweak** a vertex and you'll now be able to easily see how the impact is distributed (Figure 3.10c). Play with the dense mesh using Soft Selection and adjust the falloff and radius to get a feel for how they work.

Smooth

Smooth; Modify > Smooth;

A complement to all of the expansion and modification tools is the **Smooth** command (**Modify** > **Smooth**). **Smooth** averages the positions of the selected components' associated vertices, evening out irregularities and extremes, and the effect is something magical. It basically fixes poorly spaced and uneven geometry, and makes the job of tweaking a large mesh much easier.

To try **Smooth**:

- Create a 5 × 5 flat grid. Select **Create** > **Grid** > **opt** and set the width and depth and sections to 5. You should end up with something like Figure 3.11a.
- Now go to town messing with the grid using **Tweak** or the move manipulator. Move vertices up and down, pull out edges, etc. (Figure 3.11b).
- Now, switch to Object Selection mode and select **Modify** > **Smooth**. Instantly, you'll see much of the unevenness disappear as the grid smoothes out (Figure 3.11c). Press **Smooth** again to further dramatize the impact (Figure 3.11d).

One thing you'll notice with **Smooth** is that, by its nature, it tends to reduce the size of the polygons being smoothed. This might work in your model's favor, but might also be an undesirable side effect. If needed volume is lost, you can add it back in using **Tweak** or **Soft Selection**.

FIG. 3.11 A messy grid can easily be fixed with the Smooth tool.

Point Modeling Tools

Point modeling, also known as poly-by-poly modeling, is an alternative approach to box modeling that is all about creating each polygon in the proper place to begin with. It has a similar feel to 2D art, where an artist draws a character piece by piece, one detail at a time. This approach can feel more technical in nature than box modeling, and is often used with mechanical models or when working from reference material.

Viewports and Viewport Images

While all modelers typically work using some kind of reference material to inform how a model will take shape, when using point modeling techniques, the reference images become indispensible and a more integral part of the modeling process. Modelers will often gather various reference photos and create their own composite image of a front and side view to use in the modeling process as in Figure 3.12.

These images are loaded into a Silo scene by first navigating to an orthogonal viewport camera (references are not visible in perspective mode) and selecting **Display > Set Viewport Image**.

- Try this by loading the two reference images in Figure 3.12 in the front (press **2** to enable) and right (press **6** to enable) views of a Silo scene. The images are included with the downloadable in the Chapter 3 folder as *grey_alien_front.jpg* and *grey_alien_side.jpg*.

You will want to save the files to a local drive before starting; the images are not saved within a Silo file, so if they are moved, or if the Silo file is moved, they will no longer be visible. You might also want to use the **Vertical Split Layout** so you can see both the front and side views at once (Figure 3.13).

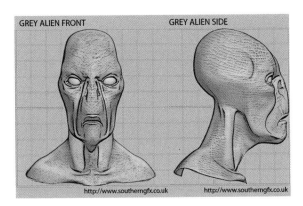

FIG. 3.12 A front and side view created by an artist in preparation for a modeling project. (Artwork courtesy of Glen Southern.)

You can enable the vertical split by selecting *Display* > *Viewport Layout* > *Vertical Split Layout* or by pressing *Control + Right Arrow*.

To work with these images, it's important that they be placed to scale with each other and in the proper position, using key matching reference points on the side and front views. In Figure 3.13, the eyes, top of the head, nose, and other key features fall at the same level on the grid. By default, Silo will center the images and place them to fill the grid, so, as long as they are the same size, not many adjustments should be needed. If the images do need to be adjusted, you can use *Display* > *Select Viewport Image*, and a manipulator will be placed on the image to allow you to move and edit it.

At times, particularly when you are using a reference image, it's important to see through a model to get a feel for how it is lining up with the reference, and Silo provides various ways to do that. From *Display* > *Object Display Mode* or *Right Click* > *Object Display Mode* you can select *Ghosted Shade Mode* (Figure 3.14b) and *Wireframe Mode* (Figure 3.14c), which provide various degrees of transparency. The default modeling mode is *Flat Shade Mode* (Figure 3.14a).

FIG. 3.13 A Vertical Split Layout in Silo with the reference images inserted.

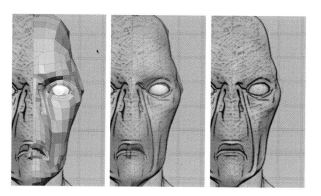

FIG. 3.14 Various display modes include Flat Shade, Ghosted Shade, and Wire Frame.

Polygon Creation Tools

With reference images in place, it's time to start laying out the individual polygons that will make up our edge loops. The key tool for this process is **Append Polygon**. **Append Polygon** is a context-sensitive command that offers a couple of ways to add geometry to your model. For now, we'll focus on the interactive polygon creation tool that will allow you to draw out new faces.

Append Polygon; Modify > Append > Append Polygon; P;

- To get started with **Append Polygon**, load the file with the reference images of the alien creature and enter the right view.
- Now engage Append Polygon by selecting **Modify** > **Append** > **Polygon** or **P**. You'll notice the cursor has changed and, when you click, a green dot will appear. This is an indication that we are in polygon creation mode.
- Continue to click out a basic polygon shape, and as soon as three vertices are in place, you will see a shaded region where the polygon would fill in if it were finalized (Figure 3.15a).
- Once the fourth vertex is in place, press **Enter** or **Right Click** to finalize that polygon.

From there you can create additional polygons by enclosing additional space and linking vertices with the already-created polygon. It's important to select points in a circular fashion (either clockwise or counterclockwise) to allow the software to create the face appropriately.

After creating the first polygon, some modelers might elect to use something other than **Append Polygon** to continue a face loop. As discussed earlier, you can use **Extrude** edges, and one option is to select an edge, press **Z**, and then use **Tweak** or the manipulator to drag out and position a subsequent faces. The universal or multi-use manipulator is particularly good for this, as it allows you to move and rotate as you go (Figure 3.16). The **Surface tool** is also a great option that works in a similar fashion. It's more commonly associated with retopology, so it's discussed in more detail in that section. The key is to find a fast and simple workflow that works well for you.

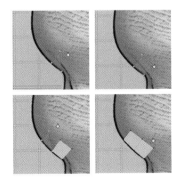

FIG. 3.15 Using the Append Polygon tool, you can begin to draw out a face loop.

FIG. 3.16 Using Extrusion and the Universal Manipulator, it's easy to draw out a face loop.

Polygon Connection Tools

Once a few face loops are in place using the polygon creation tools, the next order of business will be connecting them and filling in the gaps. There are three main ways to do so: *Append Polygon*, *Bridge*, and *Merge*.

Append Polygon

Append Polygon, like many of the Silo tools, has various context-sensitive uses. If you select three or more existing vertices before calling the command, a new face will be created from the selected vertices.

- To get a feel for this, and to get set up for learning the rest of the connection tools, open a new Silo project.
- Enter the front view and use the *Append Polygon* tool as mentioned in the previous section to create two lines of five polygons (Figure 3.17a). Use the grid lines to keep the polygons relatively straight, but they don't have to be perfect.
- Once you're done, deselect the *Append Polygon* tool, enter vertex selection mode, and select the bottom four central vertices in a circular order (Figure 3.17b).
- Now select *Modify* > *Append* > *Polygon* or press *P* to initiate the tool and you will see a polygon has filled in the space (Figure 3.17b).

Bridge

Bridge; Modify > Bridge; Shift + B;

The *Bridge* command is very similar to *Append Polygon*, but can be much faster if you are dealing with a whole string of polygons. Rather than connecting everything that is selected into a single polygon, *Bridge* will try to intelligently match up selected elements and create polygons between them. The tool can also be used to merge and connect whole objects and to turn

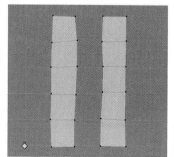
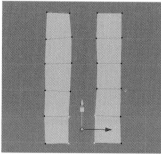
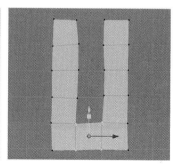

FIG. 3.17 Append Polygon can help fill in the gaps in a mesh.

congruent, selected faces into a polygon tunnel, but for our purposes, we'll just focus on connecting sides.

- To try it, go back to the object we created in Figure 3.17 and select the top three inside edges on either side of the U shape.
- Next, select **Modify > Bridge** or press **Shift + B**, and the space should be neatly been filled with quads (Figure 3.18b).

Merge

Rather than connecting geometry by creating something new, **Merge** connects separate pieces of geometry by combining them. If two vertices are selected, the first will be moved to the position of the second and they will be merged to create a single vertex. If more than two vertices are selected, any selected vertices that are closer together than the tolerance specified in the merge options (**Modify > Merge > opt**) will be merged with one another. This is particularly useful if you have separate pieces of mesh whose vertices are aligned and you want to join them. If faces or edges are selected, each face or edge will be collapsed into a single vertex. This can do things like quickly turn a face loop into an edge loop, removing the extra geometry.

Merge; Modify > Merge; Control + M;

Let's eliminate the hole we've created in our mesh from the previous commands and close a seam using **Merge**.

- First, select the two vertical edges surrounding the hole.
- Next, select **Modify > Merge** or press **Control + M**. The sides should now be eliminated and the top and bottom of the former hole will be a single edge (Figure 3.19b).
- Now eliminate the triangles on the sides by selecting the two vertices on the outside of each triangle and again pressing **Control + M**.

You'll notice that the first point selected merged to the second point, rather than meeting in the middle so the lines are no longer straight across. Straighten the edges (as in Figure 3.20a) and we can move on to merging two unconnected sides of an object.

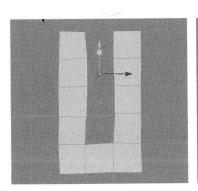

FIG. 3.18 The Bridge tool can also fill in the gaps adding multiple polygons at once.

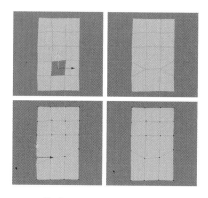

FIG. 3.19 The Merge tool collapses polygons and sides and can help eliminate holes and problem areas.

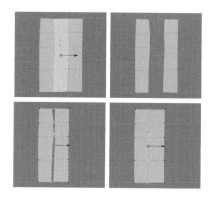

FIG. 3.20 Merge can quickly close open seams.

- Select the faces down the middle of the mesh we've created (Figure 3.20a) and delete.
- Next, select one of the halves of the model and move it close the second half, so they are almost touching.
- Enter Vertex Selection mode and, with box selection style, quickly select all of the vertices along the inner sides of the two disconnected halves (Figure 3.20c).
- Now press **Control + M** and each matching pair of vertices should come together (Figure 3.20d).

If it doesn't work the first time, try playing with the merge tolerance (**Modify > Merge > opt**) by setting the tolerance to 0.5 or higher. If only some of the points merge, you can either adjust the nonmerging vertices so they are closer to each other or continue to increase the merge tolerance.

Sculpting

One of the biggest advances in 3D modeling in recent years was the introduction of brush-based digital sculpting, or displacement painting. It has the promise of allowing 3D artists to look at their models as a lump of clay ready to be worked on, rather than a set of points that require technical fiddling. As of version 2.0, Silo includes a basic sculpting tool kit, and offers something other programs can't: the ability to switch back and forth between polygon modeling and sculpting. Displacement Painting is the only tool that can work directly with a subdivided mesh. Thus, you can still have a simple polygonal base mesh, and then sculpt details into the subdivided levels using displacement brushes.

Working with the sculpting tools is a little different from working with the standard polygon editing tools. It's conceptually much simpler but, as with polygon editing, it's easy to get lost if you don't take a few minutes to get your bearings. We cover all the basics in the next few sections.

Displacement Painting Brushes

The tools for sculpting in Silo are called displacement painting brushes. You can see the available default brushes by selecting *Editor/Options* > *Brush Editor* or *Modify* > *Paint Displacement* > *opt* or by pressing *Shift* + *T* (Figure 3.21). There are six main brush functions and seven default brushes, although you also have the option to create and save your own derivatives of the defaults. You enter the tool by selecting *Modify* > *Paint Displacement* or by pressing *T*.

Paint Displacement; Modify > Paint Displacement; T;

To get familiar with each of the functions, it is probably best to load a custom primitive base bust (*Create* > *Custom Primitives* > *Base Bust*), subdivide a few times, and then try each of the brushes. Some, you'll notice, have a much more dramatic impact than others. Also important to note is that most of the brushes have an alternate or opposite effect. To get the basic effect you'll use the *Left Mouse Button*. To get the alternate effect you use the *Right Mouse Button*. The size of the brush can be adjusted by holding the *Middle Mouse Button* or *Scroll Wheel* and moving the mouse (or with the *Radius* value in the settings screen). In general, you should see the following results:

- *Push* (or *Sharp Push*) *Brushes*: These brushes add volume to the mesh. As you can see in Figure 3.22a, we've drawn a circle around the eye with the mouse while holding down the left mouse button. Alternatively, using the right mouse button will carve into the model.
- *Smooth Brush*: The *Smooth Brush*, much like the *Smooth* command, helps put the object in order by evening out variation, diminishing the impact of other sculpting tools, and decreasing volume. The right-click alternative adds noise, making the mesh rougher. In Figure 3.22b, using the *Smooth Brush* we have eliminated much detail from the base bust.
- *Move Brush*: The *Move Brush* is much like *Soft Selection* combined with *Tweak*. It allows you to grab a chunk of polygons and move them around

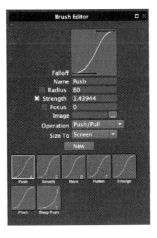

FIG. 3.21 The Brush Editor shows the displacement painting brushes available in Silo.

FIG. 3.22 The various brush tools in Silo can have very different effects on a model.

in a free-form fashion. This allows quickly adding bulk or organic growth, as in Figure 3.22c. The right-click alternative moves the polygons in the opposite direction of the mouse.

- **Flatten Brush**: Holding down the **Flatten Brush** and moving the mouse over a given set of polygons will bring the neighboring polygons into alignment with the first polygon selected. It's a great way to flatten out a portion of a model, as in Figure 3.22d.
- **Smudge Brush**: Like a smudge tool in a photo editor, the **Smudge Brush** allows you to slide and swirl content around. It can be very helpful for adding organic folds, twists, and sagging (Figure 3.22e).
- **Pinch Brush**: The **Pinch Brush** tightens up geometry. It shrinks all the polygons within the brush's radius, pulling in those surrounding the impact, as in Figure 3.22f, and can be used to sharpen the impact of other brushes. The right-click alternative is **Inflate**, which expands all the polygons within the brush radius.

Displacement Painting and Subdivision

Sculpting tools work in Silo at any level of subdivision, including the base mesh level. However, by default, changes made with brushes don't affect all of the levels of subdivision, just those at higher (i.e., smoother) levels. It is often helpful to keep the sculpting and base mesh separate, because if you have spent a significant amount of time getting the geometry of the base just right (as we'll do in Chapters 4–8), it would be a shame to muddy it up as you play with the final touches. By keeping the base mesh unaffected by the sculpting changes, you are able to export either the high-resolution model or the base mesh along with a normal or displacement map for use in other programs.

Sometimes, though, propagating changes can be quite helpful, allowing sculpting tools to dictate the direction of the base mesh. This allows a user to switch between sculpting and polygon tools more seamlessly because the geometry from all layers of subdivision is more closely related. Whether displacement is propagated to lower subdivision levels can be specified in **Editors/Options** > **Subdivision Settings**. In the settings screen you'll see the options to **Propagate Displacement to Base** and **Propagate Displacement to Lower Subdivisions**.

Displacement Painting Workflow

Combining the brushes with what we know about how displacement painting works, we can construct a workflow for the sculpting process. If we are working with sculpting layers that do not affect the base mesh, the first important step is to get the underlying geometry right before applying the brushes. Once that's in place, we'll want to work from lower subdivision layers up to higher subdivision layers. Sculpting broad forms at lower subdivision levels is better because there is less geometry to move around, which means

less chance for system slowdowns (which can happen when working with high polygon counts), and less chance for artifacts and holes that can present themselves when dramatic sculpting changes are made to large numbers of polygons.

Just as it's helpful to work from lower subdivisions up, it's often helpful to have an order for working with the brushes. One good option is to start with **Sharp Push** to carve out some of the main elements, and then use **Smooth** to soften the overall effect. Next, use **Pinch** to help define and sharpen creases or folds, and then **Smudge** to move details around, add sagging, and otherwise dramatize the organic effects.

Let's trying putting that workflow into practice by adding some organic detail to a grid shape.

- Start by creating a 10 × 10 grid from the **Create** > **Grid** > **opt** menu. It should look like Figure 3.23a.
- Now subdivide twice and try the brushes in the order discussed to create some organic shapes. In Figure 3.23, we have made two wavy lines, a ring and circle, but feel free to try other shapes if you like.
- Trace out the shapes with **Sharp Push** (Figure 3.23b), and then iron out any rough spots with **Smooth** (Figure 3.23c). Be careful not to take out too much of what you've done.
- Next use **Pinch** (Figure 3.23d) to sharpen the borders, and **Smudge** (3.23e) to add additional organic flair.
- Once you're happy with the basic feel at this level of subdivision you can start working at higher levels. Subdivide and add detail following the same steps. Continue working to see results like those in Figure 3.23f–h.

More on this process is covered in Chapter 9 as we go over clothing creation for our model.

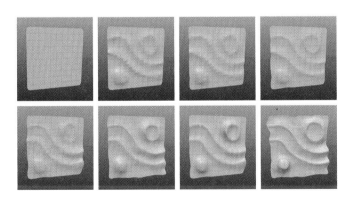

FIG. 3.23 Following the Push, Smooth, Pinch, Smudge workflow is a good way to add organic detail.

Retopology Tools

Topology is the overall flow of polygons in a given model, and retopology tools help to rebuild poor or unusable topology. Topology can be unusable either because a mesh is too dense and detailed or because it is flawed in some way, such as having poorly defined edges for animation. The goal is to make a new object with the same basic shape, but better or more efficient edge flow and geometry. Retopology is a necessary step in many modeling workflows and, given that Silo developers have strived to build the best tools for modeling, retopology tools are a natural extension of the basic Silo toolset. In this section, we talk about **Snapping** and the **Topology** and **Surface tools**. These, combined with the basic point modeling techniques discussed earlier in the chapter, provide many options for the retopology workflow. The basic concept is creating new geometry following the surface of the original, and any tools that will get you there are fair game.

Surface Snapping

The most important component to the retopology workflow—something common to pretty much any retopology technique—is surface snapping.

- To enable surface snapping, the original model (that needs to be retopologized) must be unselected in the scene.
- Then select Selection>Snapping>Surface Snapping or Alt+`.

Surface Snapping; Selection > Snapping > Surface Snapping ; Alt + `;

This will allow you to build a new shape, using any number of tools, that stays connected to the existing model, but will be a separate model in the scene.

Topology Tool

The **Topology tool** is one of the simplest and most intuitive tools in the Silo toolkit. It allows you to draw new geometry onto a mesh as though you were using paper and pencil. To try this, open the file containing the example model we created in the section on sculpting. You can find this file with the downloadable material in chapter3/retopology.sib.

Once you open the file, you'll notice we have used the **Refine Control Mesh** command (**Subdivision > Refine Control Mesh**) so that all of the organic changes we made are now reflected in the base mesh (Figure 3.24). We can use this refined mesh as a basis for our retopology work.

- To get started, engage the Topology tool by selecting Create > Topology Tool or Control + T.
- From there, just draw a few lines where you'd like the polygons to flow. For example, try making a ridge down the top fold in the mesh and a row of polygons on either side (Figure 3.24a–b).

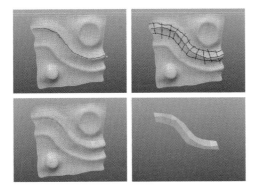

FIG. 3.24 The Topology tool is used to draw out geometry on top of an existing mesh.

- Once the drawing is done, press **Enter** to finalize the shape; you can then hide the existing model to see how the new geometry looks (Figure 3.24d).

The brush strokes are saved with the model and can be further added to by reopening the tool.

Topology Tool; Create > Topology Tool > Control + T;

Surface Tool

The **Surface tool** is a little like **Append Polygon** and **Extrude** on steroids. It's a very fast way to string polygons together one at a time. It can be used to add to existing models or to build from scratch, but its most important use comes in retopologizing. When an existing model is loaded into the scene, the **Surface tool** defaults to multi-select mode, enables surface snapping, and puts the existing model in **Ghosted Shade Mode** to make the new topology easier to see. The tool then allows you to draw out polygons point by point or quickly extrude edges.

Let's take the tool for a spin using the same mesh we used to test the topology tool. Again, you can find the file with the downloadable material in chapter3/retopology.sib.

- With the model loaded (but not selected so Silo knows we're interested in retopology rather than adding to the model), engage the **Surface tool** by selecting **Create > Surface Tool** from the menu or by pressing **Shift + P**.
- Start by creating four vertices to make the first polygon (Figure 3.25a), much the same way we did with **Append Polygon**, and press **Enter** to finalize the polygon.
- From there, quickly drag out a row of polygons one at a time by selecting an edge.

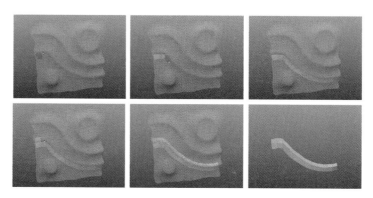

FIG. 3.25 The Surface tool allows users to quickly drag out rows of new polygons snapped to a base mesh.

- **Left Click** to terminate each polygon, and **Right Click** or press **Enter** to finish a whole strip of polygons (Figure 3.25c).
- Now create a second strip as we did with the Topology tool, but make sure the side that connects to the first strip turns red as you drag the polygons along (Figure 3.25d). This will ensure that the mesh stays connected and there are no unwanted seams.

Surface Tool; Create > Surface Tool > Shift + P;

Other Retopology Workflows

As mentioned earlier, retopology doesn't have to involve a specific set of tools, and if you are more comfortable with the control of **Append Polygon** and **Extrude**, those are very capable tools for the job. The key is to have surface snapping enabled, and a good visual setting (such as **Ghosted Shade Mode** for the base model) that will allow you to work efficiently.

Materials and UVs

Beyond modeling, a whole visual aspect goes along with working in 3D, and in this section, we will step out of gray and into color! There is a simple way to add color to polygons, which we address in the following section on Silo materials, but that alone doesn't address the complex patterns and intricate art that often needs to go into a finished product—that's where the UV tools come in. UV tools occupy the last several sections of this chapter.

Materials and UVs are often the departure points for work on a model in Silo, in the sense that they are the last level of polish you can add before heading to a third-party program for rendering, painting, animation, and so forth. Fortunately, Silo integrates beautifully with these third-party programs where you can do the additional work that will produce something like the art you see on the cover and at the end of this book.

Silo Materials

Materials are one of the few things in Silo controlled exclusively from an editor side menu. The editor can be accessed using the drop-down menu **Editors/ Options** > **Material Editor** or **UVs/Materials** > **Material Editor** or by pressing **Control** + **Alt** + **M**. When you first start a project, your palette will come with just the one default material we've used throughout this chapter, but it's easy to add more, and you have the option of creating materials that are either just color or based on an image.

Here we focus on simply adding color, and to get a feel for the tool we'll create a shirt, hair, and skin for the primitive base bust. Feel free to select any colors you like, just make sure they are distinct enough to be noticeable.

- To start, open a new project and insert the base bust (**Create** > **Custom Primitive** > **Base Bust**).
- Now open the Materials Editor using one of the methods listed previously and create a new material using the **New** button.

You will notice four color options: "Diffuse," "Ambient," "Specular," and "Emissive." "Diffuse" is the main setting we'll be working with here. The rest deal with how coloring reacts to different kinds of light.

- Once you have created the new material, click on the colored square next to the "Diffuse" setting and change the color to one appropriate for hair. Name this new material setting, and then create two more new materials—one for the shirt and one for the skin, in whatever colors you like.
- Now enter face selection mode and select the areas for the hair. Then, in the materials editor, select the appropriate material and press **Apply**.
- Repeat the process for the shirt, and you should get something like Figure 3.26a.

Rather than trying to select each of the remaining faces individually for the skin, we'll use one of the great features of the **Material Editor**: **Select By**.

- Select the default material in the editor, press **Select By**, and you should see all of the remaining polygons selected (as in Figure 3.26b). Select your skin material, press **Apply**, and you're done.

UV Basics

UV tools are some of the most difficult to understand in the Silo toolset because they involve new vocabulary, a new viewing style, and a new way of thinking about your model. In addition, unlike some of the other concepts we've discussed, working with UVs doesn't involve as much iteration—it's more like a recipe of small steps—so it's important to catch them all. This section includes a mini project: creating a T-shirt UV map to help you understand the flow and process.

FIG. 3.26 A base bust with three materials applied.

 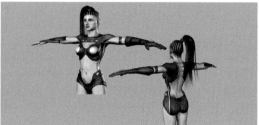

FIG. 3.27 A UV map, texture art, and final character created by Antony Ward.

To start, it's important to know what UV stands for and why UV tools are important. The letters U and V represent the two axes in a two-dimensional view of the polygons that make up a 3D model. This 2D representation or UV map contains a flattened-out version of all of the polygons, broken along seams into groups. The map is used as a template to create detailed textures for a model, a process that happens outside of Silo in a painting program. The textures are then imported into Silo and wrapped around the model, much like fabric or skin, according to the map.

Perhaps the best way to get a sense of how this works is to see a final UV and painted texture. In Figure 3.27a, it might be hard to tell at first, but what you are seeing is a model of a female character that has been flattened for UV work. The head was cut down the back and was laid out in two halves along with a mid section and other parts of the character's body. This map was then exported from Silo for painting (Figure 3.27b) and reimported for use on the model (Figure 3.27c). For now we won't try to produce anything this complex (more to come in Chapter 13), but we will look at how the tools can work on some basic models.

UV tools fall into a few categories: seam creation tools, UV unwrapping and placement tools, and UV manipulation tools. In this chapter, we walk through

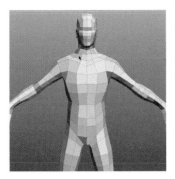

FIG. 3.28 A basic T-shirt model will serve as a starting point to learn about UV tools.

all the categories, and most of the tools in the categories. Some of the tools require a more advanced model than would be productive to create for this section, so we'll wait to cover them in detail in Chapter 13.

UV Viewing and Setup

To get started working with UVs, we need to start seeing them.

- Access the **UV 2D View**, which will show the basic square UV space, using **Right Click** > **Viewport Camera** > **UV 2D View**, or press **9**.
- Some artists like to have this view up side by side with the model using the horizontal split (**Control+Right Arrow**).
- We will also want to see the model's UV seams, which can be enabled by selecting **Display** > **Show UV Seams** or by pressing **Control** + **Shift** + **U**. It's important to note that the seams will only be visible on unsubdivided objects.

Now we're ready to load an object. In this section, we learn about UVs by creating a UV map for a T-shirt. As mentioned earlier, it's often helpful to think of UV seams as seams in fabric, making a shirt an ideal starting subject.

- You can create the T-shirt model by first loading the Base Man with Feet (**Create** > **Custom Primitives** > **Base Man with Feet**) and then deleting the arms, head, and legs.
- **Tweak** the model's shape after the sections have been deleted so it looks similar to Figure 3.28b.

It's important for this example to set up mirroring on the object using the process discussed earlier in the chapter.

- You should be able to just select the whole shirt and then select **Mirror Geometry**, assuming that the shirt is centered over the Z (blue) axis and the mirroring is set to happen along the World X axis (the default).

If you prefer, you can download our version of the starting model from the downloadable material in chapter3/startingshirt.sib.

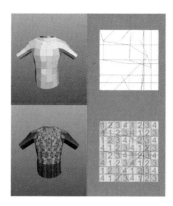

FIG. 3.29 Prior to working on a model's UVs, they will often appear quite messy and textures will show unevenly.

As you can see in Figure 3.29a, or from your own model, the UV view of the T-shirt is a total jumble. This will usually be the case with modeling projects when you first start looking at the UVs, and the problem is not just the seams. Right now, the UVs are also stretched and stacked. Think in terms of an actual T-shirt. If you were to cut up the shirt randomly, it would be difficult to paint on a design that would make sense once the pieces were back together. It would be doubly hard if all the pieces were stacked on top of each other in a heap—that heap is what we have right now.

One way modelers get a sense for the quality of the UV map is with a numbers reference image. You will find one among our downloadable material at chapter3/CheckerMap.jpg. Images like these make it very easy to see where textures are being stretched or pinched. To add this image a texture, you'll need to:

- Access the **Material Editor via UVs/Materials > Material Editor**.
- Create a new material.
- Add the image to the material by selecting the "…" next to the **Texture** field and navigating to the file.
- Finally, apply the material with the texture to the whole model using the process discussed in the Materials section.

As you can see in Figure 3.29b, the uniform image is reflected unevenly across the 3D face. The goal of working with UV maps in Silo is to eliminate this unevenness and to create a nice 2D UV shape that will allow the image to map cleanly across the 3D object.

UV Seam Creation

The first step in getting our UV map on track is to eliminate all or most of the current seams.

- Start with the **Unmark UV Seams** command (**UVs/Materials > Unmark UV Seams**) or the **Mark UV Seams Toggle** (**UVs/Materials > Mark UV**

FIG. 3.30 Add a seam down the side and bottom of the shirt arm.

Seams Toggle or Alt + U), which will mark seams on edges if unmarked and vice versa.
- Try selecting a seam or two on the model and unmarking.
- Then, in edge selection mode, select all edges (**Control + A**) and **Unmark UV Seams**.

Mark UV Seams Toggle; UVs/Materials > Mark UV Seams Toggle > Alt + U;

You should be left with only seams around the neck, waist, and arms. Because these are edges with only one face, they are natural seams.

You will notice that in spite of the seam changes, the UV view and the way the texture maps across the 3D model haven't changed much. That's because while we have sewn some of the pieces together (going back to the fabric analogy), we haven't actually spread out the fabric in an orderly fashion yet.

- The next step is to create new seams, this time using the **Mark UV Seams** command (**UVs/Materials > Mark UV Seams**) or the **Mark UV Seams Toggle** (**UVs/Materials > Mark UV Seams Toggle** or **Alt > U**).
- We can do that for our T-shirt by selecting the edge loop along each side and on the bottom of each arm (Figure 3.30). If this were actual fabric, a cut like that would allow the shirt to unfold along the shoulder and the top of the arm.

UV Unwrapping and Arranging

Now we are ready to unwrap the model, and we will use the **Unwrap UVs using LSCM** command to do so. LSCM is a common acronym in the 3D UV world and stands for "Least Squares Conformal Mapping." Basically, the LSCM algorithm keeps stretching and deforming to a minimum by attempting to preserve the angles of the polygons, while flattening and relaxing the scale.

- Try this by selecting the object, and then select **UVs/Materials > Unwrap UVs using LSCM** or press **U**.

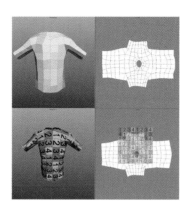

FIG. 3.31 LSCM unwrapping of the shirt.

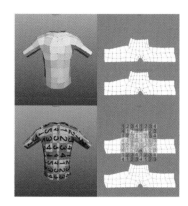

FIG. 3.32 You can split the mirrored sides of a UV map to ease the map manipulation work.

Unwrap UVs using LSCM; UVs/Materials > Unwrap UVs using LSCM > U;

The result should look like Figure 3.31, which puts us well on our way to a clean UV map. There are other unwrapping tools in the **UVs/Materials > Recreate UVs** drop-down menu, but for the most part, they are for spot work or setup on a complex model. The main tool is LSCM.

The next step involves mirroring. This might not be necessary all the time, and would likely be unnecessary for a simple object like this shirt. However, it's always an option if working with a mirrored object, and it's important to understand how it works.

• Select the object, and then select **Mirror UVs** from the **UVs/Materials** drop-down menu.

The shirt should then appear folded on top of itself because we have told Silo these two sides will look the same. However, unlike with the 3D view, symmetry isn't enabled, and working with two pieces on top of each other can be difficult. So, before we move on, we need to:

• Add a new seam down the front and back middle of the shirt (Figure 3.32a).
• Double click on one of the shell faces (or click on a face and press **Shift + 1** or select **Selection > Expand Selection** from the top menu) to select all of the connected faces.
• Slide one of the UV sides out of the way (Figure 3.32).

We'll essentially discard one of the sides, focus on getting the other just right, and re-mirror later.

Now it's time for resizing and moving the UV map to get it centered in the UV square. All the tools and manipulators available in the standard modeling kit are available to move the UV map around, but there are also some nice custom tools in the **UVs/Materials** drop-down menu.

• Try either **Arrange UVs in Bounds** or **Scale UVs to Bounds** after selecting the whole mesh and you should get something that looks like Figure 3.33.

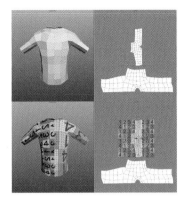

FIG. 3.33 The LSCM mesh can easy be re-centered and resized with either the Arrange UV in Bounds or the Scale UVs to Bounds command.

These commands, along with **Scale UVs Proportionally** are incredibly valuable when a UV is in multiple unmirrored pieces, as we will see in Chapter 13.

UV Manipulation

Now comes the manual manipulation of the UV map into a nice and tidy form. This will help the shirt display in as natural a state as possible, and there are some important tools to help in the process. **Pin UV Vertices**, accessible from the **UVs/Materials** drop-down menu, will fix points on the UV grid to a particular visual point on the image. This can be helpful in lining up geometry with a texture image and for smoothing out the UV interior.

- Using the **Tweak** tool, or any other polygon tool you like, straighten out the sides of the shirt as best you can.
- Next, select the outer edge loop and **Pin UV Vertices** (**Shift + U**).
- Once that's done, select all of the faces and press **U** (or **UVs/Materials >** **Unwrap UVs using LSCM**).

This will have a smoothing effect on the internal UV geometry while the edge stays locked, helping the 2D image fit better on the 3D model, (see Figure 3.34).

Pin UV Vertices; UVs/ Materials > Pin UV Vertices > Shift + U;

Another very important tool that we won't use here, but will show in Chapter 13, is the **Live UV Unwrapping** tool. Often with UV maps, parts of the mesh will be tightly compacted and distorted even after LSCM unwrapping. Moving these sections around vertex by vertex can be painstaking, so the **Live UV Unwrapping** toggle (**UVs/Materials > Unwrap UVs using LSCM** or **Control + Alt + U**) will allow you instead to pin certain sections that you'd like to stay put, and then, by dragging a vertex or two, spread out the rest using the LSCM algorithm in real time. Because our T-shirt mesh is well spaced to begin with, the tool isn't necessary, but feel free to try it anyway to see the impact. We'll use the tool in Chapter 13 to create the UV map for our character's jacket.

FIG. 3.34 The standard polygon tools can help straighten out UV edges, which can then be pinned and the interior polygons can be smoothed using LSCM unwrapping.

FIG. 3.35 The final step involves eliminating the seam needed for mirroring.

At this point, our work is mostly done and we're ready for cleanup. We need to mirror our changes on to the second side, flip one side, and then merge the two sides together. To do this:

- First, select the side we've been working on and select **UVs/Materials > Mirror UVs**. This will move the side we'd placed on the bottom back on top of what we've been working on and mirror the UVs.
- With a single side selected, select **UVs/Materials > Flip UVs**, another specialty UV tool, to horizontally flip one side so you'll be able to slide it over and get something that looks more like what we started with (Figure 3.35a).
- Finally, we need to merge the two pieces back into one. This can be accomplished by selecting the seams on the 3D object and clicking **UVs/ Materials > Unmark UV Seams**. There is also a specialized UV command for merging, **UVs/Materials > Move and Sew**, that will move the polygons with the merge in an attempt to minimize UV distortion. In the case of the T-shirt, since we already have the square shape we want, our best bet is to simply unmark the seams.

The final product should look something like Figure 3.35b.

To take the texture map into another program, you can export what's in the UV square as an image by using **UVs/Materials > Export UVs to Image**. The resulting work in the third-party program can then be imported as a texture and applied to your model.

Conclusion

That covers the main tools and workflows for Silo. We hope this section prepares you to take on the project covered in the next several chapters, and can serve as a reference when working with Silo. Now, on to our main model!

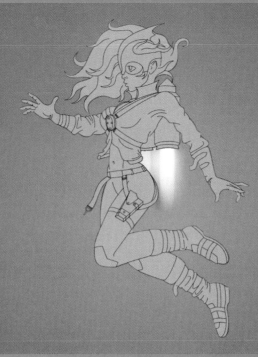

Character Pre-production

Over the past few chapters, we introduced you to the world of subdivision surfaces along with a variety of ways to create your models. You should also have a basic understanding of the application we will be using as we move forward in this tutorial.

In this chapter we start to look at the character we will be creating and make sure we are fully prepared before we start to build her.

Our Brief

Before we can do anything, we need a subject, something to bring into the 3D world, a character design to follow. Ideally, the design should have both organic and hard surface elements so we can cover all bases and really show what Silo is capable of.

For the purposes of this book, let's imagine we have been approached by a company to create a 3D model of a character, one that will be posed and rendered to be used as a book cover, illustration, or perhaps even eventually animated.

This is what they say...

"Hi there,

3D Modeling in Silo. DOI: 10.1016/B978-0-240-81481-0.00004-2

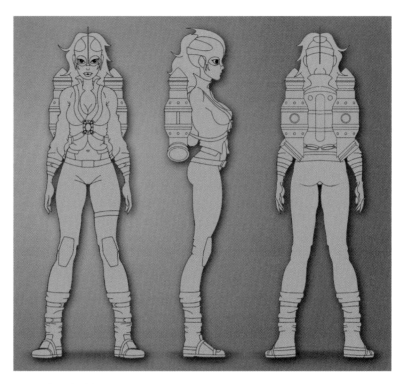

FIG. 4.1 The Rocket Girl concept artwork.

We're looking for someone to bring our Rocket Girl, Jade Raven, to life, and you're just the person to do it! She needs to be sexy and mean, not a pushover. Think along the lines of the video game *Velvet Assassin's Violette Summer* or *Tomb Raider's* Lara Croft, but not in those shorts, and you get the idea of the look we are after.

We need a high-resolution model first in the traditional T pose (arms out to the side), and then something matching the pose in the images we sent you. We are going to use the posed version for an illustration and if we get the green light, we want to rig the unposed one for an animated feature.

On top of all this, we will also need UV mapping applied to her jeans, jacket, and torso so we can add textures later.

Thanks again, we're looking forward to seeing her fleshed out!

The Client"

For this job, Silo is perfect.

Along with the brief, the client also sends along three concept images (Figures 4.1, 4.2, and 4.3).

Figure 4.1 shows us the main look and feel for the character. This model sheet also gives us the basic proportions and a little more detail.

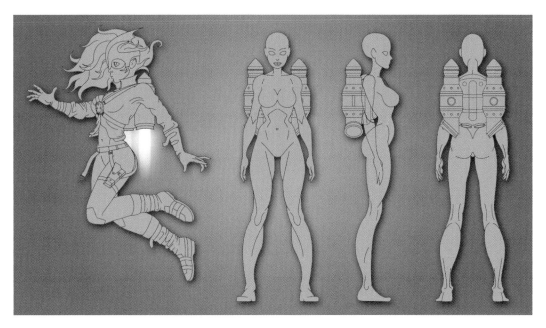

FIG. 4.2 The "base mesh" Rocket Girl concept artwork.

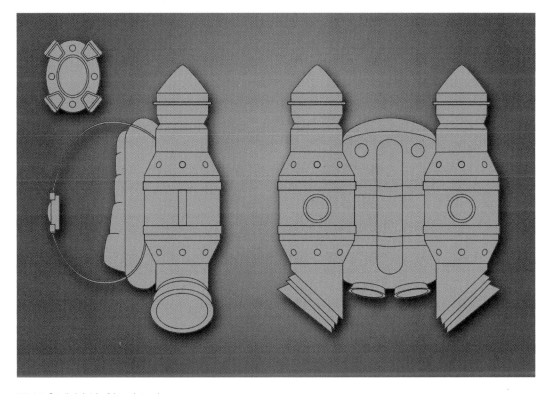

FIG. 4.3 Detailed sketch of the rocket pack.

Figure 4.2 is similar to the first concept sheet, but this time the character is naked. We have included this version because we will be taking a little detour when we begin work. We will be creating our own base female model, one that we can use on this project and many future ones.

Figure 4.3 is a detailed shot of her rocket pack to help us as we work.

Although the client has a clear idea of how they want the character to look, they have also expressed an interest in us using our own artistic license to "enhance" her. This is good, as it will give us a little freedom to work, while adding our own stamp to the final look of the model.

Research

We now have our project, but we do not need to rush ahead and start modeling. First, it is a good idea to take some time and gather some reference materials to help as you work.

Reference can come in many shapes and sizes, be it photos, sketches, 3D models, or maquettes—anything that will help you visualize each element of the character is a great help. Luckily, we can turn to the Internet to gather most of what we will need for free, but if you have the cash, it is always good to buy some of the stock reference DVDs and books available.

For some suggestions on where to visit, refer to Appendix 1.

With this in mind, let's look at our character and see what we need to find.

Base Mesh Reference

Because we will be creating a base model first, one that will be a generic nude female, we need to find some decent female photos. The problem is that our character needs to be quite stylized in proportions, and well toned, too—sort of like a comic book character.

Initially, we can use some standard female reference to get started, but after that, we need to search for comic style artwork (Figure 4.4).

In addition, search out artists like Dominic Marco and J Scott Campbell. They have a great style and are quite popular, so there will be many images online for you to use.

Clothing Reference

Now let's turn to our Rocket Girl and her clothing.

From our earlier discussion with the client we know that Jade's clothing should be loosely based on a mix between Violet Summer and Lara Croft, that sort of action, adventure oriented look.

FIG. 4.4 Stylized character reference.

She also appears to be wearing a leather flight jacket, loosely based on the A-2 Flight Jacket, but with slight alterations to fit the character. In the concept, her boots and gloves are also a custom design made from leather and steel, with scuffs and scratches to show wear and damage in flight.

This information gives us plenty to search for—images of the characters mentioned, and perhaps some old leather boots and gloves to refer to.

(Tip: If you are stuck on clothing reference, try looking on auction sites, such as eBay for photos.)

It would also be a good idea to hunt out some general clothing images, so you can study the way the folds and creases lay.

Accessories Reference

The final references we should look for are her rocket pack, helmet, and gun holster. The holster should be easy to find, as it is a standard design, but the rocket pack and helmet are original designs.

For these, try searching for other rocket or jet pack designs, and armor for the helmet so you can see the materials they are constructed from. They will also give you a good idea on how our rocket pack could look.

If you are feeling adventurous, why not search for a suitable weapon to place in the holster? A pistol perhaps?

Recycling

We have our character design, and now a wealth of reference to get us started, but there is one more thing to discuss before we open Silo—recycling.

As time goes by and you create more and more models, you will start to build up a library of characters and objects. These will be on your hard drive, forgotten about, and if you look back, you might find you ended up modeling the same hand five times.

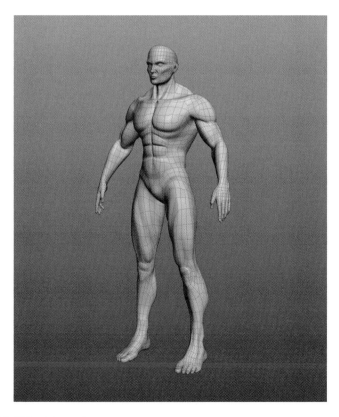

FIG. 4.5 A full male base mesh.

It is good practice to keep generic models and reuse them when needed to save you work and time that could be spent enhancing the model elsewhere.

A base mesh does not necessarily need to be a hand, foot, or eyeball; it can also be a full model. Figures 4.5 and 4.6 show two of our own base models. We use these from time to time to generate other characters, as it is easier and quicker to adjust these than build them from scratch.

A well-built low-resolution mesh is also a great addition to anyone's library. Any model can be stripped apart and reused.

Custom Primitives

A great feature built into Silo is the ability to store and access these starter models from inside the application. To do this, simply copy your model into the folder Program Files\Silo\Primitives.

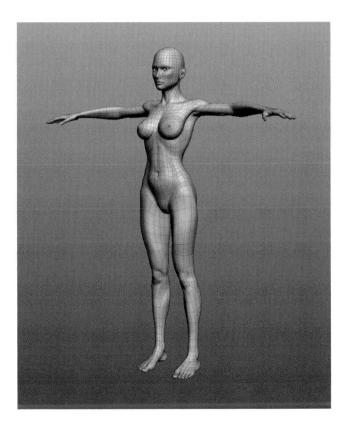

FIG. 4.6 A full female base mesh.

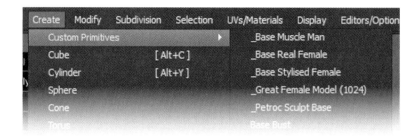

FIG. 4.7 Load Custom Primitives inside Silo.

Note that the files will need to be in a format Silo can read; .obj is a good all rounder.

When you next load Silo, go to the **Create** > **Custom Primitives** folder (Figure 4.7), and all your models will be listed, ready to be imported into the scene when you next need them.

Now, armed with your model sheets, brief, and reference, you are at a great point to begin work. So, let's do it!

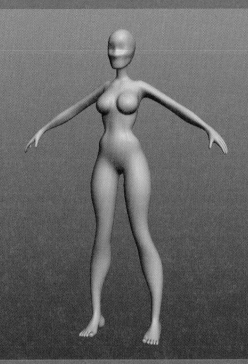

Organic Modeling—Basic Base Mesh

We are now ready to hit Silo and start working. You should have all the materials you will need, but don't feel you have to rush into modeling; the more preparation time you have the better equipped you will be.

In this chapter we will create a generic, cartoon style base mesh you can use on any project, be it virtual sculpting or modeling. This will be the foundation for our Rocket Girl, and while building it you will also be introduced to Silo's main modeling toolkit.

(Note: At this stage, feel free to skip this chapter if you have your own base model, or don't want to create a base mesh from scratch. We do, however, recommend reading through this chapter, as it will get you acquainted with some of Silo's key tools.)

(Note: You will find the files used for this section in the downloaded tutorial files inside Chapter 5/Files.)

3D Modeling in Silo. DOI: 10.1016/B978-0-240-81481-0.00005-4

FIG. 5.1 Select Set Viewport Image.

Scene Preparation

Before we build our first primitive, we need to bring the model sheet into Silo. Referring to it on a screen next to you, or on a piece of paper, is a good start, but nothing beats having the images in the scene as you work.

There are two ways to accomplish this; the first is easier for people new to Silo and the world of 3D so we will look at that first.

Viewport Image

The first method to get your images into Silo is to bring them in as Viewport Images. Each panel you work in is called a *viewport,* and in each of these (excluding the perspective view), you can add a background image to work with.

- To bring an image into the scene, first select the viewport you want to use. Let's work on the Front viewport first.

(Tip: Remember that pressing the spacebar will toggle the layout of Silo, changing it from the default four-panel view to a single panel view and back again).

- Next, go to **Display** > **Set Viewport Image** (Figure 5.1).
- Now browse to the file **ModelSheetFront.jpg**. You should see the image in the front viewport, as in Figure 5.2.
- Now repeat the process, bringing the right side view into the right viewport.

You might find that the Right viewport isn't visible, but this is easily fixed.

- Right click on a viewport in Silo to bring up a handy context menu. This holds many of the frequently used items associated with what you selected.
 1. Move down to **Viewport Camera** (Figure 5.3), and in the new menu select the **Right Orthographic View**.

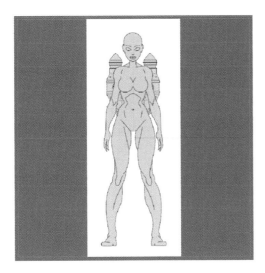

FIG. 5.2 The front image is now set in the viewport.

FIG. 5.3 Select the Right Orthographic View.

(Tip: You will also see next to many menu items its current hotkey. In this case, we could just press 6 to select the right viewport.)

• Next, go to **Display > Set Viewport Image** and browse to the image called **ModelSheetSide.jpg**.

You should now see the image in the viewport as in Figure 5.4.

If you like, you could also set the Back viewport image, but we do not need it just yet.

(Tip: Once you have your viewport images in place, you will notice that you can't physically edit or manipulate them. If you do need to move or scale

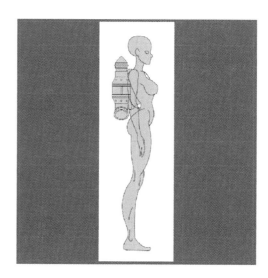

FIG. 5.4 The side image is now set in the right viewport.

them, you can do so by going to **Display** > **Select Viewport Image**, which will select the currently active viewport image, allowing you to manipulate it as needed.)

That is the first way to set your scene. It works well and allows you to model over the top of the artwork so you can get the proportions correct. The only drawback is the lack of perspective view reference.

You can find the Silo scene created in this section in Chapter05/Files/ViewportImages.sib (the texture paths might need adjusting to fit your setup).

Textured Geometry

The next method we will look into is to apply our model sheet images onto two polygonal planes. This will allow us to see the reference images in the scene, with our model close to them. Unlike the previous method, we will actually be able to see them in the perspective viewport and work with them interactively.

(Note: This is a more advanced way of setting up the viewport images, so if you are not feeling confident just yet, feel free to skip this section and come back to it later.)

We first need to create the polygons we are going to apply the model sheet images to.

- As illustrated in Figure 5.5, right click in any viewport and go to **Create** > **Cube** (or press Alt + C).

Create	▶	Custom Primitives	▶	
Selection Mode	▶	Cube	[Alt+C]	opt
Subdivide	[C]	Cylinder	[Alt+Y]	opt
Unsubdivide	[V]	Sphere		opt
Append	▶	Cone		opt

FIG. 5.5 Create a basic cube as a starting point for our model sheets.

FIG. 5.6 The cube primitive.

You should now have a simple cube, like the one in Figure 5.6.

To use the actual images in this scene, we will next need to create two new materials. These are nodes that hold color and texture information, which can then be applied to an object or polygon.

• First, open the Material Editor by going to **Editors/Options > Material Editor** (Figure 5.7).

This will open the Material Editor on the right side of your screen; you can see the default editor in the first panel of Figure 5.8.

(Tip: If you don't like the position of this, or any other editor, you can undock it from the window by double clicking on its title bar. This will allow it to float free so you can place it where you like.)

Following Figure 5.8, we will now create two new materials: one for the front view, and another for the side.

• First, click **New**. This will create a new material; in this case, it will have a default name of **Material1** and appear light gray (Figure 5.8b).

FIG. 5.7 Open the Material Editor.

FIG. 5.8 Create two new materials, one for each model sheet.

- For now, we just need to concentrate on the **Texture** section. Click on the ... button next to **Texture** and point to the **ModelSheetFront.jpg** image (Figure 5.8c). The texture is then displayed in the square window above the material name.
- Rename this material **ModelFront**.
- Now, repeat the process, but this time, point the new material to the **ModelSheetSide.jpg** and call it **ModelSide** (Figure 5.8d).
- Make sure the **ModelFront** material is selected in the **Material Editor**.
- Select the cube in the viewpanel and click **Apply** in the **Material Editor**.

Your cube should now have the material applied and look like Figure 5.9.

FIG. 5.9 The cube with the front model sheet applied.

The top of the cube looks fine, if a little out of proportion, so we will use this part for our model sheet, meaning we don't have to mess around with UV editing at this stage.

- Switch to the top viewport and select the cube.
- By default the Move manipulator will be active, so select the **Scale Manipulator** from the bottom tool bar or press **E**.

(Tip: Remember that W, E, and R will switch between the Translate, Scale, and Rotate manipulators.)

- Now adjust the size of the cube so the image is correctly proportioned (Figure 5.10). As a guide, the image should be 4 grid units wide and 10 grid units tall.

The first image plane is ready, but is still in cube form and not correctly orientated. To get a precise rotation we will turn to the **Numerical Editor** for help.

(Tip: For precise rotations you could also use the Snapping Manipulator (Selection>Manipulator Tool>Snap).)

- Go to **Editor/Options > Numerical Editor**. This will open the window shown in Figure 5.11.
- All we need to do at this stage is rotate the cube **–90** in the **Rotation X** box (Figure 5.12). You can do this by manually typing the value into the editor, or by clicking with your mouse button in the input box and dragging to interactively edit the value.

(Note: When you deselect the Numerical Editor, the value will reset to 0, so be sure you entered the correct value before you move on.)

With the cube's orientation and scale fixed, we can now remove the redundant polygons.

FIG. 5.10 Adjust the cube so the figure is correctly proportioned.

FIG. 5.11 The Numerical Editor.

- Select the cube, go to **Selection** > **Selection Mode**, and select **Face** (or press **D**).

(Tip: A, S, and D will switch between the Vertex, Edge, and Face selection modes.)

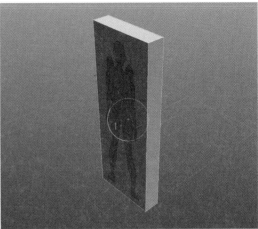

FIG. 5.12 Rotate the cube to correct the orientation.

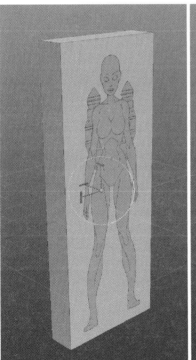
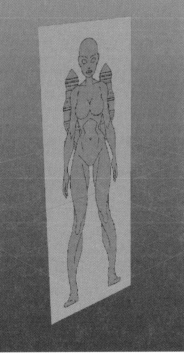

FIG. 5.13 Delete the unwanted geometry from the cube.

- Now select the faces on the top, bottom, sides, and back, leaving just the front polygon (Figure 5.13a).

(Note: Selected faces/polygons will be highlighted in yellow.)

- Press **Delete** to remove the geometry.

As illustrated in Figure 5.13b, you should now be left with a single polygon plane.

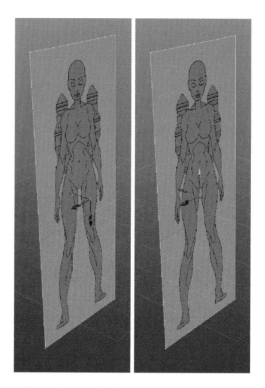

FIG. 5.14 We now need to rotate the polygon's axis.

FIG. 5.15 Use the Recenter Object Axis tool to fix the manipulator's rotation.

Manipulator Edit Mode	[M]
Recenter Object Axis	[Alt+M]
Set Object Axis	[Alt+Shift+M]

We are not finished with this element just yet. Notice that the manipulator is pointing in the wrong direction (Figure 5.14a); the green arrow (Y axis) is pointing forward instead of up. This is because we rotated the cube, so its local axis was also rotated.

- To address this, select the cube and go to **Selection > Recenter Object Axis** (Figure 5.15b) or press **Alt + M**.

The last step is to tidy the scene and bring our polygon plane back into the center of the grid. This is easily accomplished by using the **Numerical Editor**.

If you look at Figure 5.16, when we have the polygon selected, the **Position X**, **Y**, and **Z** values tell us that the object's center is not at the middle of the grid, the scenes root.

- Set these to **0**, **0**, **0** to bring the polygon back to the center of the grid, right where we need it.

FIG. 5.16 Set the Position X, Y, and Z to 0 to bring the polygon back to the center of the grid.

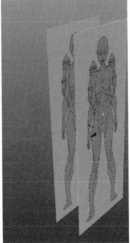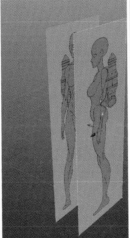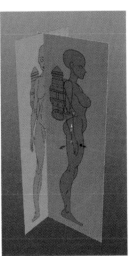

FIG. 5.17 Duplicate the front image plane to create the side.

We now have the front image plane in place, so let's create one for the side.

- Select the front image plane and go to **Create > Duplicate** (or press **Ctrl + D**). This will copy the existing image plane, but at present, it is in the same place as the original.
- Press **W** to switch to the **Move Manipulator**, and following Figure 5.17b, move the plane forward slightly so we can see it.
- Go back to the **Material Editor** and apply the **ModelSide** material you created earlier to the new model (Figure 5.17c).
- Finally, because this is the side model sheet, we need to rotate the model. Again, use the **Numerical Editor** and set the **Rotation Y** box to **−90**, turning the model as in Figure 5.17d.

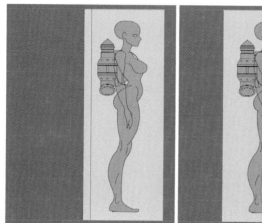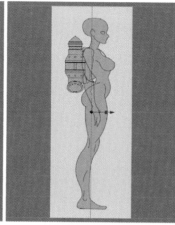

FIG. 5.18 Adjust the side model sheet's proportions.

As with the front view, the proportions are not correct because the plane is too wide.

- Switch to the Right Viewport by going to **Display** > **Viewport Camera** > **Right Orthographic View** (or press **6**).
- Select the polygon, and following Figure 5.18, scale it to the correct size. Remember to press **E** to switch to the Scale Manipulator.

All that is left now is to reset the object's pivot and position it correctly in the scene.

- First, select the side model sheet and go to **Selection** > **Recenter Object Axis** (Figure 5.15) or press **Alt + M**.
- Next, turn to the **Numerical Editor** and make sure the **Position X**, **Y**, and **Z** values are all **0**, bringing it back in line with the grid (Figure 5.19a).
- Now we need to move both planes so we can see them clearly. The front plane needs pushing back, and the side plane moving to the left as in Figure 5.19b.
- You might notice that the side image plane is pointing in the wrong direction; it needs to be looking forward to match up with our model. An easy fix for this is to go to the **Numerical Editor** and set the **Scale Z** value to − **1**. This will flip the polygon, solving the problem.

With a little more tweaking your Silo scene should resemble Figure 5.20 with the planes set up and ready to be used. Notice that we have moved our planes up slightly so her feet sit on the grid. This isn't essential; we just like to treat the grid as a virtual floor plane.

The polygon-based image planes are complete, but there is one final step to take to make sure the images can't be edited. Because they are physical objects, the artist could select each image plane by accident and possibly move or delete it, so what we can do is lock them.

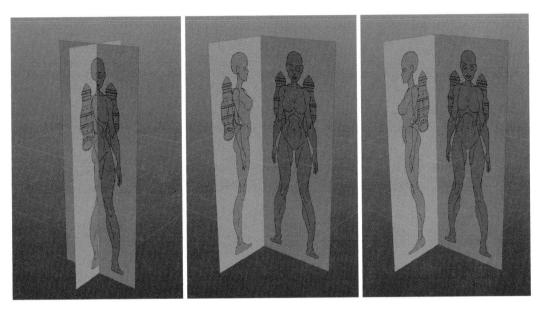

FIG. 5.19 Reposition the image planes so we can see them clearly.

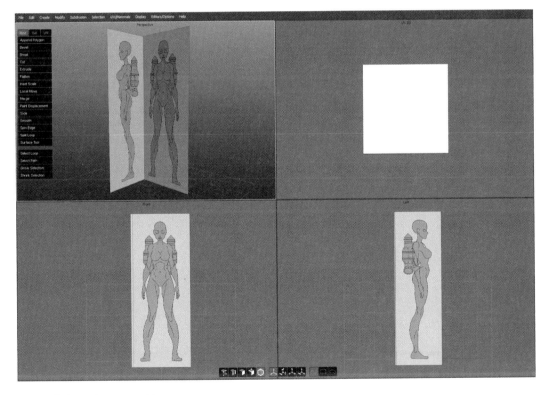

FIG. 5.20 The image planes are complete.

FIG. 5.21 Lock off the polygon planes in the Scene Editor.

- Go to **Editors/Options** > **Scene Editor** to open a new window that shows you all the objects in the current scene along with various visibility options (Figure 5.21a).

You should see, under the **Scene** tab, our two cube objects with four icons beside them. The first three icons adjust the objects' visibility in numerous ways, switching between full shaded, wireframe, and general visibility, but the one we are after is the padlock toward the end.

- Click the padlock next to each cube to lock it down.
- While you are here, you can change the names of the cubes to make them more recognizable and individual. Double click on the names and call them **FrontPlane** and **SidePlane**.

Those are the two main setups used by 3D artists when creating anything from characters to cars. Each has its own benefits, so feel free to use whichever you are most comfortable with.

You can find the Silo scene created in this section in Chapter05/Files/ViewportPolys.sib (although the texture paths might need adjusting to fit your setup).

Base Mesh Topology

Before we start work on the base mesh, it is important to briefly discuss its required topology. As this is intended to be a base mesh, we ideally need it to be made entirely of quads (four-sided polygons). The reason for this is the base mesh will be subdivided a number of times as we work on it, especially if it is later used for virtual sculpting.

Triangles, large or small, when subdivided can give unwanted results and ultimately lead to pinching and bulging in areas you don't want or need it. What's more is that these artifacts are almost impossible to remove when sculpting, so it is good practice to have a good foundation model to begin with.

This can also be true of n-gons (polygons with more than four sides), although they can sometimes be worked with, depending on the size and position.

Our goal with this model is to make it 100% quad based.

FIG. 5.22 Open the cylinder creation options.

FIG. 5.23 Adjust the cylinder options and click Create.

Torso

Time to get to work. First, we are going to block out the main torso and waist area using the model sheet we created previously to guide us.

- First, load the scene **Chapter05/Files/ViewportPolys.sib**, or use one of the scenes you created in the previous section.

There are many different approaches to creating characters; some start with a simple cube, and others have a very basic base mesh. We like to use cylinders as our starting point. It seems to make sense in a way; if you look at your arms, for example, they are cylindrical, aren't they? Starting this way saves having to add and adjust extra divisions further down the line. With that said, let's create our first cylinder.

- Switch to the front viewport, go to **Create > Cylinder**, and select the **opt** button shown in Figure 5.22.
- Figure 5.23a shows the cylinder options available to you. The default values are pretty much what we need. All you should change at this point is the **Height Sections**; make this **8** and click **Create**.

You should now have the cylinder shown in Figure 5.24a, but at the moment, it is obscuring our image plane.

- To change the display properties of the selected object, right click on the model, and in the context menu go to **Object Display Mode**. As you can see from Figure 5.25, this opens a variety of different ways to display the geometry.
- Select **Ghosted Shade Mode**, which will allow you to see through the model (Figure 5.24b).

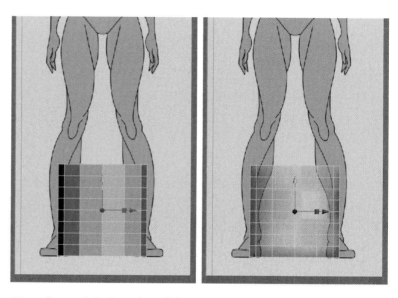

FIG. 5.24 The new cylinder obscures the model sheet.

FIG. 5.25 Change the cylinder's display so we can see through it.

With that set, let's start to edit the cylinder.

As show in Figure 5.26, we first need to move the cylinder up to the torso area, and then scale each row of vertices inward to fit the general shape of her torso.

As you read earlier in the book, Silo has three different selection styles: **Paint**, **Area**, and **Lasso**. For this section, we recommend **Area** selection.

- As shown in Figure 5.27, go to Selection > Selection Style > Area.
- Select the cylinder and press **A** to switch to **Vertex Editing Mode**.
- Now select each row in turn and scale it to fit the model sheet's torso.

(Note: Select each vertex row with the middle mouse button, as this will also select the vertices at the back of the model.)

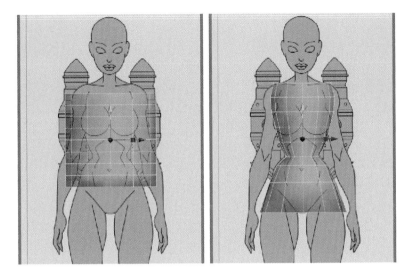

FIG. 5.26 Scale each row of vertices to fit the torso shape.

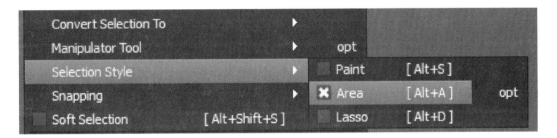

FIG. 5.27 Change the selection style to Area.

Feel free to move each row up or down to try to achieve a better fit; just remember that at this stage, we only want a rough shape.

- Next, turn to the side viewport and repeat the process, adjusting the vertices to fit the model sheet's torso (Figure 5.28). If scaling, make sure you only scale along the Z axis or you will inadvertently adjust how your model looks from the front.

Again, we are just looking for a general fit at this stage.

(Tip: Scaling the selected vertices rather than moving them will keep them nicely spaced, leaving you with good topology.)

Before we move from the main torso area, we are going to remove the caps from the cylinder. We don't need these at present so it is safe to delete them.

- Following Figures 5.29 and 5.30, select the polygons around the top and bottom of the cylinder, remembering that **D** switches to face selection mode.
- Next, press **Delete** to remove them from the model.

FIG. 5.28 Scale each row of vertices to fit the torso shape.

FIG. 5.29 Remove the upper cap from the cylinder.

FIG. 5.30 Remove the lower cap from the cylinder.

Our torso is looking pretty basic at the moment, but that is all we need for now. Remember, we are blocking out the main shape in this section; details and form refinement will come in the next chapter.

Now would be a good time to **Save** your scene before we move on and add her chest.

You can find the Silo scene created in this section in Chapter05/Files/05_Torso.sib.

Chest

We have the main torso, but she is missing her breasts, so let's add those next. For this, we will start with a sphere, and once positioned, we can connect it to the torso to give us the shape we need.

- Start by going to **Create** > **Sphere** and open the **options** window (Figure 5.31).
- Set **Radius** to **1**, **Sections** to **6**, and **Height Sections** to **6** before clicking **Create**.
- We only need half the sphere, so select the sphere and press **D** to enter face selection mode.
- As illustrated in Figure 5.32, select the lower half with the middle mouse button, and delete it.
- Now we need to move it into place. First, looking from the side viewport, move the cylinder up and scale it so it is roughly the correct size as in the model sheet (Figure 5.33a).
- Next, rotate the sphere, but we don't want it at an exact 90 degrees. If you imagine the point is where the nipple would be, we want it to point up slightly (Figure 5.33b).
- Next, switch back to the front view.

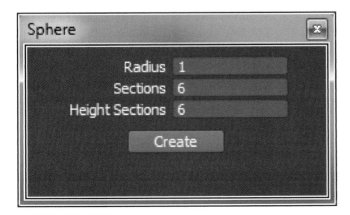

FIG. 5.31 The Sphere options window.

FIG. 5.32 Delete the lower half of the sphere.

FIG. 5.33 From the side view, move, scale, and rotate the sphere.

As you can see in Figure 5.34a, the sphere is in the center of the model, which is not good, and its orientation won't help us either. To help when we attach it to the torso, and when we come to shape it, we need to rotate the sphere first so we have a nice neat line running down the center.

- The easiest way to accomplish this is to first press **R** to switch to the rotate manipulator, and then rotate around the Z axis (blue) until the line of edges lines up with the center of the torso (Figure 5.34b).
- Finally, move the sphere over to the right, remembering to rotate it slightly so the chest points outward, **not** straight ahead (Figure 5.34c).

The main shape is now in place, so next we need to stitch the sphere to the torso, and smooth out the general area. Before we can do this, we need to make these two objects into a single element.

- Select the sphere, and while holding **Shift** add the torso to the selection.
- Right click to bring up the context menu and, as shown in Figure 5.35, move down to **Combine Objects** to combine them.

FIG. 5.34 From the front, rotate and position the sphere over her left breast.

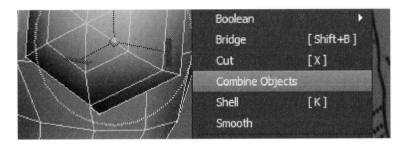

FIG. 5.35 Select both objects and combine them.

(Tip: Holding down **Shift** will allow you to add to your current selection.)

Now we can start to stitch the two elements together and remove the seams. We will focus on the top of the sphere first.

To connect the sphere to the chest, we need to open the torso and create a point we can connect to. To help us here, we will use the **Cut Tool (X)**.

(Note: Refer to Chapter 3 for more information on the Cut tool.)

To begin, we need two simple cuts across two of the large polygons on the torso.

- Select the model and go to **Modify** > **Cut** to enable the **Cut tool** (or simply press **X**). The mouse pointer will change to an arrow to indicate the tool is active.
- As in Figure 5.36b, click on the vertex on the torso just above the sphere, and then click again on the vertex below, and to the right. A line will appear to indicate the cut.
- Do this again, starting at the same vertex, but this time select the vertex to the lower left, giving us four triangles.

(Tip: If the vertex is hidden by the geometry, you can click on the connecting edge and, while holding down the mouse button, drag the point along the edge to the vertex.)

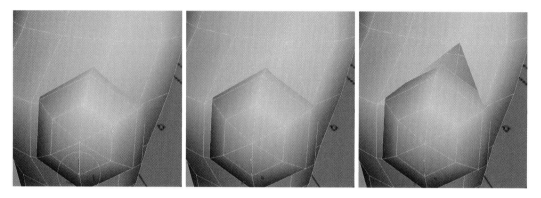

FIG. 5.36 Cut the polygons and delete the inner faces.

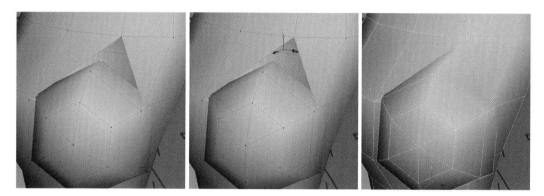

FIG. 5.37 Merge the upper vertex on the sphere to the torso.

- Now go into face editing mode (**D**) and delete the two triangles closest to the sphere (Figure 5.36c).

Now that we have made the hole, we can start to connect the vertices on the sphere to the torso. This time, we will use the **Merge tool** (**Ctrl + M**), which welds, or merges, the selected vertices, or edges, together.

- With the model selected, press **A** to go into vertex editing mode.
- As shown in Figure 5.37, we select the vertex we want to merge first, and then the one we are merging to last. This will cause the first vertex to move to the position of the second.
- When selected, go to **Modify** > **Merge** (or press **Ctrl + M**) to merge the two points.

Now let's move underneath the sphere.

You will find there aren't any vertices close to the bottom of the sphere, so any we do merge to will alter the overall shape of her chest. We were able to do this on the upper vertex because the chest hangs down slightly so we needed

FIG. 5.38 Connect the bottom of the sphere to the torso with the help of an extra edge loop.

to move the upper geometry. In this case, we need to add a new edge loop to help us.

• Following Figure 5.38, first press **S** to enter edge editing mode.
• Now hover over one of the vertical edges just below the sphere and press **Shift + X**. This will cut an edge loop around the whole ring of edges (Figure 5.38b).

(Tip: If you hold down Shift + X, you will be given the option to slide the new edge loop position across the polygons before you finalize the cut.)

Now we need to adjust the position of the new edge loop so it lines up with the base of the sphere.

• While still in edge editing mode, double click on one of the new edges. This will automatically select the whole edge loop (Figure 5.38b).

(Tip: Pressing Alt + E while you have an edge selected will also select the connected edge loop, while pressing Alt + R will select the edge ring.)

• Now if you go to **Modify > Slide** a small yellow dot will appear. If you click on this and move your mouse, you will see the edge loop sliding over the geometry. Move it so it lines up with the base of the sphere.

(Tip: Pressing and holding **J** is a quicker way to access the Slide tool. With **J** held, you simply need to move the mouse to position the edge loop, releasing the button when you are done.)

With the new vertex in place just below the sphere, we can repeat the process we used for connecting the upper sphere.

(Tip: If you need to drop out of component editing mode, simply press **F**.)

• With the model selected, press **X** to activate the **Cut tool**.
• As shown in Figure 5.38d, click on the vertex just below the sphere and then click again on the vertex above, and to the right. A line will appear to indicate the cut.
• Do this again, starting at the same vertex, but this time, select the vertex to the upper left.

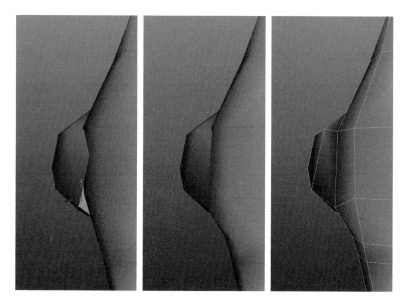

FIG. 5.39 Attach the left side of the sphere to the torso.

- Next, select the inner triangles and delete them, opening the model.
- Finally, switch to vertex editing mode, select the vertex on the lower sphere first, then the one closest on the torso (Figure 5.38f), and press **Alt + M** to merge them.

The top and bottom are now connected, so let's connect the sides.

At the left side of the model are four clear vertices we can merge. At both the top and bottom of the sphere, we have two torso vertices close by that we can use.

- Starting at the bottom of the sphere, select the two vertices shown in Figure 5.39a, making sure you choose the one on the torso last, and press **Alt + M** to merge them.
- Next, select the upper two vertices on the sphere and the torso and press **Alt + M** to merge them (Figure 5.39c).

If we move around to the front of the model, we can see what looks like an obvious way to connect the sphere. We can simply merge the two remaining vertices to the center of the model, right? Wrong. Ideally, we don't want the sphere to be directly connected to the center of the torso mesh. Instead, we need there to be a slight offset or her two breasts will become one.

If you look at Figure 5.40a, we have a large polygon cutting through the sphere. Instead of deleting this, we will use it to help us.

- Select the model and press **X** to enable the **Cut tool**.
- Place the start of the cut along the top of the polygon close to the sphere, and the end of the cut directly below it (Figure 5.40b). We now have two

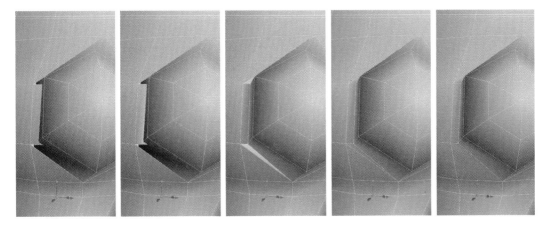

FIG. 5.40 Attach the front of the sphere to the torso.

new vertices we can merge the sphere to, meaning we retain the offset we need.

- At this point, check inside the model and delete any internal faces that are now hidden by the sphere. Remember to switch to face editing mode first by pressing **D**.
- With those deleted, we can now merge the inner vertices on the sphere to the polygon on the torso, effectively connecting them to the two new vertices we created with out first cut. You can see the result in Figure 5.40c.

What we have now is the chest fully connected to the torso, but there are two triangular holes left in the model. We could build a new polygon into the model, but instead we have a quicker option in the form of the **Fill Hole tool**.

The **Fill Hole tool** does exactly what the name suggests. If you have a hole in your model that is enclosed by a ring of edges, this will quickly fill it for you.

- Select an edge around the upper hole and go to **Modify** > **Fill Hole** (or press **Shift + F**).
- Next, select an edge around the lower hole and go to **Modify** > **Fill Hole** (or press **Shift + F**).

As you can see in Figure 5.40d, the holes are gone.

All that is left to do now is to tidy the model a little and remove the four triangles that now exist.

The first triangles to remove are at the front of the model, just where we have been working. These are easy, as the four triangles currently form two quads, so deleting the diving edge will fix the issue.

- To remove these, enter edge editing mode (**S**), select the two middle edges, and press **Delete**.

FIG. 5.41 Slide the edge loop down to even out the spacing.

Before we move on, we will address an issue with the waist area. As you can see in Figure 5.41, there are two edge loops, just under the chest, that are close together.

- Select one of the edges on the lower edge loop and press *Alt + E* (or double click) to select the whole loop.
- Holding *J*, move the mouse to slide the edge loop down slightly, evening out the space between its neighboring edges.

If we turn to the side, we can now address the other two triangles left over from connecting the sphere to the torso (highlighted in Figure 5.42a).

There are a number of ways we can tackle this, but because the triangles are connected by a single edge, we can open that edge up and create three quads. Rather than add more cuts into the model we will use the **Bevel tool** (**B**) for this job.

The **Bevel tool** is very handy for beveling off sharp corners or edges, but in this instance, we are going to use it to open the edge between these two triangles, turning a simple edge into a new quad.

- Following Figure 5.42, switch to edge editing mode (**S**), select the edge between the two triangles, and hold down **B**.
- Keeping **B** held, you can now move your mouse, much like the **Slide tool**, to define how big you want the bevel to be.
- We now have a quad between the two triangles, which in turn have also opened up and turned into quads. There are just two spare edges now in the way. Simply select the edges shown in Figure 5.42c and **Delete** them, leaving us with three clean quads.

We now have one breast attached to the model, but there is no need to repeat the whole process for the opposite side. What we can do is mirror the geometry from the model's left to the right.

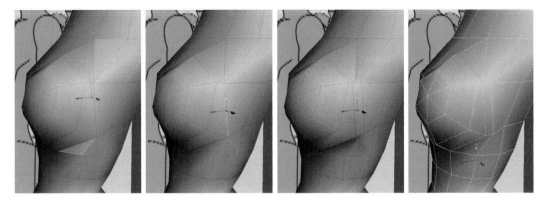

FIG. 5.42 Use the Bevel tool to convert the two triangles into tree quads.

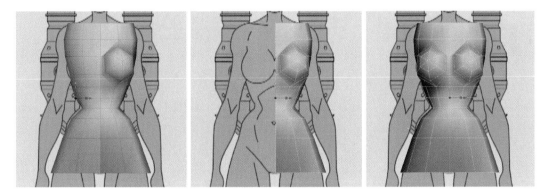

FIG. 5.43 Delete the right side of the model.

- As shown in Figure 5.43a, enter face editing mode (**D**), select the faces on the model's right side, and **Delete** them.
- Now we need to mirror the torso from her left to her right. To do this, go to **Modify** > **Mirroring** > **Mirror Geometry** (Figure 5.44) and open the **options** window.

The options for mirroring geometry, seen in Figure 5.45, are quite simple.

In **Mirror From Axis**, you specify the axis that dictates which way you want the model to be mirrored. In this case, across the X axis.

The **Tolerance** value indicates how much of the model to merge when mirroring. It uses the distance from the center of the grid as a starting point.

Enable Symmetry switches on the ability for you to work on just one side of the model with all operations being automatically applied to the opposite side.

- At this stage, we can use the default values, so click **Mirror** and you should end up with a complete torso like the one in Figure 5.43c.

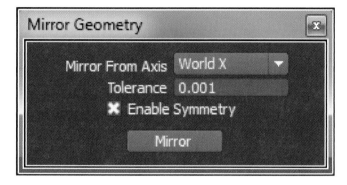

FIG. 5.44 Mirroring Geometry menu.

FIG. 5.45 The Mirror Geometry options.

(Note: If you are seeing unexpected results when mirroring, make sure the center of the model is lined up with the center of the scene. This is used as the mirroring axis so any geometry past the center will be deleted.)

We now have the basic torso and chest in place, but it still needs some work before we can move on to the limbs.

Torso Smoothing and Tweaks

We now introduce you to one of our favorite parts of Silo: its capability to turn the roughest and most jagged of objects into smooth surfaces. If you look at Figure 5.46, you will see our torso, along with two other smoother versions that are very easily achieved.

- Select your model and go to **Subdivision** > **Subdivide** (or press **C**).
- Your basic mesh has now been subdivided, so each quad or square has been divided into four while also being relaxed or smoothed. This process is covered in more detail in Chapter 1.
- Press **C** again and the model will be divided and smoothed even further.

You can continue to subdivide your model as much as you like, but eventually you won't see any difference, and your machine will start to run slower as the extra geometry starts to consume your memory.

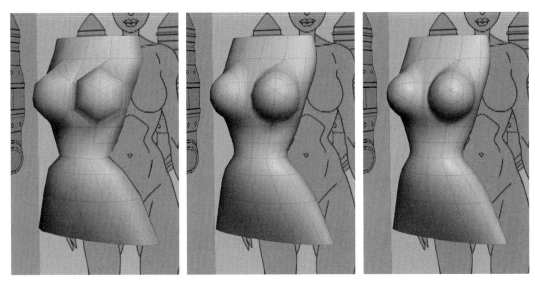

FIG. 5.46 The rough torso quickly and easily smoothed.

The beauty of this is that we can see what the smoothed version will look like, while editing the lower resolution model, or cage as it is known. We get a nice model, with minimal effort.

If you want to step down a subdivision and get back to the first model, press **V** (or go to **Subdivision** > **Unsubdivide**).

From here on, we will work on a subdivided version of the model. Just remember, **C** will **Subdivide** and **V** will **Unsubdivide**.

Before we move on to the limbs, there is one area we need to address. If you glance back at Figure 5.46c, you will see the pole above and below each breast. At the moment this isn't too much of an issue, but it could lead to problems later.

Let's quickly address this now.

* Move around to the front of the model and select the row of edges running from the top of the model to the bottom, but leave the two at the center of the sphere (Figure 5.47b).
* Press and hold **B** and bevel these edges, removing the offending points (Figure 5.47c).

(Note: Notice that because we enabled Symmetry, the bevel is also applied to the opposite side.)

Creating the bevel left us with some unwanted geometry at the center of each sphere. What we have are two new triangles, which aren't ideal but can easily be used because at present the middle of each sphere is triangle based.

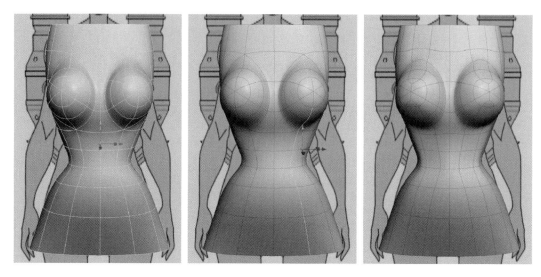

FIG. 5.47 Bevel the edges above and below each sphere to remove the points.

All we need to do is merge the two inner vertices of the new triangles with the point in the center.

- Select the inner vertex of the upper triangle, then the central vertex, and press **Alt + M** to merge the two.
- Repeat this for the lower triangle, merging the innermost point to the middle of the sphere.

The result should be similar to that in Figure 5.48b, leaving you with a cleaner model.

The extra geometry has altered the shape of our spheres making them lumpy and uneven. For now, we can smooth these out with the help of the **Smooth tool**, which simply relaxes the selected geometry.

- Select the middle row of faces first and then press the + key to expand the current selection to the next ring of polygons (Figure 5.48c). (The − key reduces the selection.)
- Next, right click on the model to bring up the context menu and move down to **Smooth** to relax the sphere.

The chest is now much smoother but still not the ideal shape. We will not worry about this now; we can address the overall form later.

You can see from Figure 5.49a that we have two n-gons around the side of the chest. We can address these with a few simple steps.

- Select the edge rings shown in Figure 5.49b, moving from the n-gon all the way around her back.

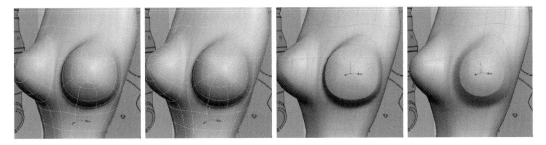

FIG. 5.48 Remove the extra vertices and smooth out the chest.

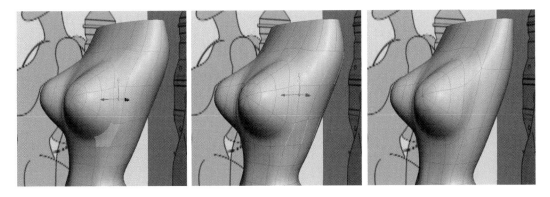

FIG. 5.49 Merge the edges moving around the back to remove the n-gons.

- Press **Ctrl + M** to merge these, effectively collapsing them and turning the n-gons back into quads (Figure 5.49c).

(Note: There are also four n-gons at the front of the model, two above and two below each breast. We can leave these and edit them later, once the limbs and head are attached and we have a better idea of the overall topology.)

The basic torso is pretty much complete, We do, however, recommend working on the overall shape before you proceed. There is no need to add any more geometry; simply move the vertices and edges, manipulating them until you have a shape you are happy with. Now would be a perfect time to use the Tweak tool mentioned in Chapter 3 to almost sculpt the surface.

(Tip: Remember to use the Smooth tool to help soften those lumpy areas.)

When finished, you should have something resembling the torso and chest in Figures 5.50b and 5.50c.

Save your work now before we move on to the limbs.

You can find the Silo scene created in this section in Chapter05/Files/05_Chest.sib.

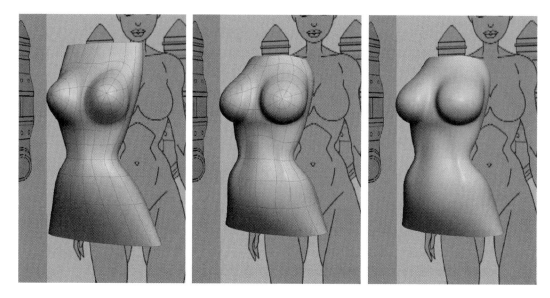

FIG. 5.50 Tweak the overall shape of the torso to create a more natural looking figure.

Arms

With the torso, we have a great starting point for our base mesh, so let's move on and give her arms. Much like the torso, we will start with a simple cylinder and rework the shape until we have a basic arm shape, and then we will attach it to the torso.

- First, load the scene **Chapter05/Files/05_Chest.sib**, or use the scene you created in the previous section.
- Initially it would be better to hide the torso for now, so select it and go to **Display > Hide Selected** (or press **H**).
- Switch to the front viewport, go to **Create > Cylinder**, and open the **options** window.
- Set **Sections** to **8** and click **Create**.

You should now have a cylinder like the one in Figure 5.51, but it is obscuring the model sheet. To work with it, we need to make it semitransparent, as we did with the torso.

- With the cylinder selected, right click on the model, and in the context menu go to **Object Display Mode > Ghosted Shade Mode**.

Now we are ready to start reshaping the cylinder.

- Still in the front viewport, move the cylinder up to the arm in the model sheet (Figure 5.52a).
- Next, rotate it so it matches the concept's orientation while also scaling it to the arm's general shape (Figure 5.52b).

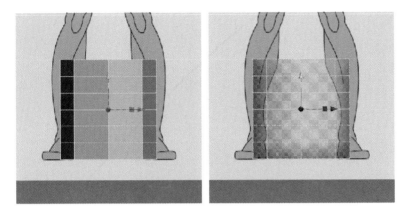

FIG. 5.51 Create a new cylinder for the arm and enable Ghost Shading Mode.

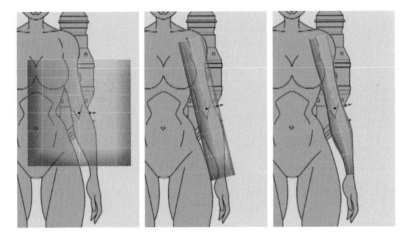

FIG. 5.52 Move, rotate, and scale the cylinder before adjusting it to fit the arm shape.

- Now work on the shape. By editing the vertices or edges, scale each edge loop until you get the general arm shape (Figure 5.52c).
- Switch to the side viewport.
- Repeat the process shown in Figure 5.53, adjusting the cylinder to match the shape of the arm. This time, feel free to rotate each edge loop to follow the natural contours of the limb.

(Note: Make sure when scaling that you only scale across one plane; in this case, the Z plane. If you globally scale the edge loops you will affect how the arm looks from the front.)

Before we continue, we are going to make a drastic move and deviate from the model sheet. At present, her arm position won't work well for us, and it will make life difficult when we add her clothing and when someone comes to rig her for animation.

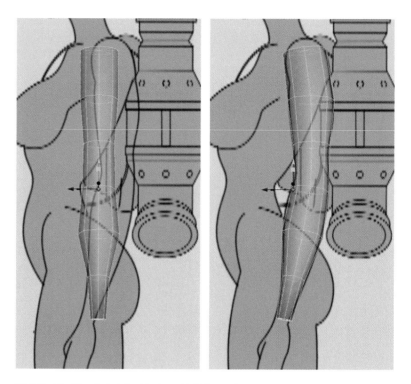

FIG. 5.53 Adjust the cylinder in the side viewport to fit the arm shape.

What we are going to do is raise her arm up slightly, and in doing this we can also introduce you to **Manipulator Edit Mode**. This mode allows us to change the pivot position on an object, allowing us to rotate it from a different point, rather than its center.

- First, let's bring back the torso model by going to **Display** > **Show All** (or pressing Shift + H).
- Following Figure 5.54, first switch back to the front viewport. The manipulator is currently in the center of the arm, where it should be.
- Make sure you have the **Move Manipulator** active, and go to **Selection** > **Manipulator Edit Mode** (or press **M**). Your manipulator will turn white to show it is active.
- Moving just along the Y axis, raise the manipulator up to where her shoulder area is (Figure 5.54b).
- When happy with the position, press **M** again to drop out of **Manipulator Editing Mode**. We can now rotate the arm from this point.
- Press **R** to activate the Rotate Manipulator and rotate the arm around the X axis (red) until it matches that in Figure 5.54d, roughly 30 degrees.

This is a much better pose for us to work with. Next, we will connect the arm to the torso.

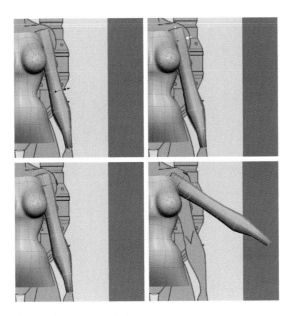

FIG. 5.54 Move the manipulator so we can raise the arm.

- Select both pieces of geometry and right click to bring up the context menu.
- Select **Combine Objects**.

Now they are a single object, and we can begin to weld the shoulder area together. Before we can do this, though, we need to remove the cap from the upper arm.

- Following Figure 5.55, select the upper cap faces and press **Delete** to open up the upper arm.

We are not going to connect the arm to the top of our torso model; if we do, the position of the shoulder will be too high. We need to make a hole in the upper torso, around the armpit area, for us to connect the arm.

- Select the polygon in the upper middle of the torso, just where the armpit area would be, and delete it (Figure 5.56a).
- Now use the **Merge tool** to connect the lower two vertices of the arm to the bottom two vertices of the new hole (Figure 5.56b).
- Move around to the front of the model and merge the two vertices just up from the armpit on the arm and torso (Figure 5.57).
- Next, following Figure 5.58, repeat this, but on the back of the shoulder, merging the two vertices just up from the armpit area.

Finally, adjust the shape of the shoulder area to fill it out and remove any unnatural shapes (Figure 5.59). Use whatever method you like to edit and move the vertices; again, the Tweak tool is a great place to start, and don't be afraid to use the Smooth tool to soften the area.

FIG. 5.55 Before we can attach the arm, we need to delete the upper cap.

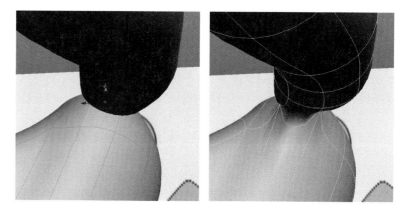

FIG. 5.56 Make a hole for the armpit before merging the lower arm vertices to the torso.

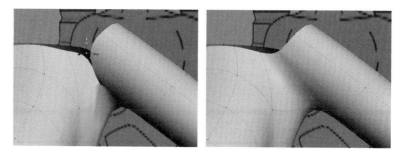

FIG. 5.57 Merge the vertices at the front of the arm.

FIG. 5.58 Merge the vertices at the back of the arm.

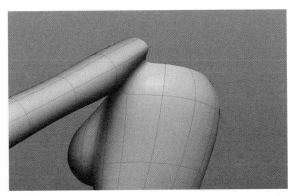

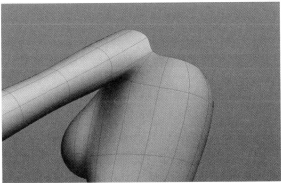

FIG. 5.59 Adjust the shoulder area to remove the pinching.

Now that the arm is in place, feel free to move around the torso and make any other adjustments to the overall shape. When satisfied, save your work and we will move on to the hand.

You can find the Silo scene created in this section in Chapter05/Files/ 05_Arms.sib.

93

Hands

At this point, we have a decent torso and arm, but we need a simple, quad-based hand that we can add detail to later. This will complete the left arm, which we can easily mirror later to generate her right arm.

If you navigate to the wrist area of the arm you created, you will see we still have a cap. We do need geometry here, but at present the topology isn't correct, so to begin we need to rebuild this area.

- For this section, it is probably easier to work on the first subdivision level of your model, so press **V** to step back to the lower resolution mesh.
- As illustrated in Figure 5.60, first select the polygons of the cap and delete them. This opens the wrist nicely.

What we need are three vertical quads, but rather than trying to build in a new polygon and connect it, we can use a simple **Bridge** to help us. This connects the selected edges with a new polygon, bridging the gap.

- Select the upper and lower edges of the wrist (Figure 5.60c).
- To create the **Bridge**, go to **Modify > Bridge** or press **Shift + B**.

This leaves two holes on either side, which we can quickly fill using the **Fill Hole tool**.

- Select an edge around the first hole and press **Shift + F** (or go to **Modify > Fill Hole**) to fill it.
- Repeat this for the second hole, filling in the wrist and giving us the three quads we need.

We are now in a much better position to construct our hand. The three vertical quads will act as the base for the first three fingers, and to help us we will use the **Extrude tool**.

The **Extrude tool** will literally pull new geometry out of your model—be it faces or edges—and gives you a great way to quickly add details to any model.

- Following Figure 5.61, first select the new faces at the wrist and go to **Modify > Extrude**.

FIG. 5.60 Rebuild the wrist using the Bridge and Fill Hole tools.

A yellow dot will appear giving you the option to adjust the extrusion. If you click on this and drag your mouse, you can edit the amount the new geometry is pulled out.

- Move the new geometry out slightly and then repeat the process, in effect creating two new extrusions (Figure 5.60c).

To create the three fingers, we need to select each of the three end polygons in turn and extrude them. We do this so they remain separate.

- Select the two outer faces of the wrist cap (Figure 5.61d).
- Press and hold the **Z** key to create new extrusions. This time, instead of selecting the yellow dot you can drag your mouse to edit the amount you extrude by.
- Release the **Z** key when done.
- Finally, select the remaining polygon in the middle of the wrist and perform another **Extrude** (either via the menu or pressing Z), pulling it out a bit further than the other fingers (Figure 5.61e).

That's the base for the fingers created. To make them easier to edit we will now use the **Smooth tool** to relax the geometry, making the fingers easier to edit.

- Select the vertices of the main hand.
- Apply a **Smooth** to them (**Modify** > **Smooth**). This will relax the hand and open it up as in Figure 5.62.
- As in Figure 5.63, you might also want to scale up the entire hand area; presently, it is far too small.

FIG. 5.61 Extrude the fnd of the wrist to start building the fingers.

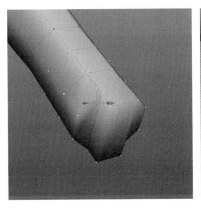

FIG. 5.62 Apply a Smooth to the hand to relax the vertices and open it up.

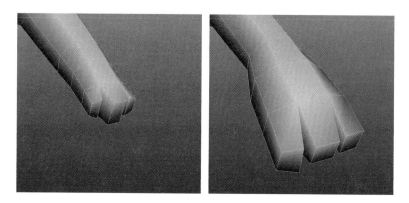

FIG. 5.63 Scale up the hand before you continue.

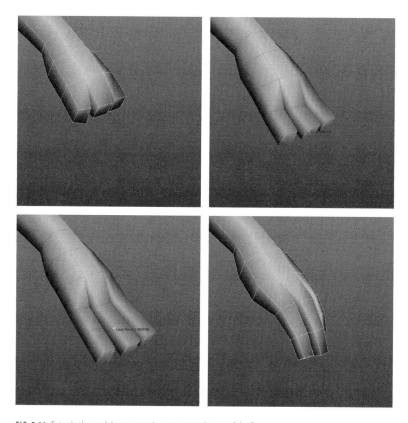

FIG. 5.64 Extrude the model two more times to create the rest of the fingers.

Now we need to build in the remaining parts of the fingers. There are two joints in each digit, so we need two more extrusions per finger.

- As illustrated in Figure 5.64, select the faces at the end of each finger and **Extrude** them two more times.

FIG. 5.65 Extrude more geometry to create the index finger.

- Next, shape the fingers into a more natural pose, as in Figure 5.64d.

The hand now has three basic fingers, which for now is perfect. She does, however, need her index finger and a thumb. We can add these by extruding more geometry and pulling it out of the existing hand.

- Select the two faces on the side of the hand, just below the ring finger, and **Extrude** them (Figure 5.65b).
- Next, select the face at the front of these and add three more extrusions to create the index finger (Figure 5.65c).

In Figure 5.66, you will see that we need to adjust the model slightly at the base of the thumb, before we create it. This can be done later if needed when we reshape the whole hand.

- Rework the main polygons at the back of the new index finger, making the area we will extrude for the thumb larger (Figure 5.66b).
- Create two more extrusions out to the side as shown in Figure 5.66c, moving these down slightly to form the thumb.

The main geometry for the hand is in place, so all it needs now is some TLC. Using the **Tweak tool**, rework the vertices until the model looks more like that in Figure 5.67. Try to achieve a relaxed feel to the hand, and refer to your own hand, or some other reference, to make sure the fingers are the correct length and orientation.

The left arm is now complete so let's apply the same procedure we performed on the torso and mirror the geometry to create the right arm.

- Following Figure 5.68, first delete the model's right side.
- What you might find is that the whole torso is removed; this is because symmetry might still be enabled from the last mirror operation we performed. To disable it, simply select the model, press Alt + N, and try deleting the geometry.

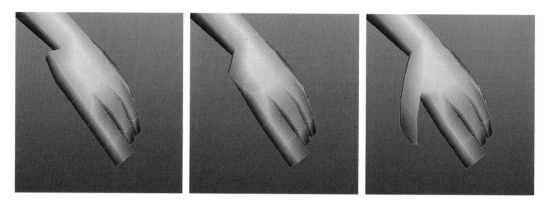

FIG. 5.66 Adjust the base area for the thumb before extruding the new geometry.

FIG. 5.67 Rework the model to create a more natural-looking hand.

FIG. 5.68 Mirror the left side of the torso to create the right arm.

- With the torso now split, go to **Modify** > **Mirroring** > **Mirror Geometry** to generate the opposite side.

With both arms attached, with hands, we can now add legs. As always, feel free to work further on the overall shape before you proceed, but try not to add any extra geometry just yet. We want to keep the model

FIG. 5.69 The complete torso, with arms attached.

simple; in the following chapters, you will get the opportunity to apply more details.

Figure 5.69 shows the complete torso, with arms and hands.

Remember to save your work.

You can find the Silo scene created in this section in Chapter05/Files/05_Hands.sib.

Legs

The base mesh is starting to take shape and we are over half way to completing her. What we will do now is give her legs in pretty much the same way we added her arms. We will start with a basic cylinder and adjust it to fit the leg in the model sheet.

- Load the scene **Chapter05/Files/05_Hands.sib**, or use one of the scenes you created in the previous section.
- Let's hide the torso and arms, so select the model and go to **Display** > **Hide Selected** (or press H).
- Switch to the front viewport and go to **Create** > **Cylinder**. You shouldn't have to open the options box, as it will retain the previous settings.
- Click **Create** to generate a new cylinder.

You should now have a cylinder like the one in Figure 5.70. Again, let's make it semitransparent so we can work with the model sheet behind it.

- With the cylinder selected, right click on the model, and in the context menu go to **Object Display Mode** > **Ghosted Shade Mode**.

Let's turn this cylinder into a leg.

- Still in the front viewport, move the cylinder up to the knee in the model sheet (Figure 5.71a).
- Next, rotate it so it matches the concept's orientation while scaling it to the leg's general shape (Figure 5.71b).

FIG. 5.70 Create a new cylinder for the leg and enable Ghost Shading Mode.

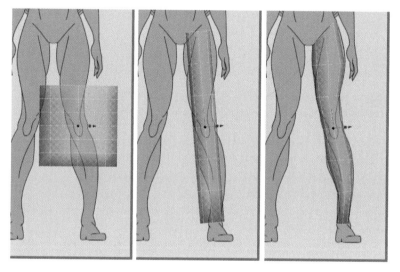

FIG. 5.71 In the front view, adjust the leg to fit the concept.

- Now work on the shape. By editing the vertices or edges, scale each edge loop until you get the general leg shape (Figure 5.71c).
- Now switch to the side viewport.
- Repeat the process shown in Figure 5.72, adjusting the cylinder to match the shape of the leg. As with the arm, feel free to rotate each edge loop to follow the natural contours of the limb.

When finished, you might find that the lower leg is quite angular, particularly around the knee and calf area. We can smooth this out by adding extra geometry into the model.

- Following Figure 5.72c, select the two edge loops below the knee.
- Holding **B**, bevel these to create two new edge loops. Move your mouse to adjust the spacing so they are even on both sides

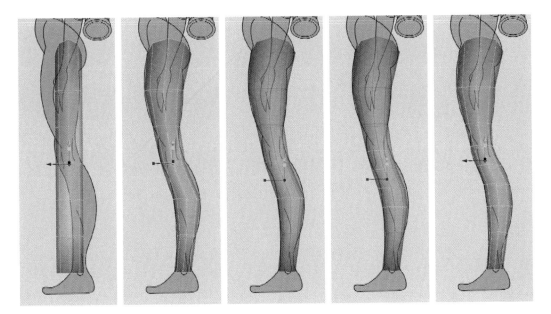

FIG. 5.72 In the side view, adjust the leg to fit the concept.

(Figure 5.72d). Using a Bevel will also average out the shape, as opposed to two direct cuts.

• Finally, adjust the new edge loops to reshape the lower leg.

The main leg is complete, so now we need to attach it to the torso, making sure we keep the correct topology around the waist area while sticking to a quad-based model.

• First, we need to remove the cap from the top of the leg cylinder. Select the faces shown in Figure 5.73 and delete them to open up the leg.
• Next, unhide the torso and arms by pressing **Shift + H**.
• Select both the torso and the leg, right click, and select **Combine Objects** from the context menu.

Now that the models are a single mesh, we can work our way around the hip, merging the vertices to connect the leg. We do this all the way around the leg, but keep the crotch area free, as this will need building in later.

• Following Figure 5.74, merge the outside vertices of the torso to the ones closest on the leg. We are merging to the leg so the torso vertices move to the correct hip position.

(Note: Don't worry if you end up with a spike as we have in Figure 5.74; this will go away when we are done.)

• Next, work your way around the front of the thigh merging each vertex in turn, stopping as you reach the crotch (Figure 5.74c).

FIG. 5.73 Remove the upper cap from the leg cylinder.

FIG. 5.74 Starting at the side, work your way around the hip merging the vertices.

- Finally, move around to the back of the model and continue to merge the vertices as shown in Figure 5.75, making sure you don't continue all around the model.

Now that we have the main leg in place, and most of it connected to the waist, we need to finish the area by building in her crotch. At this point, it is easier to work on a full model rather than half, especially when we can have symmetry enabled, so we need to regenerate the right side of our character.

- First, select the faces and delete the right side of the torso and her right arm (Figure 5.76a).

Again, if the whole torso is removed, or if part of her left side disappears, it is because symmetry might still be enabled from the last mirror operation we

FIG. 5.75 Move to the back of the model and continue to merge the vertices.

 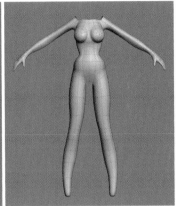

FIG. 5.76 Regenerate her right side using the Mirror Geometry tool.

performed. First, Undo the delete; then, to disable symmetry, simply select the model, press **Alt + N**, and redo the delete.

- Select the remaining model and go to **Modify** > **Mirroring** > **Mirror Geometry** to generate the opposite side (Figure 5.76c). Make sure **Enable Symmetry** is ticked in the options box.

(Note: Some of you might be wondering why we don't use a mirrored instance at this stage. An instance is just the application displaying the same geometry twice, which would work, but we need our model to be seamless down the center. With a mirrored instance, there would be a noticeable seam as both models would still be separate.)

Now we can start to fill in the gap, and because we have enabled symmetry, we only need to worry about one side.

- As seen in Figure 5.77, look from underneath the model and select the four edges on either side of the hole.
- To fill these we will create **Bridge**, so go to **Modify** > **Bridge** (or press **Shift + B**) to connect the two sides (Figure 5.77b).

FIG. 5.77 Use a Bridge as a starting point to filling in the crotch area.

Now, move around to the front and you will see we have a small hole. We could use the Fill tool to quickly fix this, but doing so would leave us with a triangle, not a quad. To get around this we can split the geometry we just added, using the new vertex to seal the hole.

* Switch to **Edge Selection Mode** (**S**) and hover over the front larger edge of the new polygons.
* With it highlighted, press **Alt + X** to create the cut seen in Figure 5.78b.
* The last step is to select the two vertices around the middle of the hole and merge them (**Ctrl + M**), closing the hole.

Moving around to the back now, we can see a larger hole (Figure 5.79), but this one is a little easier to fill.

* Select a upper and lower edge on one side of the hole (Figure 5.79a).
* Now create a **Bridge** (**Shift + B**). This will generate a new polygon between these two edges; however, because we have symmetry enabled it copies the action to the opposite side (Figure 5.79b).
* All that is left to do is to tweak and smooth the area to remove the crease, but remember to keep referring to the model sheet to make sure the area is the correct shape (Figure 5.79c).

The legs are more or less ready, but before we move on to the feet, double check the shape hasn't altered with the changes we made.

* As you can see in Figure 5.80, her thighs and calves seem slimmer now, so make sure this is corrected before we proceed.

Save your work and go grab yourself a well-deserved cup of coffee.

You can find the Silo scene created in this section in Chapter05/Files/05_Legs.sib.

FIG. 5.78 Split the new polygons so we can close the small hole.

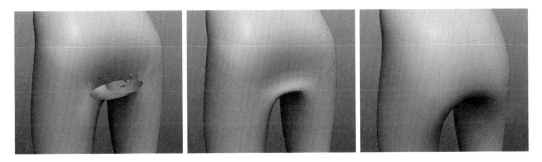

FIG. 5.79 Use a Bridge as a starting point to fill in the crotch area.

Feet

The feet are created in a similar way to the hands, using the **Extrude tool** to generate the main foot and each toe. Luckily, we only need to work on one foot, because with our last Mirror operation we enabled Symmetry, meaning we can now quickly create both her left and right feet at the same time.

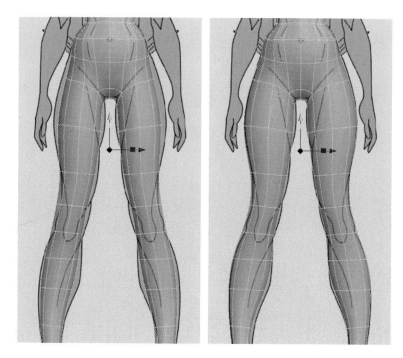

FIG. 5.80 Double check the shape of the legs before we move on.

Our first task is to delete the lower cap from the legs. Unlike the arms, we need to start from a clean and open ankle area.

• As shown in Figure 5.81, first select the faces forming the lower cap of the leg, and delete them.

With the end of the leg now open, we can start to build the main shape for her feet.

• Switch to the side viewport so we can use the model sheet as a rough guide. For now, there is no need to enable **Ghost Shading Mode**, as we only need the outline of the concept to help with the overall size of the foot.
• Following Figure 5.82, first select the lower edge ring.
• Press **Z** to create the **Extrude**, but because we are working on edges, you will not be taken to the local move tool.
• You should have the new edges automatically selected, so move these down to the base of the foot (Figure 5.82b).
• Now select the four front faces, and press and hold **Z**. Now you are selecting faces you will be able to move your mouse to specify the distance.
• Move the new faces out to the start of the toes.
• Now adjust the foot geometry to fit the shape of the foot outline.

Switch to the perspective viewport next so we can add the first four toes; again, we will be using extrusions to help create them.

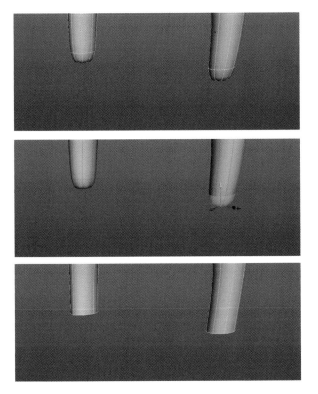

FIG. 5.81 Remove the lower cap from the legs.

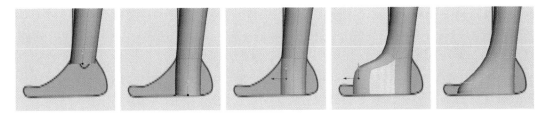

FIG. 5.82 Use the Extrude tool to create the main foot shape.

- Select the front four polygons and extrude them to add an extra section at the front of the foot (Figure 5.83b).
- In turn, select and extrude each of the four new polygons to create the toes (Figure 5.83c and 5.83d).

That's the geometry for the first four toes created, so let's next add the pinkie toe.

- Select the face on the outer edge of the foot, the one shown in Figure 5.84a, just behind the toe.
- **Extrude** this out to the side.

FIG. 5.83 Again, use the Extrude tool to create the toes.

FIG. 5.84 Extrude the side of the foot to create the pinky toe.

- Next, select the front of the new geometry and **Extrude** this forward to create the fifth toe.

At the moment it doesn't look much like a foot, but we now have the main geometry in place to reshape into our foot. What's more, we have a foot model made of all quads, but that won't be the case soon. For now, let's adjust the foot to make it more natural looking.

First, we need to enlist the **Smooth tool** to relax the toes and the front of the foot.

- Select the vertices around the front of the foot as illustrated in Figure 5.85, and go to **Modify > Smooth**. This will make the toes' vertices easier to edit, and soften the overall shape.
- Next, adjust the vertices further, as in Figure 5.85c, giving the toes a little more definition.

We can leave the foot for now, as there is little point in working on it further until we fill in the underneath. Once the sole of the foot is whole, we can move on, but adding the sole will also present us with a few topology problems to overcome.

Let's start by filling in the main areas.

- Following Figure 5.86, select three edges on either side of the foot, leaving the two at the very back, and the area around the toes free.

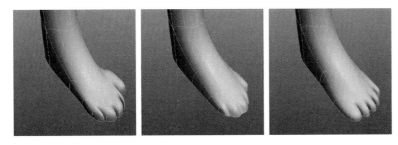

FIG. 5.85 Smooth the vertices of the foot before reshaping the toes.

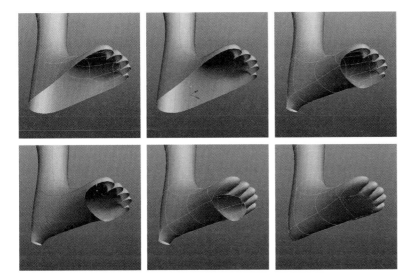

FIG. 5.86 Fill in the underneath of the foot.

- Go to **Modify** > **Bridge** (**Alt + B**) to connect them (Figure 5.86c).
- Next, select the edges on either side of each toe and create a **Bridge** to complete each toe. For best results, do this one toe at a time. Your foot should look like that in Figure 5.86e when done.

This leaves us with two holes, one at the ball of the foot, and a smaller one at the heel. Rather than try to build in the geometry for these, we will fill them using the **Fill Hole tool**.

- First, select an edge around the front hole and press **Shift + F** to fill it.
- Repeat this to fill in the hole at the heel (Figure 5.86f).

The sole of the foot is now closed, but at the ball area, we have a large n-gon made up of seven edges. Our next task is to convert this to quads, and remove any triangles left over.

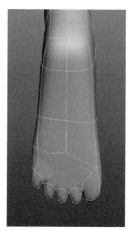

FIG. 5.87 Create a cut on the foot's sole so we can remove the triangle at the heel.

Looking beneath the foot (Figure 5.87a), we can clearly see the large n-gon at the front of the foot, but we also have a triangle at the heel. We will remove the triangle first, and as we do so, we can help to reduce the n-gon slightly.

- Select the four main edges across the sole of the foot, shown in Figure 5.87a.
- Press **Alt + X** to cut them, creating a new line of edges (Figure 5.87b).

Although this has turned the triangle at the heel into a quad, the topology isn't how we want it to be. Having this quad could lead to problems later because it interrupts the natural flow of the geometry, and has given us a few poles. What we can do is simply remove it by merging the two central vertices.

- To do this, select both central vertices and press **Ctrl + M** to merge them, collapsing the polygon and cleaning up the heel as in Figure 5.87c.

Now let's tackle the larger n-gon.

At present, there aren't enough vertices around the n-gon for us to work with. If we tried to connect these now, we would end up with some bad topology, so subdividing the model further would lead to pinching.

We need to do some preparation work first. What we will do is create a cut around the foot, ending at the n-gon. This will give us an extra vertex to use.

- As shown in Figure 5.88a and 5.88b, select the ring of edges starting on top of the foot, working your way underneath. When you reach the central edge under the foot, turn the selection toward the n-gon.
- If you now create a cut (**Ctrl + X**), it will follow your selection, bending to point toward the n-gon (Figure 5.88c).

FIG. 5.88 Add two new cuts across the n-gon.

We can now connect these vertices with the ones opposite using the **Cut tool**. This will give us our first two quads.

- Press **X** to activate the **Cut tool**.
- Select the first lower vertex, and then the one opposite, across the n-gon between the toes.
- Continue to cut; this time, follow the existing edge to the next toe.
- Finally, move back across the n-gon and select the second open vertex.
- You should have two new cuts like the ones highlighted in Figure 5.88d.

Now, part of the n-gon is fixed and converted into neat quads; however, what we have now are a triangle and a five sided n-gon. Because these are connected, it is an easy fix.

- Select the edge, which connects the triangle and the n-gon (Figure 5.89a).
- Pressing **Ctrl + M** will collapse this, removing the triangle and converting the n-gon into a quad (Figure 5.89b).

That was easy, and as an added bonus the topology is now spot on. You can see how the polygons curve behind the big toe; there is a natural ball on our feet here so this will fit nicely.

We are almost done with the sole, but we have one more n-gon to break down. In Figure 5.89b, you can see the n-gon behind the pinkie toe; we need to divide this, turning it into two quads.

- Select the edges show in Figure 5.89c. We want to split the opposite edge, and bend this new cut around to the side of the foot.
- Pressing **Alt + X** will create a new cut between the edges (shown in Figure 5.89d).
- Next, we need to quickly remove the new triangle. Select the new edge shown in Figure 5.89d and **Merge** it (Figure 5.89e).
- Now we have a new vertex to use for our cut, so press **X** to switch to the **Cut tool**.
- Select the vertex between the toes, and the one opposite it, to break the n-gon into two quads (Figure 5.89f).

FIG. 5.89 Add new geometry to the sole to remove the n-gon.

FIG. 5.90 Use a Bevel to add definition to the ankle.

The sole of the foot is now complete. We successfully removed all the n-gons and triangles, leaving it clean and ready to work with. Next, we will add a little more definition to her ankle.

In Figure 5.90, the ankle has almost no shape to it; the foot seems to seamlessly blend into her lower leg. What we need is an extra edge loop to help us out.

- Select the current ring of edges around the ankle area (Figure 5.90a).
- Press and hold **B** to bevel them, moving your mouse to adjust the size of the bevel to that in Figure 5.90b.
- Creating this bevel has added in two triangles, and made two five-sided polygons below them (on both the inner and outer foot). Simply select the lower edges of each triangle and **_Merge_** them (**_Alt + M_**) to remove both.

The ankle should now look like that in Figure 5.90c—much better.

Let's move back to the foot now, and the two n-gons that exist around the pinkie toe area. Before we can complete the foot, we need to address these.

FIG. 5.91 Cut around the back of the foot, using the new vertices to remove the n-gon.

FIG. 5.92 Split the n-gon above the pinkie toe.

To remove the n-gon on the outside of her foot, we have to add an extra edge loop around the back of the foot. This will give us the extra vertices we need to remove the n-gon, and add some extra definition to her heel.

- Select the four vertical edges around the back of the foot, and the one opposite our n-gon (Figure 5.91a).
- Press **Ctrl + X** to cut them (Figure 5.91b).
- Now, using the **Cut tool**, make a cut across the n-gon behind the pinkie toe, connecting the two vertices (Figure 5.91c).

Move to the top of the foot next, just above her pinkie toe.

- As in Figure 5.92, add a cut across the n-gon above the pinkie toe. This will give us a quad, and a triangle to deal with.

We now have two issues remaining: the triangle above the pinkie, and an n-gon on the inside of the foot, a side effect to our earlier cut around the back of the foot.

We can eliminate both at the same time.

- Select the edge ring starting from the inside of the foot, just below our n-gon (Figure 5.93a).
- Follow this underneath to the outer foot, turning the selection to the edge to which the triangle is connected (Figure 5.93b).
- Press **Alt + X** to split the edges.

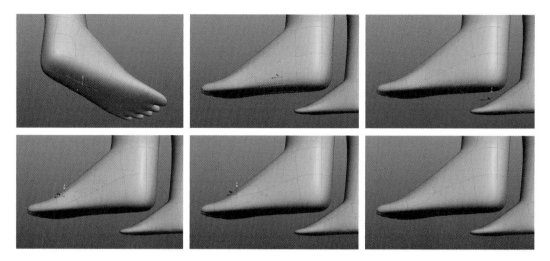

FIG. 5.93 Cut under the foot to help remove the triangle above the pinkie toe.

FIG. 5.94 Connect the two remaining open vertices and collapse the new edge.

- We now have a series of n-gons on the outside of the foot. Create a new cut, continuing the previous cut forward to meet the existing triangle (Figure 5.93d).
- Select the edge behind the new cut, the one forming both the triangle and the n-gon, and merge it to remove both the triangle and the n-gon.
- Finally, select the edge between the two remaining triangles above the pinkie toe (Figure 5.93e) and press Delete, turning it into a quad (Figure 5.93f).

Now that the triangle is taken care of, let's go back to the n-gon on the inside of the foot. This can be fixed quite easily and the result will be ideal, as it will alter the topology to flow as a natural foot would.

- Create a cut across the n-gon, connecting the two vertices on the inside of the foot (Figure 5.94b).
- Select the new edge and **_Merge_** it, bringing the two points together as in Figure 5.94c.

FIG. 5.95 Add a new edge loop around each toe.

FIG. 5.96 The completed foot model.

Now we have a clean foot model, and the start of a nice, natural-looking heel.

Before we move on and start to rework the overall shape, we need to do one more thing: the toes are too basic and have little shape to them. Adding a new edge loop around each will give us that little bit of extra geometry to work with.

- Switch to **Edge Selection Mode** (**S**) and hover over one of the edges of each toe.
- Press **Alt + X** to create a new loop.
- Repeat this for each toe (Figure 5.95).

Now, refer to your reference material and rework the foot into a more natural shape.

Your final foot should resemble that in Figure 5.96.

We are almost done; just need the head. Save your work and move on to the final section of this chapter.

You can find the Silo scene created in this section in Chapter05/Files/ 05_Feet.sib.

Head

All we need to do now is give our model a head and neck. We only need a simple head shape; any facial details will be added in the following chapters.

Remember, this is just a base mesh. From this, you can continue to model, or alternatively can choose to use Silo's sculpting tools to add the details.

Load the scene Chapter05/Files/05_Feet.sib, or use the scene you created in the previous section.

To start on the head, we are going to use another primitive, but this time it won't be a cylinder. We won't be using a sphere either; a sphere has a point at the top and bottom axes, points made up of triangles, and will cause pinching. What we will do is begin with a cube.

- Go to **Create** > **Cube** and move the new primitive up in the scene, to around the head position, as in Figure 5.97a.
- With the cube selected, press **C** twice, to subdivide it two times. This gives us a sphere based entirely on quads.
- The problem is that this is still in effect a cube. What we need to do is bake the subdivision so we can edit each vertex and face, rather than the cage. To do so, go to **Subdivision** > **Refine Control Mesh** (Figure 5.97c).

Now that we have our quad-based sphere, we can start to turn it into a basic head.

- Switch to the side viewport and adjust the head to fit the model sheet. Remember to enable **Ghost Shading Mode** if it helps, (Figure 5.98).
- Next, switch to the front view and repeat the process, tweaking the shape to fit the head as shown in Figure 5.99.

FIG. 5.97 Create a sphere, from a cube.

With the general shape of the head complete, we don't need any more detail at this time. However, if you are feeling confident, add some extra edge loops to give the head more definition.

- Move to beneath the head now and select the four faces at the center (Figure 5.100a).
- Press and hold **Z** and **Extrude** these to form the neck.
- To finish, delete the bottom cap from the neck, as we won't be needing it (Figure 5.100c).
- When the neck was extruded, it would have moved out following the direction the selected faces were pointing. If this was the case, you need to now return to the side (Figure 5.101) and front (Figure 5.102) viewports and tweak the shape.

FIG. 5.98 Adjust the sphere to fit the head from the side view.

FIG. 5.99 Adjust the sphere to fit the head from the front view.

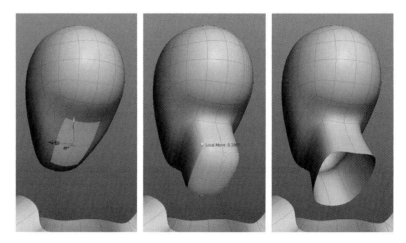

FIG. 5.100 Extrude faces beneath the head for the neck.

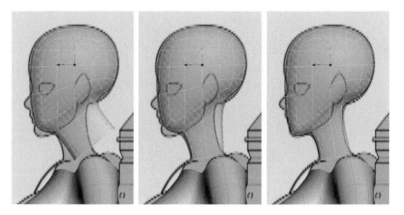

FIG. 5.101 Fix the neck in the side viewpanel.

Now that we have the head and neck, we can start to connect them to the main body.

- First, select both models and combine them into a single mesh. Right click, and from the context menu select **Combine**.
- Next, select the edge ring around the lower neck (Figure 5.103a).
- Press **Z** to create an extrusion and scale out the new edges to reveal the additional faces (Figure 5.103b).
- We only want to connect the front three vertices for now, so select and **Merge** (**Alt + M**) each pair to connect them (Figure 5.103c).

Because there are more faces around the shoulder than there are on the neck, we need to connect this area differently using a combination of tools.

FIG. 5.102 Adjust the neck in the front viewpanel.

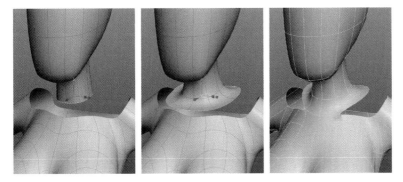

FIG. 5.103 Start to connect the neck to the torso.

- Following Figure 5.104, select the second from the front edge around the neck, and the equivalent around the shoulder.
- Press **Shift + B** to create a **Bridge** between the two (Figure 5.104c).
- Next, use the **Fill Hole tool** to fill the hole at the front of the shoulder. Simply select an edge around it and press **Shift + F** (Figure 5.104d).

What we have now is an n-gon at the front of the shoulder.

- Create two cuts across the Bridge you created earlier (Figure 5.104e). Do this by using the **Cut tool**, or by selecting both edges and pressing **Alt + X** to split them twice.
- Now, use the **Cut tool** to divide the n-gon and connect these edges with the ones at the front of the shoulder (Figure 5.104f).

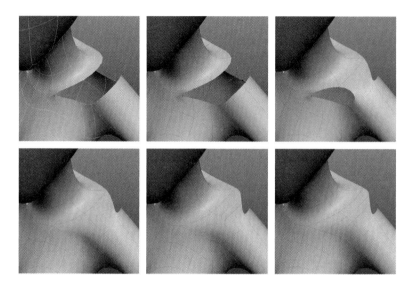

FIG. 5.104 Fill in the front shoulders.

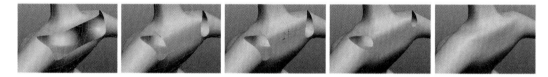

FIG. 5.105 Start to fill in the back of her shoulders.

(Note: If symmetry was enabled, you will find that both shoulders were completed. If it wasn't, you can easily delete half the model and perform a Mirror Geometry operation as we did earlier in the chapter to update the opposite side.)

Spin the model around, and now let's work on the back of her shoulders.

- Start in the center and create a **Bridge** between the upper and lower edges to build the two large faces seen in Figure 5.105b.
- Next, split these faces by selecting the vertical edges and pressing **Alt + X** to cut them (Figure 5.105c).
- Now that we have this extra split, we can create another **Bridge** from the lower polygon on her back to the one opposite on the arm (Figure 5.105d).
- For the remaining hole, use the **Fill Hole tool** to fill it. This will give us a large n-gon, but we can divide it next.
- Moving on to Figure 5.106, create a new **Cut** across the two central polygons of the upper back (Figure 5.106b).

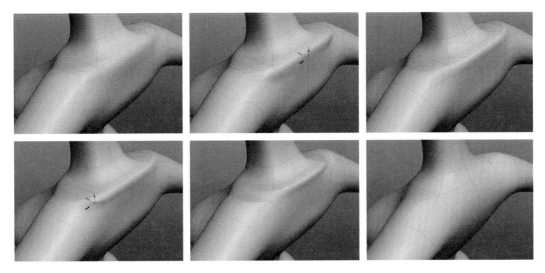

FIG. 5.106 Continue to work on the shoulders, smoothing the area when done.

- Create another **Cut**, connecting it across the n-gon on the upper shoulder (Figure 5.106c).
- This still leaves us with an n-gon, and an odd shape at the base of her neck. What we can do now is add another cut between the vertex closest to the neck, and the new vertex opposite (Figure 5.106d).
- If we now **Merge**, this new edge cleans up the area leaving only quads (Figure 5.106d).
- All that is left to do is select the faces around the shoulder and lower neck and use the **Smooth tool** to relax them. You might need to do this a few times before the area is sufficiently smoothed (Figure 5.106e).

Final Tweaks and Fixes

The head is now fully connected, meaning we have our whole base model. What we can do now is return to the n-gons above and below her breasts where there are still four five-sided polygons. Now that we have the head and neck in place, it is safe to fix this, as we know the topology around this area isn't going to change.

- Move to the front of the model; as you can see from Figure 5.107a, the first two n-gons are obvious.
- First, create a **Cut,** dividing the left n-gon from the top-right corner down to the center (Figure 5.107b). This will also be applied to the opposite side.
- Next, select the edge above the two new triangles and **Merge** it (Figure 5.107d).
- This gives us four new triangles, but we can now delete the edge dividing these to give us back quads (Figure 5.107e and 5.107f).

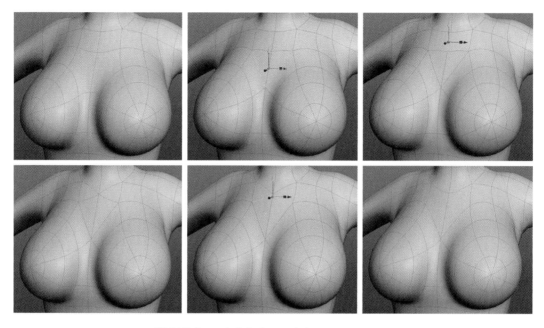

FIG. 5.107 Remove the N-Gon between the breasts.

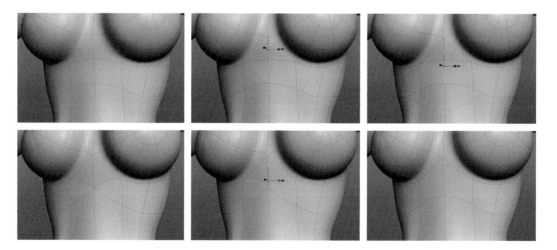

FIG. 5.108 Remove the n-gon beneath the breasts.

For the remaining n-gon underneath, we can repeat the process.

- Move so you can see below the chest area; again, as you can see from Figure 5.108a, the remaining n-gons are obvious.
- First, create a **Cut**, dividing the left n-gon from the top center corner down to the bottom right (Figure 5.108b).

FIG. 5.109 Convert the triangles at the front of the chest into quads.

- Next, select the edge below the two new triangles and **Merge** it.
- Again, this gives us four new triangles, so select and delete the dividing edges shown in Figure 5.108e.

One last area is staring us right in the face: the front of each breast is made up entirely of triangles. Because there is an even number of triangles—eight to be exact—we can delete every second edge from the ring.

- As you can see from Figure 5.109, doing this leaves us quads, and removes the pinching you might have been getting as you subdivided your model.

We are done (for now). We created our base mesh that can now be stored and used on numerous projects, and is perfect for sculpting.

Additionally, we managed to make it completely from quads.

- If you want to see for yourself, go to **Editors/Options** > **Scene Info**.

In Figure 5.110, we can see at the bottom that we have 880 four-sided faces, 0 three-sided, and 0 that have more than four sides—excellent, Figure 5.111 shows the final Base Mesh model.

Before moving on to the next chapter, spend some time on the model, adjusting the shape to suit your needs. When you are happy with the results, place it in the Silo Primitives folder (see Chapter 4) so you can easily access it in the future.

(You can find the Silo scene created in this section in Chapter05/Files/05_Complete.sib.)

In the following chapters, we start to add detail to this model, giving her a bit more personality, depth, and a face.

FIG. 5.110 The Scene Info window.

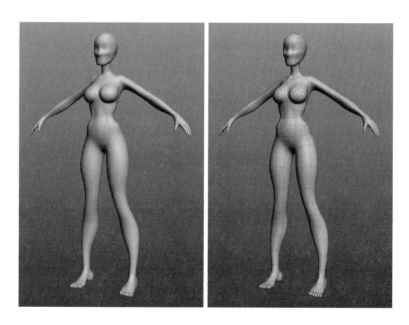

FIG. 5.111 The final base mesh.

Organic Modeling: Torso

In Chapter 5, we explored Silo's main modeling tools as we created our basic base mesh. In the following chapters, we step things up a notch as we work on the detail pass where we will build in the main muscles, hands and feet details, and a fully featured face.

(Note: Unlike Chapter 5, we will not be too concerned with explaining each previously used tool and process, so we recommend that you read the previous chapters before continuing. You will find the files used for this section in the downloaded tutorial files inside Chapter 6/Files.)

Preparation

Before we begin this section, we need to have the relevant reference materials on hand. You should have gathered most of this in the early chapters of the book, but following are a few pieces we think will help throughout this chapter.

The first in Figure 6.1 is a drawing displaying the main muscle groups. This will be essential to refer to, as following the main muscles as we work will make the character appear more realistic, and help make the model easier to animate.

3D Modeling in Silo. DOI: 10.1016/B978-0-240-81481-0.00006-6

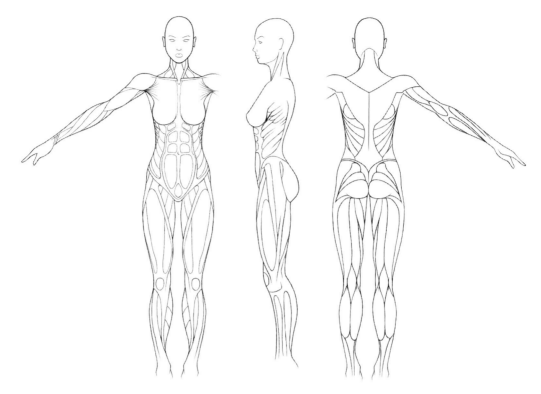

FIG. 6.1 The main muscle maps.

Figure 6.2 is a render of a previously created stylized female character. This is included so we can refer to the topology of the model to see how she is built and see what our goal in the next few chapters will be.

Finally, be sure you have plenty of real-life photo references, too. Looking at an actual live person is always a great starting point with any anatomy study. Helpful photos you can use as general reference can be found at *www.3d.sk,* which is mentioned in the appendix and well worth a visit.

With these at hand and any other images you have to help you, let's start working the details into our model.

Torso

The torso is always the best place to start. It is the core of the body with the limbs and head branching from it. Any changes we make to this will eventually affect how we detail the limbs, so it is a good idea to start work here.

We will split this section to make it easier to follow.

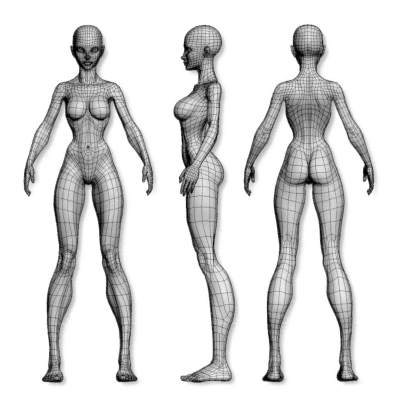

FIG. 6.2 Another detailed base mesh.

Stomach

The first part of the torso we will work on is the model's stomach area. At present, it is flat, with no detail or even a naval. We want to add in her rib cage and abdomen muscles while being careful to not go over the top. These want to be subtle additions, hinting at the muscles beneath the surface.

- First, load the scene *Chapter06/Files/06_BasicBaseMesh.sib*.
- Your model will be in at its initial, low-resolution state, so select it and press **C** two times to smooth her out.

Now we can start work. First, we want to create a loop around her stomach area, which will help to initially define her ribs and stomach.

- Following Figure 6.3, first select the five edges seen in Figure 6.3b.

(Note: Your model should still have symmetry enabled, so working on one side will be fine.)

- Next, hold **B** and create a ***Bevel***, moving the new edges apart slightly (Figure 6.3c).
- The Bevel has given us four new triangles, one in each corner. Select the outer edges of each triangle and ***Merge*** them (***Alt + M***).

FIG. 6.3 Bevel the edges around the stomach area.

FIG. 6.4 Alter the topology to work on the rib cage.

- Now we have a nice loop, but before we proceed, select the faces and apply a **Smooth** to relax the area.

Now we have a good starting point for the stomach. This gives us a subtle shape we can work on top of, and we have the initial shape of her lower ribs. Next, we will move to her side and alter the topology to account for her rib cage.

- Turn to the side of the model and select the edges shown in Figure 6.4a, first moving out from the stomach area and up to the armpit.
- **Cut** these (**Ctrl + X**), giving you the new line seen in Figure 6.4b.

FIG. 6.5 Connect the new cut to the front ribs.

- Next, **Merge** the edge forming the lowest new triangle; this should leave you with two remaining (Figure 6.4c).
- As shown in Figure 6.4d, create a new **Cut** next to the two triangles.
- Finally, **Delete** the inner edges of the triangles (Figure 6.4e), cleaning up the area.

Now we want to connect our initial, large cut to the ribs, which we can do in three easy steps.

- Select the top, inner edge shown in Figure 6.5a and perform a **Bevel** on it (**B**).
- Create a **Cut** across the two upper vertices of the n-gon, creating a new triangle (Figure 6.5c).
- Finally, **Merge** the lower edge of the triangle to return the area back to quads.

The stomach area is starting to take shape. As illustrated in Figure 6.6, now is a good time to smooth out the area and tweak the overall shape, enhancing the rib cage and the stomach before we move on.

Next, we will add more shape to her abdomen muscles and her rib cage before we build her naval. At present, she is quite bland, and her ribs are unnaturally joined in the center of her body. First, we will tone her stomach a little more.

- Select the central horizontal edges of her ribs and continue down, selecting the ones over her stomach (Figure 6.7b).
- We are going to split these to give us some extra geometry to work with. Press **Alt + X** to **Cut** these edges, creating a new line down her stomach (Figure 6.7c).

The bottom of our new cut has left us with two n-gons; ideally, we need the polygons to bend and follow the curvature of her stomach topology and remain as quads.

- Continuing with Figure 6.7d, select the two lower vertical edges.
- **Cut** across these and then **Merge** the lower edge highlighted in Figure 6.7e.

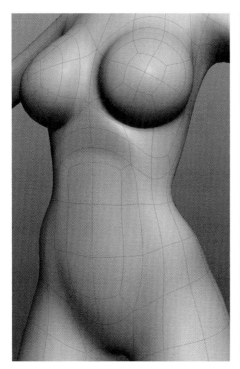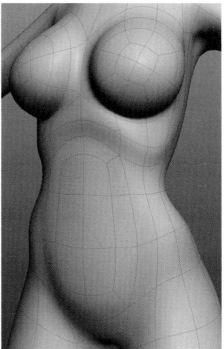

FIG. 6.6 Work on the overall area to refine the shape and enhance her stomach and ribs.

We have successfully turned the open cuts in on themselves and cleaned up the topology (Figure 6.7f).

- Following Figure 6.8, create a *Cut* running from the upper ribs to the clavicle area. The easiest way to do this is to select the edges shown in Figure 6.8b and press *Alt + X*.
- This will give you four triangles on her inner chest. *Merge* these next to remove them (Figure 6.8c).
- Finally, create a *Cut* across the n-gons to connect the upper vertex on the ribs to the base of the new cut (Figure 6.8e).

(Note: This leaves us with an n-gon above her chest, but we can use this later to help define her clavicle.)

We now have the topology in place to add more shape to the stomach and ribs. Before we move on, rework the overall shape, but do not go too over the top. We only want subtle shapes for now.

Figure 6.9 shows the reworked torso.

Looking at how the model is shaping up, one thing stands out. Her hips are currently too far back, so we need to move them forward slightly. How can we

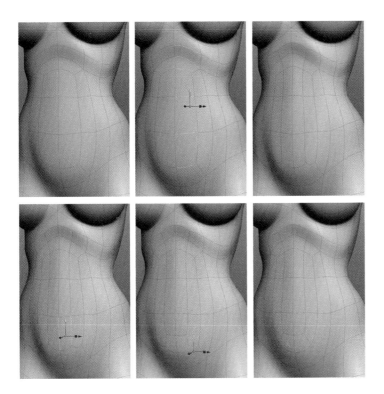

FIG. 6.7 Create a vertical cut down her stomach and reroute the flow of the geometry. Now let's fix the n-gons on her ribs.

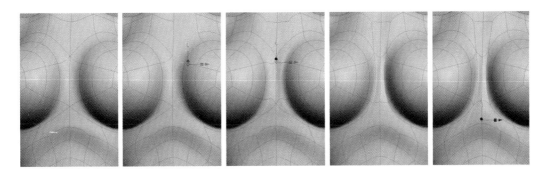

FIG. 6.8 Create a new cut down her inner chest.

do it quickly and with the least disruption? We can use another of Silo's tools here, the **Soft Selection tool**.

(Note: For more information on the Soft Selection tool, refer to Chapter 3.)

Let's try this new tool.

- Following Figure 6.12b, select the vertices around her waist. Include her upper legs and lower torso.

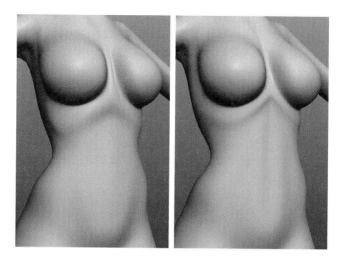

FIG. 6.9 Rework the overall shape of her stomach.

FIG. 6.10 Enable the Soft Selection tool.

- Now go to **Selection > Soft Selection** (Figure 6.10) and open the options window.
- Figure 6.11 shows the various options available to you. For now, click **Enable**. What you should see now are the colored vertices on your model showing the selections falloff (Figure 6.12c).
- Move the hips forward slightly and you will see the main vertices follow as you move while the others movement depends on the color of the vertex.

(Tip: You can interactively adjust the falloff by scrolling the middle mouse button.)

With the hips in a better place, let's now add her navel.

- Focus on the center of her stomach and select the six vertical edges around where her navel would be (Figure 6.13b).
- Press **Alt + X** to **Cut** (Figure 6.13c) these before **Merging** the two outer upper and lower edges (Figure 6.13d).

FIG. 6.11 The Soft Selection tool options.

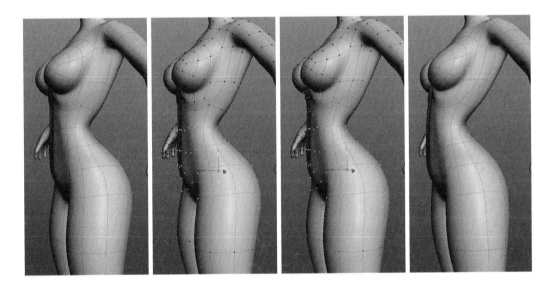

FIG. 6.12 Use the Soft Selection tool to move the hips forward.

This leaves us with four triangles, but we can use these and turn them into quads, while adding more detail into the area.

- Select the three horizontal edges next running from the upper to the lower triangle (Figure 6.13f) and create another **Cut**.
- As you can see from Figure 6.13g, this gives us back the quads.
- As a final step, select the middle four quads and press **Z** to **Extrude** them. However, rather than moving the geometry into the model or out, simply scale it, making it smaller for now. This extra extrude will give us the polygons we need to form the actual navel.

Now we have the correct topology and can start to work on her navel.

FIG. 6.13 Work in extra geometry so we can add the navel.

- Following Figure 6.14, select the four central polygons and **Extrude** them into the model.
- Initially reshape this area, rounding it off before you add an extra edge loop around the opening (Figure 6.14d). You can do this by selecting the edge ring and pressing **Alt + X**.

We could, after a bit more reshaping, leave the navel here, but the reference we have has a crease above the naval.

- Select the top two edges above the navel's opening (Figure 6.15a).
- Create a **Bevel** to open up the edge, and **Merge** the two outer edges of the new triangles.
- Now move the new vertices in slightly to create the crease.

There we have it, her stomach area is complete. Yours should resemble that in Figure 6.16.

We could at this point work more detail into her abs and ribs, but remember, we do not want too many muscles to show. Besides, once this model is complete, you can always come back to it to add any extra details you want.

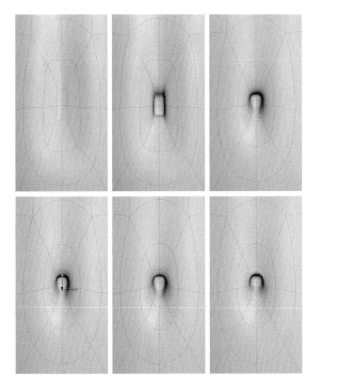

FIG. 6.14 Now add in her navel.

FIG. 6.15 For more detail, add a crease above the naval.

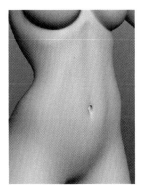

FIG. 6.16 The completed stomach area.

Clavicle

When detailing her stomach we created a cut that moved up the center of her chest and ended just above her breasts. We left this cut open for a good

reason, as we can now continue to work with it, adding more geometry to help us build in the clavicle.

- In Figure 6.17, you can see the five-sided polygons in the center of her chest. First, we will create a *Cut* across these (Figure 6.17b).
- Next, select the three horizontal edges (Figure 6.17c), starting at the new cut and ending in the middle of her neck.
- *Cut* these to divide the polygons (press *X*).
- Next, create another *Cut* to connect the new cuts with the ones left over from the stomach work (Figure 6.17e).
- Finally, *Merge* these and the central edge to close the triangles.

With that area fixed, we next need to add an extra edge loop running across her upper chest and onto her shoulder.

- As illustrated in Figure 6.18b, select the edges moving across her upper torso and onto her shoulder .
- Press *X* to *Cut* them.
- This gives us two triangles to deal with next. Select the edges shown in Figure 6.18d and *Merge* them. This will leave you with an n-gon on the

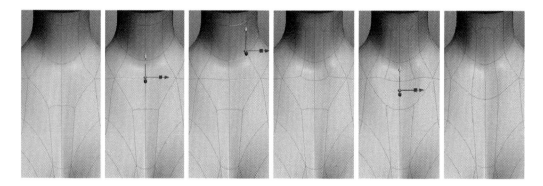

FIG. 6.17 Follow the cut from the stomach to the neck.

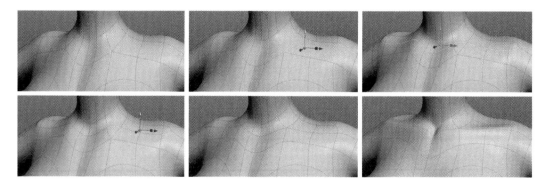

FIG. 6.18 Split the geometry further so we can work in the clavicle detail.

shoulder, but that is fine for now, as we can use this to help further define the shoulder later in the chapter.

- Now simply adjust the vertices to achieve the clavicle shape seen in Figure 6.18f.

(Tip: If you are unsure how this area should look, refer to your reference materials.)

The clavicle is now in place, and while building it we cleaned up the topology above her chest.

Shoulders

Next, we will move on to her shoulders and work in the main deltoid muscles. We will work on these now, rather than in the arms section, because we will need to see how the topology forms around those areas, especially where the shoulder and upper torso meet.

First, we will work on the pectoral muscle that connects the main chest to the shoulder. We are looking for a nice arc moving from her upper breast to the front of her armpit.

Following Figure 6.19, move to just under the arm. We need to alter the flow of the polygons, bending them as they connect with the torso so they run down the body.

- Select the edges highlighted in Figure 6.19b, around the front of the armpit, and apply a **Bevel** to open them up.

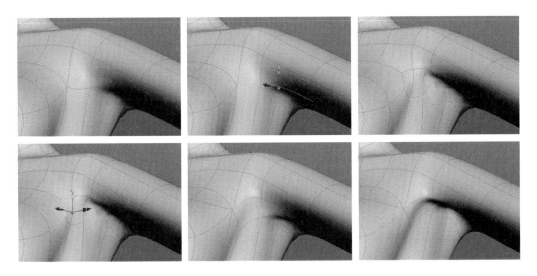

FIG. 6.19 Alter the topology to bend the flow of polygons down the body.

- Now we want to **Merge** the edges we no longer need, so select the triangle under the arm, and the three at the top of her chest (Figure 6.19d), and **Merge** them.
- As you can see from Figure 6.19e, this alters the topology to give us the bend we need. Now all we need to do is adjust the area to give the armpit more definition (Figure 6.19f).

(Note: This will leave you with unclean topology, like the triangle on her upper chest, but do not worry; we aren't finished with the shoulder yet.)

- Move to the upper arm next and select the edge loop shown in Figure 6.20a.
- Apply a **Bevel** to it, giving us some more geometry. We can use this to help define the deltoid while also cleaning up the armpit topology.

Now it is time we did some much needed housecleaning and repair some of the topology issues we created while working. A good clean model is paramount; it not only makes the geometry look neater but it's also easier to work with so be sure to tidy as you go.

Move back to the front of the shoulder. We are going to remove the triangle on her upper chest first.

- Select the two vertical edges next to the triangle; these should form the quad connecting the arm and torso (Figure 6.21a).
- **Cut** these, and then create another cut connecting it with the upper point on the triangle (Figures 6.21b and 6.21c).
- Now you can delete the edge below, removing the two triangles and converting them into a quad (Figure 6.21d).

FIG. 6.20 Bevel the upper arm to help define the deltoid.

FIG. 6.21 Clean up the topology above her chest.

- Moving on, go under the arm so you can see the armpit, which is quite messy with n-gons and pinching geometry all over the area.
- First, select the three edges seen in Figure 6.22a and **Merge** them. This will clean that section, and reroute the flow of polygons back toward the torso Figure (6.22b).
- Next, create a **Cut** across the n-gon just above the armpit (Figure 6.22c).
- Create two more cuts, this time across the polygon above the cut you just made, and dividing the quad to the right (Figure 6.23b).
- **Merge** the edge for the second cut you made, collapsing this triangle.
- Finally, delete the edge below your last cut. This should give you back a quad, and leave your model like that in Figure 6.23c, with just one more triangle to deal with.

Just a few more steps before we can leave her shoulder.

- Move to the back of the shoulder. As seen in Figure 6.24a, we have a nasty pinch, which was left over from an earlier Bevel operation.
- Select the edges opposite, following the flow of the original bevel, turning the selection back toward the torso (Figure 6.24a).
- Apply another **Bevel** to the selection (Figure 6.24b).
- Finally, **delete** the edge dividing the two bevels, and **Merge** the outer edge of the triangle toward the end of the new bevel. This should give you a cleaner shoulder (Figure 6.24c).
- Switch back to the front of the shoulder now, to our remaining triangle (Figure 6.25).

FIG. 6.22 Clean up the topology around her armpit.

FIG. 6.23 Continue to rework the topology around the shoulder.

FIG. 6.24 Clean up the back of her shoulder.

FIG. 6.25 Split the geometry over the shoulder to remove the triangle.

- Select the edges running up from this triangle (Figure 6.25a) and **Cut** them, turning the triangle into a quad and giving us some extra geometry to play with.

The shoulder topology is now complete. We rerouted the flow of the polygons to follow the deltoid and pectoral muscles, making the area appear more natural. Use your reference material to work more on the overall shape of the clavicle, shoulder, and armpit area.

Breasts

We have one more section to look at before we begin working on her back— her breasts. Currently they are flat with no detail, which would be perfect for most models, but if you need a nude character, she will need nipples.

- Following Figure 6.26, select the four quads at the center of her chest.
- Press **Z** to perform an **Extrude** and scale the new polygons, making them slightly smaller (Figure 6.26c).
- With the geometry still selected, create another **Extrude**, this time scaling it in even further, to the general size of the nipple. This will form the areola (Figure 6.26d).
- Now create a final **Extrude**, this time moving the new geometry out to form the nipple itself.

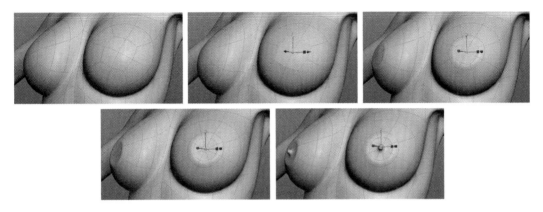

FIG. 6.26 Use the Extrude tool to form the areola and nipple.

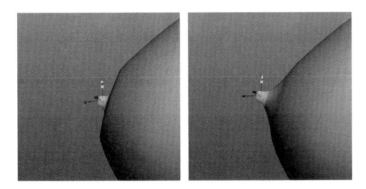

FIG. 6.27 Remember to round off the end of her chest.

Because we were scaling the extrude operations, the front of the chest will now look flat, so make sure to adjust the geometry, as shown in Figure 6.27, to round off the end of her chest.

All that remains to do now is to revisit the front of her torso as a whole and work on the overall shape. Again, good reference at this stage is key, so be sure to refer to it frequently. Look for the subtle curves of the hips, and how the abdominal muscles help to form the stomach area. Also, add more definition to the shoulders now that we have the extra geometry to do so.

Your resulting model should resemble that in Figure 6.28.

Don't forget to save your work before we move on and work on her back.

(You can find the Silo scene created in this section in Chapter06/Files/06_ TorsoFront.sib.)

Back

Next, we will build the detail into her back. This will include adding the shapes her muscles, shoulder blades, and spine will make. To start, we need to add a

FIG. 6.28 The completed front torso.

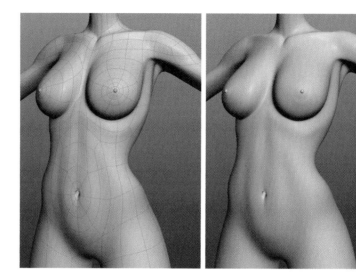

FIG. 6.29 Select the edges over her hips and up her back.

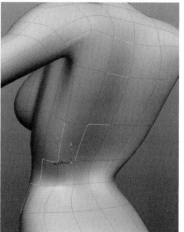

cut around her hips. This will follow the natural muscles of the body and give us great polygon flow for when she is posed and animated.

- Starting at the front of her hips, select a series of edges moving over her hips and up her back (Figure 6.29).
- Now press **X** to **Cut** these edges, giving you a nice line around her torso (Figure 6.30a).

Creating such a long cut around her body will leave you with numerous triangles and n-gons to deal with, so let's address those next and get them out of the way.

FIG. 6.30 Cut and clean up the topology, removing the new triangles.

FIG. 6.31 Merge the triangle on her back.

- First, select the triangles above her hip (highlighted in Figure 6.30b) and **Merge** them to collapse them.
- Next, move around to her back and **Merge** the large triangle seen in Figure 6.31b. As you can see, the polygons are now flowing nicely down her back, and around her side, but we still have more triangles to remove.
- Now move around to her side, so you can see the remaining triangles (Figure 6.32a).
- Create a **Cut** above and below the two connected triangles, and to the side (Figure 6.32b).
- **Delete** the crossing edges to give you the quad seen in Figure 6.32c.
- This now leaves us with two more triangles. To remove these, select the edges shown in Figure 6.32d and **Merge** them.
- The hip will now look like Figure 6.33a, and have an ugly crease. Soften this with the **Smooth** tool to give you a softer hip (6.33b).

Creating this cut and altering the topology has given us a much better flow of geometry. Now the polygons follow the natural muscles of the back, and from here, we can work on her shoulder blades, upper torso muscles, and her shoulder.

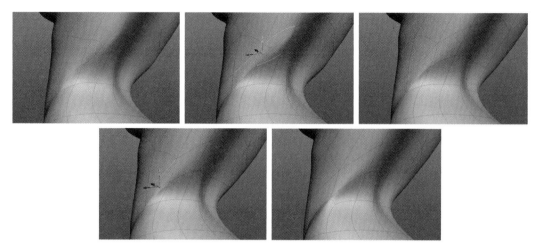

FIG. 6.32 Clean the unwanted triangles from her side.

FIG. 6.33 Soften the crease on the hip.

In the next section, we will add more geometry into her back, which will later allow us to define her spine, and continue the earlier cut we created on her rear shoulder.

- Select the four horizontal edges moving up the center of the model. Follow this selection to also add the edges leading to the open edge on the shoulder. These edges are highlighted in Figure 6.34a.
- **Cut** these edges by pressing **X** (Figure 6.34b).

We now have three triangles to remove. We can adopt a similar process to how we fixed her side, turning the two connected triangles into a quad.

- Create the three **Cuts** shown in Figure 6.34c—one on either side of the triangles and another connecting the open edges near the shoulder.
- Now **Delete** the crossing edges, and **Merge** the remaining triangle above them, giving you something similar to Figure 6.34d.

FIG. 6.34 Create a new cut running up her spine, toward her shoulder.

FIG. 6.35 Split the geometry on her shoulder to reroute the edge loop.

This gives us some more geometry to play with, and fixes the n-gon on the shoulder. However, now we have an unwanted bend in the polygons' natural flow, directing them back to the armpit when we need them to move up toward the shoulders.

- Following Figure 6.35, select the four edges on the back of her shoulder, and the two next to them.
- **Cut** these edges to give us the two new vertical edge loops seen in Figure 6.35c.

145

- Create two more **Cuts** next, connecting the previous cuts with the vertices below them (Figure 6.35d).
- This leaves us with one more triangle. To remove it, select the four edges to its side and hold **B** to **Bevel** them.
- Remember to delete any new, unwanted edges created by the bevel so your back's topology is clean (Figure 6.35f).

Let's focus on her upper shoulders next. In Figure 6.36a, we can see an n-gon on the back of her shoulder that needs to be addressed .

- Select the edge opposite the n-gon, and the ring of edges flowing to the spine (Figure 6.36b).
- **Cut** these (Figure 6.36c) and merge the lower edge of the triangle toward the end of the cut (Figure 6.36d).
- Now create another **Cut**, this time across the n-gon on the shoulder, dividing it and making two quads (Figure 6.36e).

One final thing to do before we move on is to change the topology slightly, and reroute the direction of the polygons.

- Cut the polygon shown in Figure 6.36e, select the edge you just made, and **Merge** it.

FIG. 6.36 Create a new cut, and adjust the topology to help remove the n-gon on the shoulder.

- Doing this will alter the direction of the edge ring, directing it back toward the shoulder. We do this to help define the top of the shoulder blades, and the trapezium muscle.
- Move to the upper shoulder, close to the base of her neck, and you will see another n-gon (Figure 6.37a).
- Drawing freely this time, create the cut shown in Figure 6.37b. Notice that the first and third cuts go across the edges, and do not join existing vertices.
- Select the edges highlighted in Figure 6.37c and **Merge** them.
- This should leave you with four neat triangles. Select the center edges (Figure 6.37e) and **Delete** them to return them to quads.

Now, take a break from cutting and merging, and adjust the overall shape of her back, using the new geometry to help define the shoulder blades and spine.

Looking at Figure 6.38, we can see her back is starting to take shape. The detail we are adding gives it much more appeal.

Don't spend too long on this, as there is still work to do on her back.

Move around so you are looking at the model's back more or less straight on. From this angle, we can see she needs more definition in her spine and shoulders.

First, let's work on the topology.

- Create a **Cut** running the length of her spine (Figure 6.39b). Do this by selecting the horizontal edges and pressing **X**.
- We now need to reroute the middle edge ring so it doesn't flow to the base of the spine, so **Cut** the polygons seen in Figure 6.39c.

FIG. 6.37 Create a new cut to remove the n-gon on the shoulder.

FIG. 6.38 Adjust the new geometry to help define the shoulder blade and spine.

FIG. 6.39 Add some more cuts to help define the spine.

- Once **Cut**, select the new edges and **Merge** them. Merging these quads now forces the geometry to follow the edge ring before it and run around the side of the torso.

Now is a good time to revisit the shoulders and the base of her neck. The topology in this area isn't great, and we need to add some more detail. If we do not get the topology right, she will look odd, and will not deform, (bend and stretch) correctly when she is posed or eventually animated.

(Tip: Do not worry if your model is not perfect the first time you build it. Very few people, if any, can create a fully detailed model in one pass, without any revisions. It is only natural to come back to an area and see an obvious issue you never noticed before.)

- Move back to the upper shoulder area, so you are looking at it as in Figure 6.40a.
- Select the edges as shown, moving from the clavicle back to the shoulder blade, and **Cut** them (Figure 6.40b).

FIG. 6.40 Create more cuts over the shoulder to clean the topology.

- That's the first cut; now we need a second cut. Select a new set of edges now running over and then down the back of her shoulder (Figure 6.40c), and **Cut** them (Figure 6.40d).
- What you should have now are two joined triangles (Figure 6.40d). Create a **Cut** on each side of these (Figure 6.40e), and then **Delete** the edges forming the cross.

This gives us a cleaner shoulder area with more geometry to work with. Let's now add an extra cut around the armpit area, again giving us more geometry to work with as we reshape her.

- The best way to do this is to select an entire ring of edges around her arm (Figure 6.41).
- Once selected, simply **Cut** them, making sure to check the new cut for triangles that can be **Merged** to remove them.

Adding all this extra geometry around the shoulder blade has left us with two large n-gons (Figure 6.42a). To remove them we will adjust the topology, bending the flow of the polygons to form a new edge ring.

- Start by creating two vertical **Cuts** across each n-gon.

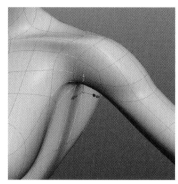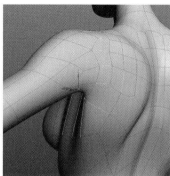

FIG. 6.41 Create an extra edge loop around the shoulder.

- Next, **Cut** these horizontally, so you end up with the area looking like that in Figure 6.42b.
- Next, **Merge** the lower vertex on the right, to the one on its right. This creates the first bend (Figure 6.42c).
- Now create a **Cut** across the n-gon on the left (Figure 6.42d).
- **Merging** this new edge will form the second bend, looping the geometry back up toward the upper shoulder (Figure 6.42d).

At the base of the neck now, just behind the clavicle, we have another n-gon to deal with. Much like the others we have fixed, this will help us to add definition to this area.

- Following Figure 6.43, select the edges moving from the lower neck to the n-gon.
- **Cut** these, and create an extra **Cut** across the n-gon (Figure 6.43b).
- Finally, **Merge** the edge on the new triangle that faces the n-gon, removing both in the process (Figure 6.43c).

We now need to adjust two more areas, mainly around the upper shoulder, to make the model look and move better.

- Looking at your model, or at Figure 6.44, you will see that the geometry moves from the neck and bends to flow down her back.

For this to mimic the actual trapezium muscle, we need the topology to flow from the neck and across the upper shoulder.

- Select the two edges shown in Figure 6.44a and **Merge** them. This will look odd, but doing so gives us the main flow of geometry we need.

- Next, create a **Cut** starting above the upper triangle and ending on the shoulder (Figure 6.45b).
- **Delete** the central edge now, just below your first cut, to turn the two joined triangles into a quad.

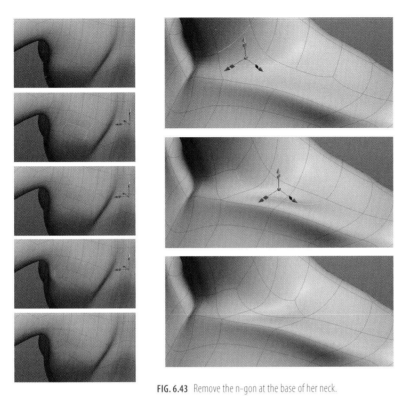

FIG. 6.42 Adjust the topology to reroute the flow of polygons and remove the n-gons.

FIG. 6.43 Remove the n-gon at the base of her neck.

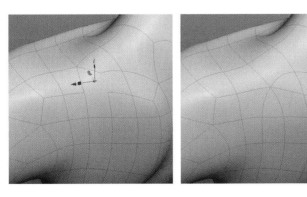

FIG. 6.44 Merging these edges will force the flow of the geometry across the shoulder.

Switch to Figure 6.46, and we will remove the second triangle. For this, we will start below the actual shoulder blade. Editing the topology here will allow us to quickly remove the triangle.

• As shown in Figure 6.46b, create a **Cut** across the lower n-gon, just under the armpit.

151

FIG. 6.45 Add a new cut to help remove the first triangle.

FIG. 6.46 Alter the topology on her back to remove the triangle.

- Continue this **Cut** across the model, spanning the next two quads (Figure 6.46c).
- Now select the horizontal edges moving down the model from the triangle, ending at our last cut (Figure 6.46d).
- **Merge** these to remove the triangle, and clean up the topology.
- Finally, **Delete** the edge between the last two triangles (Figure 6.46e), giving us a much cleaner back (Figure 6.46f).

Move back up to the base of the neck for the final stage. We will now remove the remaining n-gons, and in doing so give this area some more shape and definition.

FIG. 6.47 Create a new cut across the clavicle.

- *Select* the edges moving across the front of her clavicle, before turning the selection toward her back (Figure 6.47b).
- *Cut* these to give you an extra edge loop (Figure 6.47c).
- We now need to clean up some of the redundant edges. Select the ones highlighted in Figure 6.47d, the edges that are mainly part of existing triangles or n-gons.
- *Merging* these will now clean up the topology and remove all but one triangle, and one n-gon at the front (Figure 6.47e).
- Finally, create the *Cut* seen in Figure 6.47f, deleting the edge behind it to change the triangles into a quad.

We now have a much cleaner back and shoulder area, with great topology that follows her body's natural muscles.

Save your scene before we continue.

(You can find the Silo scene created in this section in Chapter06/Files/06_TorsoBack.sib.)

Waist

Let's work our way down the body now and look at the hips and waist area, along with her buttocks.

What we can do initially is use a couple of the cuts we created for the torso, which were left open, and join them to add an extra edge loop around her hips.

- Select the series of edges shown in Figure 6.49. Start on the inner crotch area and work your way around and up her back.
- Press *X* to create a *Cut*.

FIG. 6.48 The finished back.

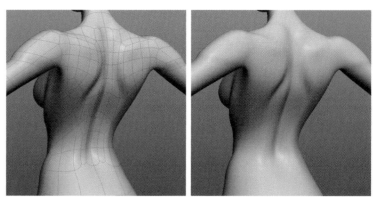

FIG. 6.49 Select and cut the edges running around her hip.

FIG. 6.50 Convert the triangles into a quad.

The new cut should leave you with the two triangles at the front of her hip (Figure 6.50a).

- Create a new **Cut** either side of these (Figure 6.50a).
- Next, **Delete** the four edges that make up the cross (Figure 6.50b).

FIG. 6.51 Connect the edges above the buttocks.

- Now move around to her back and create the **Cut** shown in Figure 6.51a, dividing the n-gon.
- Use this new geometry to work in the basic shape of her buttocks (Figure 6.51b).

We now need a few extra edge loops around her upper thigh, so we will do this with the help of a Bevel. Adding these will help us shape her buttocks and crotch area.

- First, select the edge loop around the upper thigh (Figure 6.52a).
- Press and hold **B** to define your **Bevel** (Figure 6.52b).
- Finally, make sure you **Merge** those new triangles we do not need, removing them from the front and the back of the model (Figures 6.52c and 6.52d).
- Next, select the edge ring that spans the center of her waist and **Cut** it (Figure 6.53).
- Now, use this extra geometry to add more shape to her buttocks.

FIG. 6.52 Add an extra edge loop around the upper thigh.

At the base of her spine are two n-gons, but we can use these to our advantage. Once we convert them into quads, we can use the vertices to help give her some dimples.

- Following Figure 6.54, first create a vertical **Cut** down the n-gon, and then a horizontal **Cut** across the center of the model.
- This has left us with four n-gons, but we can remove them by simply **Merging** the lower vertices to the ones beside them (Figure 6.54c).
- We now have a nice flow of polygons around the base of her spine. Use the new vertices to give her dimples.

Looking at the upper thigh, we can probably use another edge loop. This will help greatly if we decide to add a small crease under each buttock, and around the front of each leg.

As we did before, and as shown in Figure 6.55, create another bevel around the upper thigh area. First, select the edge loop and then press and hold **B** to define the actual bevel.

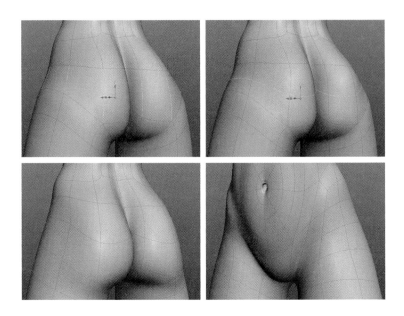

FIG. 6.53 Add an extra loop into the waist to help shape the buttocks.

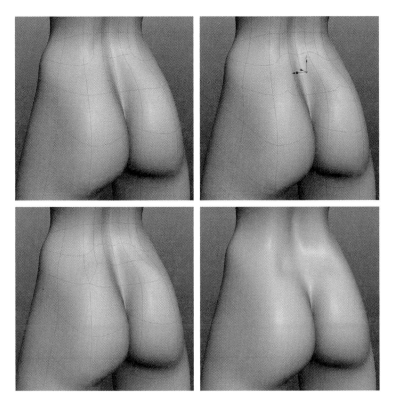

FIG. 6.54 Remove the n-gons at the base of her spine, and add her dimples.

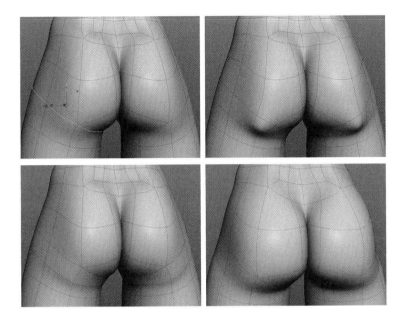

FIG. 6.55 Add another bevel around the upper thigh.

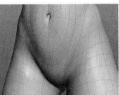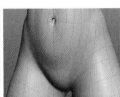

FIG. 6.56 Remove the triangles close to the crotch.

- When finished, be sure to remove the new triangles from the base of each buttock by merging the upper edges (Figure 6.55b).
- Also, move around to the front of the model and remove the triangles near the crotch; again do this by merging the upper edges of the triangles (Figure 6.56).

If we take a step back now and look at the waist from a few different angles, we see that her buttocks are a little square. This is because the model's topology on each cheek is a little sparse.

- Select the edges seen in Figure 6.57a. Start under the model and work your way up, selecting the horizontal edges moving toward the dimples we added earlier.
- *Cut* these and, as shown in Figure 6.57b, create another cut connecting the two opposing vertices.
- This now leaves us with two triangles. Select the horizontal edge loop connected to each triangle, moving around the front of the model, too (Figure 6.57c).

157

FIG. 6.57 Adjust the topology around her buttocks, allowing us to give them more shape.

- *Bevel* this selection, opening up the area (Figure 6.57d).
- This operation will leave you with two unwanted edges (Figure 6.57d). *Delete* these before using the new geometry to add more shape to her buttocks.

When creating the last bevel, we also altered the topology at the front of the model (Figure 6.58a). We have numerous n-gons, most of which cannot be removed by simply deleting edges. First, we need to continue where the cut down her buttock left off.

- Select the edges shown in Figure 6.58a, moving from beneath her crotch and up to her hip.
- *Cut* these (Figure 6.58b), and then select and *Merge* the four edges shown in Figure 6.58c—the ones forming the quad in the center of the four n-gons.
- Now all we need to do is connect the two cuts we created underneath her (Figure 6.59).

We still have a slight issue with her buttocks. In Figure 6.60a, you will see a large quad on the outside of each buttock. This in itself is not a problem; what *is* an issue is the way it points at her leg, forming a pole. When subdivided this will be enhanced and could form an unnatural pinch. Although we cannot remove this pole, we can reposition it, placing it somewhere less noticeable.

- Create a *Cut* across this quad, and the one next to it (Figure 6.60b).
- Select the edge beneath (Figure 6.60c) and press/to spin the selected edge. Continue to press/until the edge spins around, moving the triangle to the opposite side as in Figure 6.60d.
- Now *Merge* the outer edge of the triangle (Figure 6.60e), and you will see that we have rerouted the topology to move the pole.

We could leave her waist here and move on, but one area still needs adjustment. Moving back to the front of the hips, you should see that the flow

FIG. 6.58 Remove the n-gons at the front of the hips.

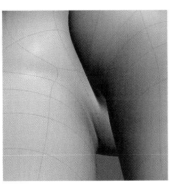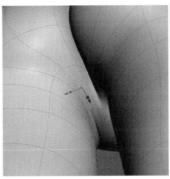

FIG. 6.59 Create a new cut, connecting the two points underneath her.

of the edge loops takes an edge ring up her inner thigh and then across, just beneath her hip. We ideally need this to move over her hip instead.

- First, create a **Cut** up the front of her waist (Figure 6.61b). It needs to follow the natural crease between her thigh and her groin.
- Select the upper and lower edges seen in Figure 6.61c and **Merge** them.
- Now create two **Cuts** on either side of the resulting, joined triangles (Figure 6.61d).
- With those in place, **Delete** the edges forming the cross between them.
- We now have two triangles remaining, but they are offset slightly so we cannot just **Merge** the edges between them. Instead, select the inner edges of each triangle (Figure 6.61f) and **Merge** those instead.
- All you should have left now are two triangles (Figure 6.61g). **Delete** the inner edge and we are done.

159

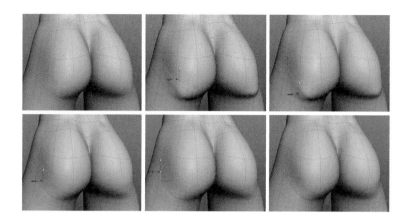

FIG. 6.60 Alter the topology to reposition the pole.

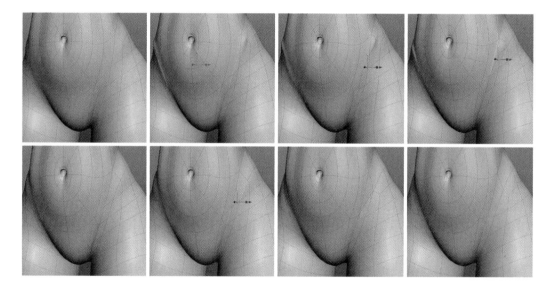

FIG. 6.61 Rework the topology around the hip.

All we have to do now is refer to the reference photos and play around with the shape of her body. Look at the torso as a whole and take your time. You should be getting the hang of Silo's modeling tools by now, so feel free to enhance or optimize any areas you see fit before continuing.

Our resulting torso should look similar to that in Figure 6.62.

Save your scene now before we move on to the next chapter and tackle her limbs.

(You can find the Silo scene created in this section in Chapter06/Files/06_Torso.sib.)

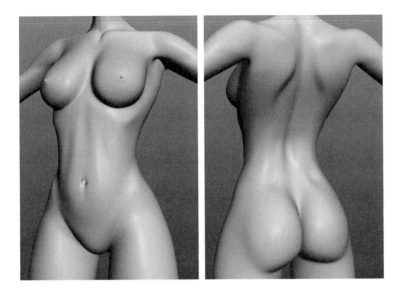

FIG. 6.62 The completed torso.

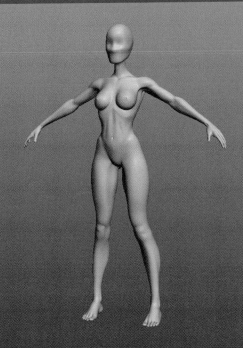

Organic Modeling: Limb Detail

In the last chapter, we tackled our girl's torso and waist area. In this one, we continue to work on the detailed base mesh by adding detail to her limbs, hands, and feet.

(Note: You will find the files used for this section in the downloaded tutorial files inside Chapter 7/Files.)

Legs

When we left our model, we had just finished working on the waist area, so it makes sense for us to continue down the body and work the detail into her legs, and then her feet.

If you look at your reference materials you will see that the muscles at the front of the thigh sweep from the hip, down and across to the inner leg, above the knee. We do not want to model in every muscle, as that would look unnatural, so for now we will add a few extra edge loops to hint at these muscles.

- First, load the scene Chapter07/Files/07_Torso.sib.
- Your model will be brought into the scene at its initial, low-resolution state, so select it and press **C** two times to smooth her out.

3D Modeling in Silo. DOI: 10.1016/B978-0-240-81481-0.00007-8
© 2011 Elsevier Inc. All rights reserved.

- As shown in Figure 7.1, select the edges starting just above the knee and work your way up to the groin.
- Press and hold **B** to create a **Bevel**.
- Next, **Merge** the resulting, unwanted triangles (Figure 7.1c).
- Finally, adjust the area so the muscles can be seen on her inner thigh (Figure 7.1d).
- Next, create a new edge loop around the thigh as shown in Figure 7.2. This will allow us to adjust the thigh further, to give it a much better shape.

Moving on, let's look at her knee. Now, we have very little to work with, so first we need to update the topology.

- First, hover over the front vertical edge and press **Alt + X** three times, creating three Split Loop **Cuts** around the knee area (Figure 7.3b). This gives us eight quads instead of two, which should be a perfect starting point.
- Now we need to isolate the knee a little, and enclose it in its own edge ring. Select the edges around the eight middle quads (Figure 7.3c), and perform a **Bevel** operation (Figure 7.3d).

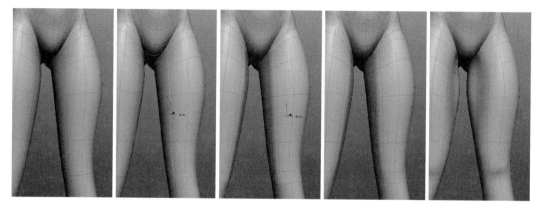

FIG. 7.1 Add in extra edge loops so we can include the thigh muscles.

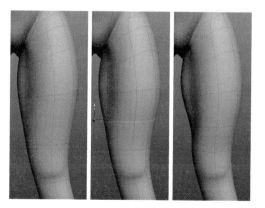

FIG. 7.2 Add an extra edge loop to help define the thigh.

- As always, **Merge** the triangles we do not need. This will give you the knee seen in Figure 7.3e.

Before we adjust the shape of her knee, let's fix the n-gon above the knee. We created this with our first cut when we added detail to the thigh.

- Rotate around to the outer knee and select the four edges just beside the knee (Figure 7.4a).
- Perform a **Bevel** to open up the edges (Figure 7.4b).
- Create a new **Cut**, connecting the upper triangle with the existing edge above the knee, across the n-gon (Figure 7.4c).
- Finally, **Merge** the triangles, removing the upper n-gon and adjusting the flow of the geometry around the knee (Figure 7.4e).

Now that we have the topology we need, we can use it to form the knee for our model. You can see this in Figure 7.5, but feel free to follow your own reference materials if you would like it to look different.

(Note: Remember that once these chapters are completed, your model does not have to be. You can continue to tweak and enhance her as much as you like until you are completely happy. It usually pays to step back from the model and revisit it later.)

Let's turn our attention to the inner knee now. Our initial cut, which helped add detail into her thigh, has not worked as planned. Although it follows the

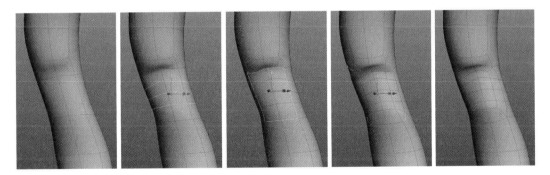

FIG. 7.3 Add in new geometry so we can build her knee.

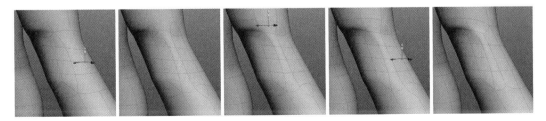

FIG. 7.4 Remove the n-gon above the knee.

muscles, we have ended up with a pole above the knee. It is probably best to remove this, as it will result in an unwanted pinch in the model's surface.

We will continue the horizontal cut above the knee around the leg.

- Following Figure 7.6, **Cut** the two polygons just above, and to the side of, the knee (Figure 7.6b).
- Next, select the vertical edge ring seen in Figure 7.6c, and press **X** to divide it (Figure 7.6d).
- Create two more **Cuts**, connecting the previous cuts with the edge above the knee (Figure 7.6e).
- This leaves two triangles, which can easily be removed by deleting the edge between them.

With the pole removed, we can now adjust the knee further to enhance the shape (Figure 7.7). The adjustment is subtle, but now the knee looks more natural.

Let's continue down to her lower leg and include the shin and calf detail. Again, we are only after subtle shapes here, not dense muscle masses.

What we can do first is continue one of the last cuts we created when removing the pole above the knee. This will give us an extra row of edges to help define the shinbone.

FIG. 7.5 Adjust the model to form the knee shape.

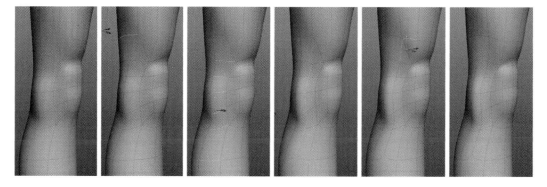

FIG. 7.6 Rework the knee area to remove the pole.

- Start by continuing the **Cut** down the side of the leg (Figure 7.8).
- Next, switch to Figure 7.9 and adjust the shape to enhance the curve of the shinbone.

Moving around to the back of the lower leg, we can add in some detail around her calf muscle. Again, we could go overboard and give her toned muscles, but we do not need them in this model.

- What we need is an edge loop running around the actual muscles, so first select the edges shown in Figure 7.10 running down from the n-gon on the side of her knee, around the back of her leg.
- Press **X** to cut the geometry.

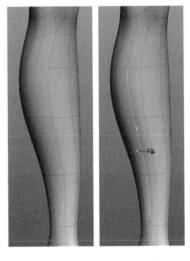

FIG. 7.7 Adjust the shape of the knee.

FIG. 7.8 Continue the cut down the inner shin.

FIG. 7.9 Use the new cut to define the shinbone.

FIG. 7.10 Select the edges around the calf muscle.

- Looking at the outer leg now, create a new **Cut** down the n-gon connecting the two edges (Figure 7.11a).
- Next, **Merge** the triangle just below that cut to remove the n-gon and give us the topology we need (Figure 7.11b).
- Now turn to the inside of her lower leg and select the edges shown in Figure 7.12a, the ones connecting the two n-gons.
- **Merge** these to reroute the flow of the edge loops and give us the topology needed to define the calf muscle (Figure 7.12b).

FIG. 7.11 Cut, and clean up the calf topology.

FIG. 7.12 Merge the unwanted edges to define the calf area.

One final area to adjust on the leg: behind her knee. What we need to add in here are the two main tendons running down behind the knee.

- Move around to the back of the knee and select the six quads seen in Figure 7.13.
- Press **Z** to perform an **Extrude** (Figure 7.13c).
- With the polygons still selected, apply a **Smooth** on them, to relax the model (Figure 7.13d).

The main topology is now in place, but before we adjust it we need to take care of the n-gon that still exists above the back of the knee.

- The quickest way to remove this is to select the edges running up the inner thigh (Figure 7.14b).
- Perform a **Bevel** on these (Figure 7.14c).
- Next, **Merge** the two edges shown in Figure 7.14d. This will remove the n-gon and give us a nice edge loop to work with.

With the main topology in place, we can now reshape the back of her knee, and revisit the legs as a whole.

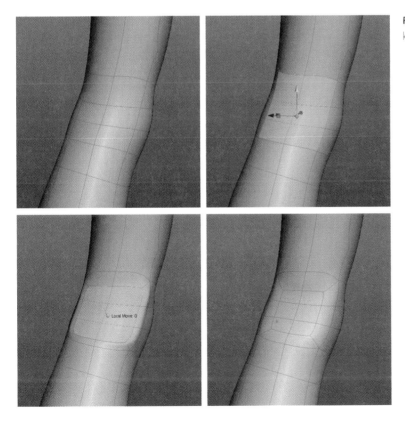

FIG. 7.13 Extrude the back of the knee.

169

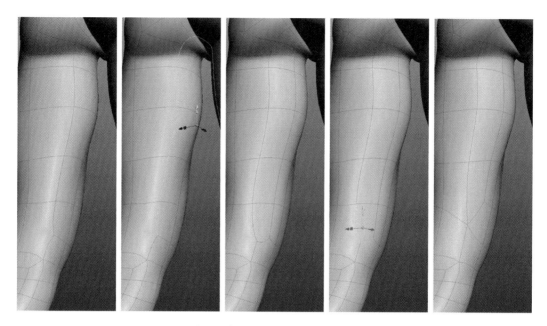

FIG. 7.14 Use a bevel to help remove the n-gon behind the knee.

FIG. 7.15 The completed legs.

Your legs should now resemble those in Figure 7.15, but feel free to add in any more details you might need.

There is one area we missed—the ankles. We will add in her foot detail first, as this might alter the topology around the ankle area.

Feet

Time to tackle the first of the extremities, her feet. Along with the hands and the head, these areas hold the most detail, so we will be adding in lots of extra geometry as we work.

It is important to keep in mind, as with the rest of the model, that we will not be sticking rigidly to quads. Adding in lots of detail will mean having to use n-gons in the model, which for this base mesh is fine. It is ideal, however, to keep triangles to a minimum.

(Note: The steps in this section might get a little complicated, and as a result, your model might not turn out the same. Don't let this worry you though; as long as the final topology is similar, it doesn't matter how you get there.)

Let's start by working in some extra geometry into her toes.

- Our first step is to create a **Cut** down the top of each toe, around the front and back underneath (Figure 7.16).

Next, we need to separate each toe a little more. There currently is not a gap between the toes as they join the foot, which could cause problems when the foot is animated.

- Following Figure 7.17, select the edges between each toe, making sure to select the upper and lower edges on the foot.
- **Bevel** these edges to create an extra polygon separating each toe (Figure 7.17b).
- The bevel has left us with a few problems, including a series of n-gons at the start of each toe. Select these edges now (Figure 7.17c) and **Merge** them.
- Next, move to the upper foot and remove the triangles shown in Figure 7.18a. Simply select the outer edge and delete it.

Now we are going to add in some more geometry that we can later use to shape the front of the foot.

FIG. 7.16 Cut around the front of each toe.

171

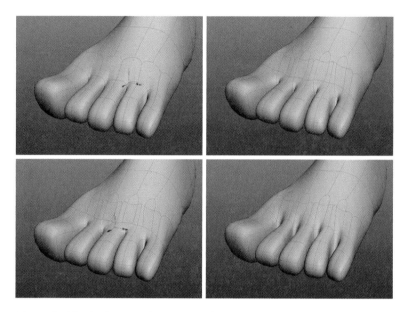

FIG. 7.17 Bevel the edges between each toe to separate them.

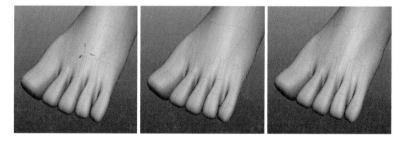

FIG. 7.18 Remove the triangles and create extra cuts over the top of the foot.

- We need to add an extra **Cut** between each toe, one that also moves over the top of the foot (Figure 7.18c).

Time to clean up some of the topology (Figure 7.19).

- Start by creating a **Cut** across the foot, just behind the toes. This also needs to go under the foot.
- With that in place, we can next select and **Merge** the edges (Figure 7.19b) running behind each toe, on either side of the central split.
- This will leave you with four triangles on the top of the foot. **Merge** these to remove them (Figure 7.19d).

We now have a cleaner upper foot, but the n-gons are too close to the toes and could cause model artifacts.

FIG. 7.19 Clean up the topology on the top of the foot.

- Create a series of **Cuts** running back from each toe to the next quad (Figure 7.19f) to move the n-gon back.
- Finally, we can remove the triangles between each toe. Select the central edges and delete them, turning the triangles into quads (Figure 7.19g).

The top of the foot now looks much cleaner, and we are starting to achieve better topology, which will allow us to add detail into the foot.

Next, turn the foot over and look underneath—not pretty, is it? Let's clean this up next.

- Start by making sure you have edges running back from the toes (Figure 7.20a). Just **Cut** across the n-gons to achieve this.
- We have an n-gon on the outer foot; this was probably created when we added the cut across the upper foot. Continue this **Cut** across, up to the base of the big toe (Figure 7.20b).
- Looking at the toes now, we can see the n-gons created by the earlier bevel. Select the edges shown in Figure 7.20c and **Merge** them, giving you something like that in Figure 7.20d.
- We still have some odd geometry between the first two toes, most likely a triangle or two. Before we can safely remove these, we need to create a few more cuts, moving back from the toes and removing a few n-gons as we go (Figure 7.20e).

FIG. 7.20 Clean up the topology beneath the foot.

- With these cuts in place, you can now remove the triangles between the big toe, and the toe next to it. Simply **Merge** the opposite vertices to close the quad and fix the topology.
- Just as we did with the upper foot, we are now going to **Merge** the edges running back from each toe, giving us the triangles between the toes. Select the edges shown in Figure 7.20f and **Merge** them.
- Finally, we can turn the triangles between the toes into quads, but we cannot simply delete the central edge. If we do that, the topology between the toes will be wrong. Instead, create four **Cuts** behind each toe (Figure 7.20h).

Moving on, let's look at the topology behind the big toe. We need to alter the flow of the polygons so they move backward from the toe, and not off to the side as they currently do.

- Start by creating two **Cuts** running back from the toe (Figure 7.21a).
- Next, create another **Cut**, this time going across the base of the toe (Figure 7.21b).
- With that cut in place, you can now delete the edges in Figure 7.21c, turning the four triangles into two quads.
- We still have a triangle left on the big toe, so create another set of **Cuts** beside it and around the side of the toe (Figure 7.21d). Delete the dividing edge to turn the triangles into a quad.

FIG. 7.21 Clean up the topology on the ball of the foot.

Your foot's topology should now be cleaner. We are looking for nice, clean grid style topology, which will ultimately be easier to adjust and work with.

- Next, select the two edges highlighted in Figure 7.21e and **Merge** them.
- This will give you a triangle between the toes again, but we can create a **Cut** from the triangle, back across the two next quads, to remove it (Figure 7.21f).

We are now left with a large n-gon at the ball of the foot, but because we have reworked the topology around it, we can easily divide it with a few cuts.

- First, **Cut** the two quads behind the n-gon (Figure 7.22a).
- Next, divide the n-gon with two more **Cuts** across each other, forming a cross (Figure 7.22b).
- Finally, create two more **Cuts** moving back from the toes (Figure 7.22c).

The underside of her foot is cleaned up, and looks much better.

FIG. 7.22 Divide the large n-gon on the ball of the foot.

FIG. 7.23 Create a new cut around the front of the foot.

We have added geometry across each toe, so next we need to add it around them, and add in extra edge loops for the knuckles.

Luckily, this is a much simpler task to complete.

- First, create a **Cut** around the toes, taking it half way back on the foot (Figure 7.23).
- Next, select the edge loop around the base, and the middle of each toe (Figure 7.24).
- Apply a **Bevel** to change these two edge loops into four.
- Finally, the bevel will give you a series of triangles around the base of each toe. **Merge** these now to remove them (Figure 7.24c).

That's the main topology for the toes and the front of the foot. We still have lots to do, but take a break and rework the overall shape of the foot until you have something like Figure 7.25.

You could leave the toes as they are, but we will continue and build in the actual toenails. Before we do that, though, we need to fix a few small issues around the front of the foot.

- First, on the outer big toe we have an n-gon toward the top where the toe meets the foot. To remove this, select the two edges below it and **Merge** them as shown in Figure 7.26.
- You will now be left with a triangle just under the toe. To remove this, follow Figure 7.27 by first selecting the two edges highlighted in the first panel. These are just behind the base of the toe.
- **Merge** these and then select the edges seen in Figure 7.27c.
- **Delete** these to clean up the area (Figure 7.27d).

FIG. 7.24 Add extra edge loops around each toe.

FIG. 7.25 Take a break and rework the shape of the front of the foot.

Now move over to the pinkie toe. We have a similar n-gon here, which we will remove next.

- First, select the edges shown in Figure 7.28a, just below the n-gon, and **Merge** them.
- Next, select the edge forming the triangle in Figure 7.28b and **Delete** it.

The front of the foot is much cleaner now, with good topology. Next, we will work in some more detail by adding in her toenails.

- Following Figure 7.29, first select the two quads at the front of the big toe, the ones covering the general nail area.
- Press **Z** to **Extrude** these, and then press it again giving you two extrudes.

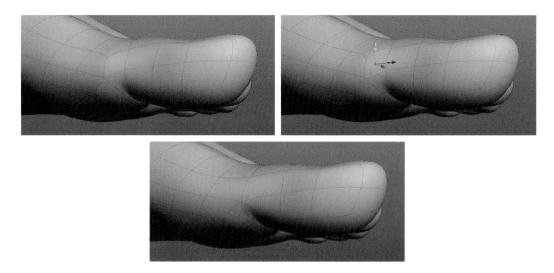

FIG. 7.26 Merge the edges on the outer big toe.

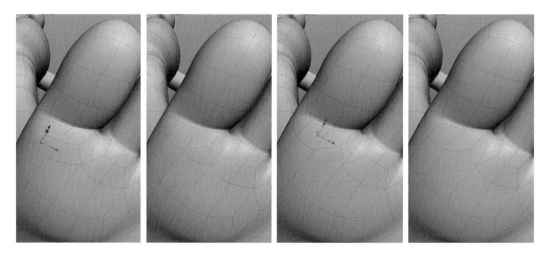

FIG. 7.27 Adjust the edges beneath the foot to remove the triangles.

- As you can see from Figure 7.29d, this has now given us plenty of geometry for the toenail, so now work in the toenail shape and the creases around it (Figure 7.29e).

We can also add some extra geometry around the toe's knuckle, allowing us to build some wrinkles into her toe.

- This can be achieved by **Extruding** the polygons around the knuckle area and tweaking the vertices to get the desired shape (Figure 7.30).

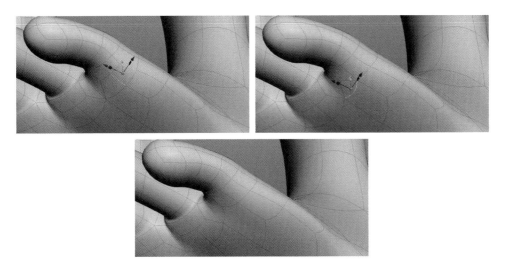

FIG. 7.28 Clean up the n-gon on the outside of the foot.

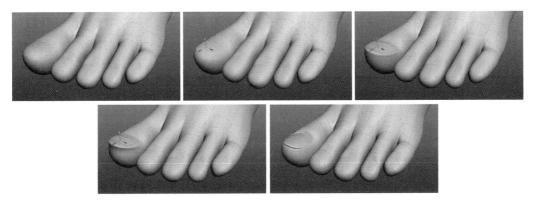

FIG. 7.29 Build in the big toenail.

Apply these steps to the other four toes and work on the overall shape of them before we move on to the back of the foot (Figure 7.31).

At either side of the foot, we have two large, obvious n-gons. We will use these to help define the back of the foot and the ankles.

- First, create the **Cut** seen in Figure 7.32, splitting the n-gon and then bending the cut up around the back of the leg.
- Be sure to **Merge** the outer edge of the triangle, leaving you with just quads (Figure 7.32c).
- Next, repeat this process on the inside of the foot (Figure 7.33).

FIG. 7.30 Add in some extra detail on the toe's knuckle.

FIG. 7.31 Repeat the process on the remaining toes.

FIG. 7.32 Create a cut along the side of the foot, and up the back of the leg.

We now need to add an extra edge loop around the base of the foot to add mass and weight to the overall shape.

- Following Figure 7.34, you should have an n-gon just behind the pinkie toe. Start the **Cut** there and work your way around the foot to the inside of the heel.

FIG. 7.33 Create a similar cut on the inside of the foot.

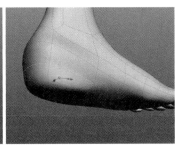

FIG. 7.34 Create a new edge loop around the base of the foot.

We now have a nasty pole on the arch of the foot. You could probably adjust the shape to reduce the pinching, but while we are here let's remove it completely.

- Following Figure 7.35, first create a **Cut** across the n-gon behind the big toe. Continue this back as shown, joining it with the edge loop on the heel.
- Next, create a second **Cut**, this time running up the foot from the new triangle (Figure 7.35c).
- This gives us three triangles to remove. Simply **Merge** the upper triangle's outer edge, and delete the edge between the lower triangles (Figure 7.35d).
- Now the topology is much better, so alter the general shape to smooth out the area.

Let's focus on the ankle now to add in an extra edge loop around the base of the leg.

- Select the edges shown in Figure 7.36a and **Bevel** them (Figure 7.36b).
- **Merge** the lower edges of the new triangles to clean up the bevel (Figure 7.36c).

Now we can add in the actual ankle detail. This is quite easy, as you can see in Figures 7.37 and 7.38.

FIG. 7.35 Create two cuts to remove the pole on the foot's arch.

FIG. 7.36 Add a new edge loop around the base of the leg.

- Simply **Extrude** the three polygons in the ankle area, pulling out the ankle shape (Figure 7.37).
- Repeat this for the inner ankle, extruding the ankle out of the leg (Figure 7.38).

(Tip: Remember, your inner ankle is slightly higher than the outer one.)

- Finally, delete the two upper edges from the extrude (Figure 7.39). This will soften the upper parts of the ankle.

FIG. 7.37 Pull the outer ankle out of the leg.

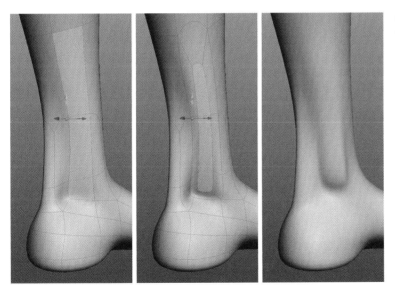

FIG. 7.38 Pull the inner ankle out of the leg.

The foot is now complete. As always, take some time to examine the shape, and spend as much time as you need to get the foot looking right.

You should now be quite confident with Silo, so try to add in some subtle details yourself. As you can see from Figure 7.40, we have created a few

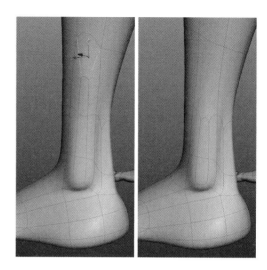

FIG. 7.39 Delete the upper edges from the extrude.

FIG. 7.40 Continue to work on the legs as a whole to add in any other details you might want.

wrinkles on the back of her foot, and adjusted the topology on the back of the knee slightly.

(Note: If, while we are working you fancy a break from her foot, why not look over the rest of the body for any more areas to tweak or add detail to. This is, after all, your model.)

Save your work before we move on to the arms.

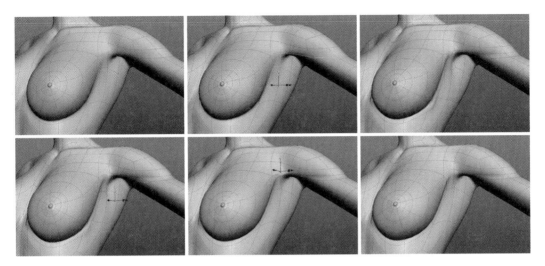

FIG. 7.41 Adjust the geometry around the shoulder and under her breast.

(You can find the Silo scene created in this section in Chapter07/Files/07_ Legs.sib.)

Arms

On to the next limbs. Let's look at turning the bland cylinders coming out of the torso into actual arms, and what better place to start than at the shoulders?

Currently, we have a decent shoulder setup, but it could use a few improvements to make it look even better. The Pectoralis Major muscle should run from the breast and up onto the shoulder itself; we have this hinted at, but it could use some enhancement.

- Turn to Figure 7.41. We first need to select the edges running from around the deltoid muscle, across and under her breast (Figure 7.41b).
- **Bevel** these to add in more geometry, and create a slight crease (Figure 7.41c).
- As usual, the bevel will create a few triangles, and added in geometry where we do not need it. Select the edges shown in Figure 7.41d and **Merge** them to remove the geometry we do not need.
- This leaves us with two triangles in front of the armpit. Create the **Cut** shown in Figure 7.41e and **Delete** the central edges; this should give you the shoulder in Figure 7.41f.

We now have a large polygon on the outer breast, with a pole at the top. Although it is not obvious now, this could cause an artifact later and detract from the smooth muscle we need.

FIG. 7.42 Cut Around the side of the body and up onto her breast.

FIG. 7.43 Create an extra cut to move the triangle on her chest.

- First, create a **Cut** across the side of the body and up onto her chest (Figure 7.42a).
- This leaves you with an n-gon on the upper breast. Create a second **Cut**, dividing the n-gon and reforming the edge loop around the chest (Figure 7.42b).
- Move around to the front of the body and create another **Cut**, this time cutting the quad above the last cut you created (Figure 7.43a).
- Now **Delete** the edge below your last cut, turning the triangles into a quad and leaving you with one remaining triangle (Figure 7.43b).
- We can now continue our initial **Cut** that ran under the breast, up over her chest and around to meet the remaining triangle (Figure 7.44a).
- **Delete** the dividing edge to give you a nice clean quad (Figure 7.44b).
- As a final cleanup, **Merge** the edges seen n Figure 7.44c, on the inner chest.

If we move to the armpit now, we can start to add in some extra detail, while cleaning up some of the n-gons in this area.

FIG. 7.44 Continue your first cut around her chest.

FIG. 7.45 Add two new cuts in the armpit area.

- First, create the **Cuts** seen in Figure 7.45a, continuing the edge loops onto the arm.
- **Merge** the outer edge on the triangle around the start of the cut to clean the topology (Figure 7.45b).
- Turn to the back of the shoulder. As you can see from Figure 7.46a, we have a few n-gons here to clean up.
- Start by **Cutting** the lower n-gon on her body, below the shoulder (Figure 7.46b).
- Next, select and **Merge** the edges connecting the two remaining n-gons (Figure 7.46c).

The topology under the arm is still not right. The way the polygons flow across, and then up toward the armpit doesn't seem natural. Moreover,

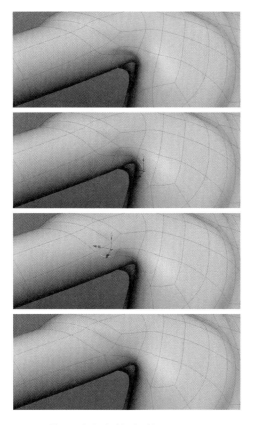

FIG. 7.46 Clean up the back of the shoulder.

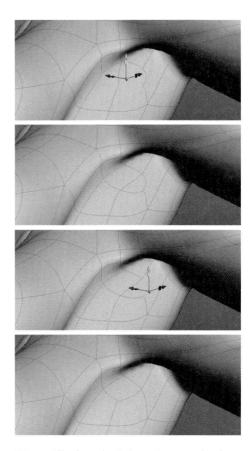

FIG. 7.47 Adjust the topology in the armpit to remove the pole.

we have a polygon that needs to be removed; otherwise, we will end up with a slight pinch in front of her shoulder.

Let's see if we can fix these before we move on.

- Following Figure 7.47, first create the series of **Cuts** shown. This will allow us to reroute the flow of polygons and remove the pole.
- **Delete** the lower edge from the pole to smooth out the topology. Your armpit should now resemble that in Figure 7.47b.
- Now all we need to do is **Merge** the outer edge of the remaining triangle and we are done (Figure 7.47c).

That's the topology sorted for the shoulder and armpit area. Using your reference, play around with the shape until you are happy to move on.

Figure 7.48 shows the current torso.

Now let's look at the arm. We do not want her to be overly muscular, but her arm desperately needs more shape and definition.

FIG. 7.48 The Current torso and shoulder.

FIG. 7.49 Add three edge loops into the upper arm.

- Let's begin by adding a few more edge loops around the upper arm. Three should be enough for now (Figure 7.49).

We now need to adjust the flow of the edge loops around the middle of her arm to help define the elbow and lower arm muscles.

- Select the three horizontal edges at the back of her arm, just above the middle edge loop. When just above the elbow, turn the selection and select the two upper edges (Figure 7.50a).
- Select the same edges on the underside of the arm.
- Now **Bevel** away, and remember to remove the new triangles so your topology resembles that in Figure 7.50c. Leave the triangles at the front of the arm, around the inner elbow area for now.

Now turn to the front of the arm. We need to adjust the topology on the inner elbow and lower arm.

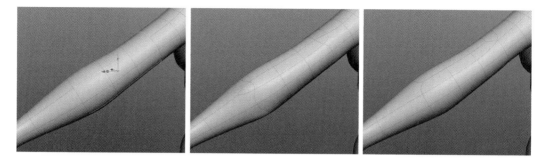

FIG. 7.50 Adjust the topology around the middle of the arm so we can add in arm muscle detail.

FIG. 7.51 Adjust the front of the lower arm.

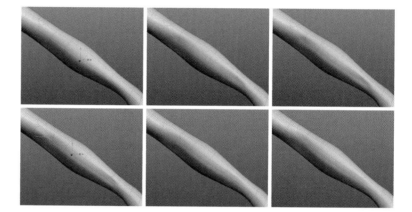

- Following Figure 7.51, first select the three edges at the front of the forearm.
- **Bevel** these to give us some new geometry (Figure 7.51b).
- Next, create a new **Cut**, this time running down the center of the new bevel.
- Now move to the inner elbow and create the **Cuts** shown in Figure 7.51d, splitting the n-gons and connecting this bevel with the one we created on the back of the arm.
- Delete the unwanted edges next, leaving your topology like that in Figure 7.51e.
- Finally, split the n-gons at the inner elbow, giving you something similar to that in Figure 7.51f.
- Switch to the back of the arm now and create the **Cuts** shown in Figure 7.52. These will allow us to add the elbow detail into the model.
- Also, move around the lower arm, dividing any remaining n-gons as shown in Figure 7.52b.

Because the model's hand is pointing down, we now need a slight twist in the forearm because the muscles from the elbow to the wrist have twisted slightly. To achieve this, we need to separate the hands.

- To do this, simply **Delete** the faces above the wrist (Figure 7.53).

Divide the back of the arm now to prepare it for the elbow.

FIG. 7.53 Detach the hand so we can add in a slight forearm twist.

FIG. 7.54 The Current Arm Model.

- Now pull the remaining edges of the arm down toward the hand, and rotate them forward, giving us the forearm twist (Figure 7.53c).

Take a breather now and look at the arm as a whole; be sure to reshape and tweak any areas you feel you need to.

Moving on, we could use some more geometry on the forearm, to smooth out the overall shape and allow us detail in the elbow.

- To do this we will create two **Bevels**, the first around the middle of the arm, (Figure 7.55) and the second lower down the arm (Figure 7.56).

Finally, we are going to add in the actual elbow. You can follow these steps in Figure 7.57.

- To do this, first **Extrude** the four quads in the elbow area.
- Apply a **Smooth**, to soften the area.
- Finally, **Delete** the lower edges highlighted in Figure 7.57d.

FIG. 7.55 Bevel the middle of her arm to add an extra edge loop.

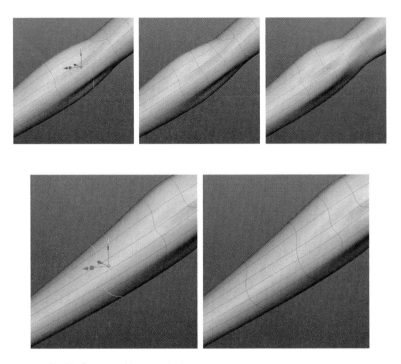

FIG. 7.56 Bevel the forearm to add an extra edge loop.

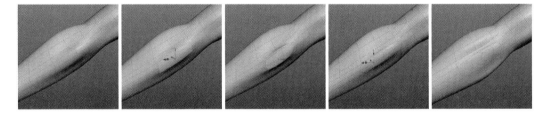

FIG. 7.57 Build the elbow into the model.

The main arm is now complete; with a little more TLC, it should look like the one in Figure 7.58.

Don't forget to save your work before we move on to the hand.

(You can find the Silo scene created in this section in Chapter06/Files/06_Arm.sib.)

Hands

For the hands, we are going to try a slightly different approach. They are low resolution now, so, just like the feet, we need to add in some geometry. This

FIG. 7.58 The finished arm.

FIG. 7.59 Separate the hand from the rest of the model.

time, though, instead of adding each edge loop we will add the geometry globally.

First, we need to separate the hands; we do this so we do not accidentally increase the geometry on the rest of the body.

• Select all the faces of the hand.

(Tip: A quick way to select the components on a whole object is to select a single face and then press **Ctrl + 1**. This will select the entire shell.)

• Next, right click and select **Break** from the context menu (Figure 7.59). This will separate the selected faces from the main model, making the hands a unique object.

Now the hand is a separate entity, so we can begin work.

As you can see from Figure 7.60a, the current hand is very boxy. For us to see it in a smoother state, we need to apply a subdivision. However, this does not give us more geometry to play with. Silo allows us to "bake" the current subdivision onto the model, leaving the geometry intact and editable.

• Select the hand model and press **C** to subdivide it once (Figure 7.60b).
• Now, with the hand selected, go to **Subdivision > Refine Control Mesh** (Figure 7.61).

As you can see from Figure 7.60c, this retains the subdivision, but bakes the geometry, allowing you to then edit it afterward. So now, we have a much better starting position for the hand model.

• Now that we have the model subdivided, let's reshape it slightly to take full advantage of the new topology (Figure 7.60d).

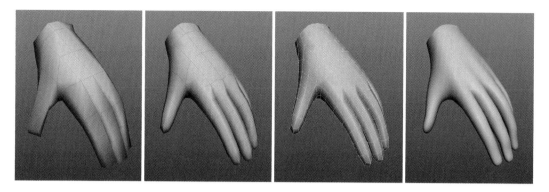

FIG. 7.60 Bake the subdivision into the hand.

FIG. 7.61 Use Refine Control Mesh to bake the current subdivision.

Let's start working some details into the fingers. The following steps will be applied to a single finger as an example, but can easily be transferred and repeated for the other digits.

- Following Figure 7.62, first **Bevel** the edge loops around the knuckles.
- Next, create a new edge loop between each bevel, giving us three edge loops around each knuckle (Figure 7.62d).
- We can now add more definition into the knuckles, including the creases beneath each finger.

Now focus on the finger's tip as we add in the fingernail. For this, we will adopt the same process we followed for the toenails (you can also follow this in Figure 7.63).

- First, select the faces that lay in the fingernail area.
- Press **Z** twice to perform two **Extrude** operations.
- Now simply edit the new geometry to create the fingernail shape.
- Now that we have the basic detail in one finger, continue and add this into the rest. Your hand should look like that in Figure 7.64 when complete.

FIG. 7.62 Bevel the edge loops around each knuckle.

FIG. 7.63 Extrude the fingernail polygons to add more detail.

FIG. 7.64 Apply the same process to the other fingers and thumb.

Moving on, we will build in more detail to the back of the hand and the palm, but before we do, it might be a good idea to reattach the hand to the arm. This way, we can keep a close eye on how the topology is shaping up around the wrist.

- First, select the hand, and holding **Shift** select the main body, too.
- Right click and select **Combine Objects** from the context menu.

The hands and body are now a single object again, so let's fix the hole in the wrist.

- As shown in Figure 7.65, select the edges around the wrist on both the hand and the arm.
- Press **Shift + B** to create a **Bridge** between the two objects.
- If the number of edges on the hand and arm were different, you might end up with a hole in the wrist, like the one in Figure 7.66. If so, simply use the **Fill tool** to fill the hole. We can rework the topology later once we have a better idea of how the hand is working out.

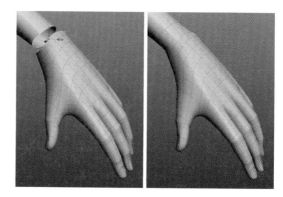

FIG. 7.65 Reattach the hand to the arm and create a bride to fill the gap.

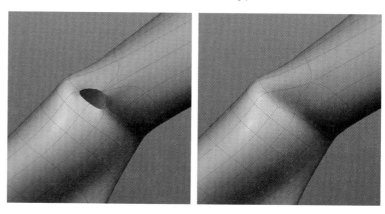

FIG. 7.66 Fill any holes remaining around the wrist.

We are going to leave the fingers now and move on to the knuckle area. We want to separate each finger, so there is room for them to bend, and create a crease on the upper hand that will help us to add in the tendons.

- First, select the edges around the base of each finger, and two running back onto the hand (Figure 7.67b). Remember to also select the edges under the hand.
- Next, **Bevel** these edges (Figure 7.67c) and then remove the unwanted triangles that were created (Figure 7.67d).

Take the opportunity now to tweak the shape of the hand. You should not need to do much work to get it looking like the hand in Figure 7.68.

We want the tendons on the upper hand to run back to the arm, almost to a point beyond the wrist. The problem is the topology behind the index finger prevents us from doing that.

- Following Figure 7.69, create the series of **Cuts** shown in Figure 7.69b. Here we are trying to alter the flow of the edges so they move more toward the wrist.

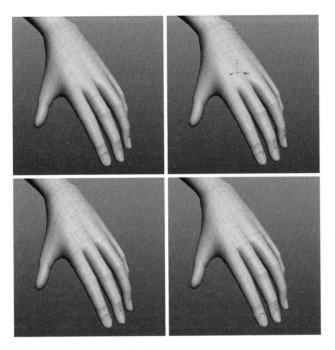

FIG. 7.67 Bevel the edges around the base of each finger.

FIG. 7.68 The tweaked hand.

- Now **Delete** the edges creating the unwanted triangles. The back of the hand should look like the one in Figure 7.69c when you are done.

Now let's enhance the knuckles and tendons a little more.

- As illustrated in Figure 7.70a, create two **Cuts** either side of the middle edge loop, running back from each finger. Make sure you cut the area behind the index finger slightly longer, as shown.

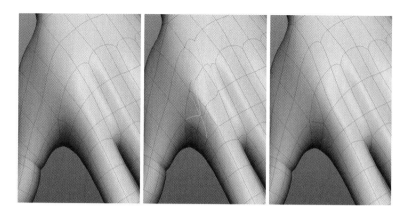

FIG. 7.69 Adjust the topology on the top of the hand.

FIG. 7.70 Create a series of cuts on the upper hand.

- Next, continue these cuts, connecting them with the base of each finger as shown in Figure 7.70b.
- Finally, cut in front of each knuckle as shown. This will turn the triangles into quads.
- With the extra geometry in place you can easily reshape the top of the hand to enhance the knuckles (Figure 7.71).

Time for some topology tidying. If we look at the back of the hand, we can optimize it slightly, without affecting the overall shape.

- Select the edges running back from between each finger (Figure 7.72a).
- **Merge** these edges.
- Now select the triangle near the thumb and **Delete** it (Figure 7.72c).

We are going to move on to the underneath of the hand now. First, we need to create a cut that will help us define the base of the thumb.

- Starting from the knuckles, **Cut** the hand as shown in Figure 7.73, working your way around the base of the thumb.

With that cut in place, we are free to adjust the palm's topology to take advantage of the new edge loop.

- Select the edges shown in Figure 7.74a and **Merge** them.
- Next, create the **Cuts** shown in Figure 7.74b.

FIG. 7.71 With the topology updated, reshape the knuckles to suit.

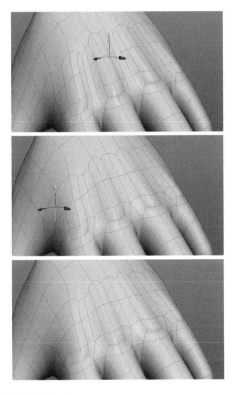

FIG. 7.72 Optimize the back of the hand.

- Create a second **Cut** now, cutting both the triangles seen in Figure 7.74c.
- **Merge** this cut to convert the triangles into three quads.

We now have another pole just down from the thumb; again, this will cause a pinch in this area if we do not remove it.

- Following Figure 7.75, create a new **Cut** across the polygons near the pole.
- **Merge** the first cut you created (Figure 7.75c).
- Next, **Delete** the edge connecting the two triangles.

199

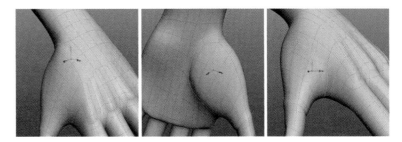

FIG. 7.73 Cut the hand around the base of the thumb.

FIG. 7.74 Rework the palm area.

Moving on, let's see if we can remove the triangle behind the index finger.

- First, create a **Cut** next to the triangle, and a second one further out running onto the palm (Figure 7.76b).
- Next, **Delete** the two dividing edges splitting the quads behind the index finger. As you can see from Figure 7.76c, this cleans up that area.
- Finally, **Merge** the edge of the triangle that connects it to the inner n-gon (Figure 7.76d).

With the palm cleaned up, we can start to add in some more details, like the piece of skin between your thumb and index finger.

- To add this, create a new **Cut** from the middle of the thumb, to the base of the index finger (Figure 7.77b).
- Now **Merge** the two triangles at the start of the cut. This will leave you with a couple of n-gons, but that is fine for this area (Figure 7.77c).
- Adjust the area next to flatten the flap of skin, as in Figure 7.78.

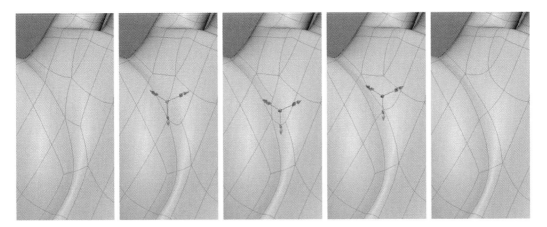

FIG. 7.75 Remove the pole at the base of the thumb.

FIG. 7.76 Adjust the hand to remove the triangle at the base of the index finger.

We will work on one final section, the small bone on your outer wrist. While adding this into the model we can also eliminate one or two triangles and n-gons.

- Following Figure 7.79, create a **Cut** running back from the triangle behind her pinky finger, to just behind the wrist.
- Now **Delete** the edge near the pinky, giving you back a quad (Figure 7.79c).
- Create another **Cut** now running from the top of the hand, around to join your previous cut (Figure 7.80).

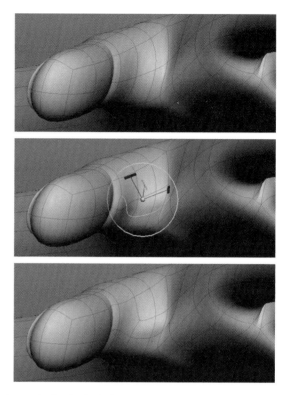

FIG. 7.77 Cut between the thumb and index finger.

FIG. 7.78 Rework the shape of the skin.

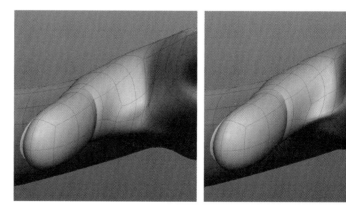

As you can see, this has created a loop around where the bone would be, meaning that once adjusted you can easily add this detail.

Figure 7.81 shows the current hand model.

We could continue building in all sorts of details and reworking sections in the hand and entire body, but doing so would make these chapters drag a

FIG. 7.79 Create a cut from the fingers to the wrist.

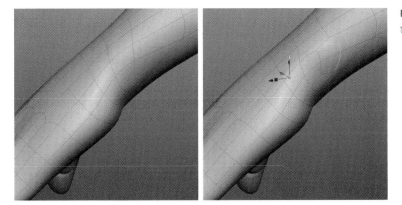

FIG. 7.80 Cut around the outer hand to divide and join connect the poles.

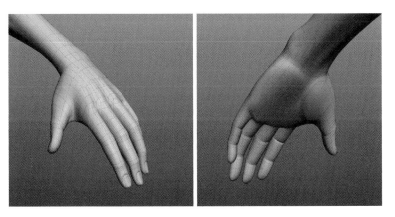

FIG. 7.81 The current hand model.

little. Besides, by now we are sure you are feeling confident with Silo, so why not have a go at working around the body, trying to find areas to enhance, optimize, or tweak?

Figure 7.82 shows our current body model and some areas we tweaked and enhanced. Following is a list of areas we edited as a possible guide, but feel

FIG. 7.82 The completed detailed base mesh body.

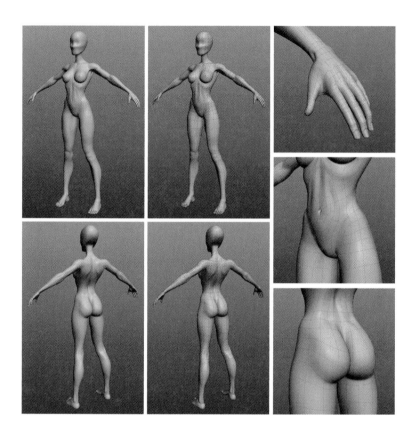

free to load the model from the downloaded tutorial files and take a more detailed look.

1. Added some edge loops around the middle of her body to help smooth her out.
2. Removed the pole above her hip by rerouting the flow of edges.
3. Added some more detail into her hands, including the creases on her palm.
4. Created a new edge loop around her buttocks, to round them off.
5. Reworked the overall shape, including her hips.

In the next chapter, we will complete this base mesh by giving her a face. For now, save your work, and before we move on, feel free to play around with your mesh until you are happy.

(You can find the Silo scene created in this section in Chapter07/Files/07_Body.sib.)

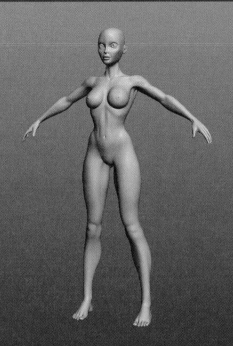

Organic Modeling: Head Detail

In the last two chapters, we added detail into our base character meshes body and limbs, making her much more appealing to look at. In this, the final chapter in this section, we will finally give her a face.

(Note: You will find the files used for this section in the downloaded tutorial files inside Chapter 8/Files.)

Nose

We are going to start with her nose. This is in the center of the face, so it will dictate how the topology starts out. From this, we can then branch out and continue working on her mouth and eyes.

- Begin by loading the scene **Chapter08/Files/08_Body.sib**.
- Your model will be brought into the scene in at its initial, low-resolution state, so select it and press **C** two times to smooth her out.

The head's polygon count is currently far too low for us to do anything, so start by dividing the face.

3D Modeling in Silo. DOI: 10.1016/B978-0-240-81481-0.00008-X

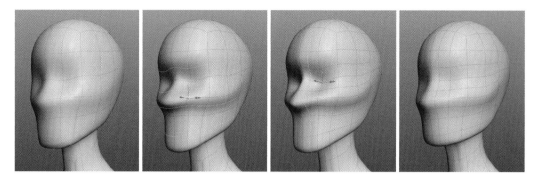

FIG. 8.1 Divide the face.

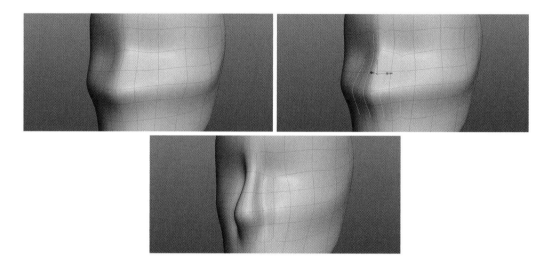

FIG. 8.2 Divide the nose area next.

- First, create three **Cuts** horizontally.
- Then create another **Cut** down the center of the face (Figure 8.1).
- With those in place, focus on the nose area and, as illustrated in Figure 8.2, create four more vertical **Cuts** down the face.
- Before you move on, adjust the geometry to achieve a basic nose shape.

We are going to build in some new geometry now, which will help us define the nostrils.

- Following Figure 8.3, begin by deleting the two faces shown. These are roughly where the nostrils would naturally be.
- Select the three edges on the inner nostril and **Extrude** them out to meet the edge of the holes (Figure 8.3c).
- **Merge** the vertices from the extrude to the ones on the head (Figure 8.3d).

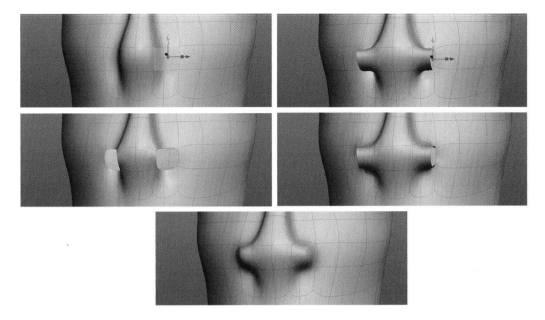

FIG. 8.3 Add new geometry for the nostrils.

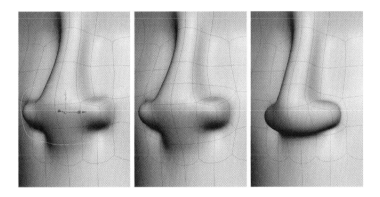

FIG. 8.4 Create an edge loop around the nose.

- Finally, use the **Fill tool** to close the remaining hole.
- We are going to create a new edge loop next, around the nose. As you can see from Figure 8.4, this will help us add more definition to the overall shape.

(Note: Remember to merge the triangles at each corner.)

Focus on the nostril area next. With the groundwork in place, we can move on and build in the actual holes that will help form the key parts of the nose.

- Select the edges seen in Figure 8.5a, the five forming a loop around the opening to the nostril.

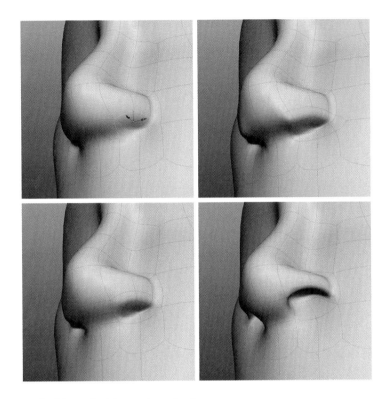

FIG. 8.5 Bevel the nostril to help create the nostril cavity.

- Perform a **Bevel** on these edges, removing any triangles created in the process and sealing the edge loop (Figure 8.5c).
- Next, move the middle three quads up into the nose to create the cavity seen in Figure 8.5d.

The nose is starting to take shape, but we still have work to do. Let's focus back on the main areas of the nose next.

- First, create a new horizontal **Cut** across the front of her nose, carrying this onto her cheeks (Figure 8.6b).
- Now select the edges around the base of the nostril and up the end of her nose (Figure 8.6c).
- **Bevel** these edges, cleaning up any stray triangles or edges created in the topology (Figure 8.6e).
- With the extra geometry in place, enhance the shape of the nose, as shown in Figure 8.6f.
- In Figure 8.7, you will see that we have an n-gon on top of the nostril. Quickly create the **Cut** shown in Figure 8.7b, running across the n-gon and up the side of her nose.

Let's go back to the nostril now. This is just a personal preference, but when working on a nose we like to delete the inner polygons of the nasal cavity.

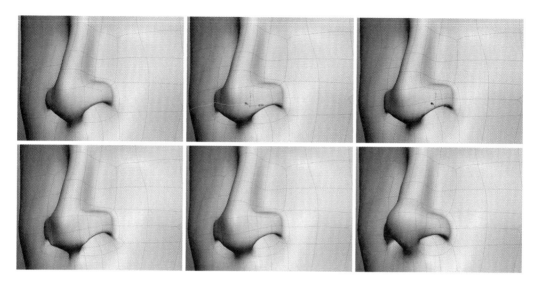

FIG. 8.6 Add more geometry into the nose and rework the overall shape.

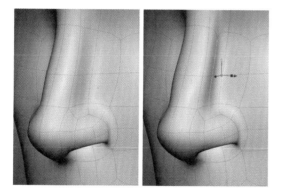

FIG. 8.7 Cut the side of her nose to remove the n-gon.

If you keep these in the model, you might spend time trying to keep this area clean when it will never be seen. If, once the head is complete, we find we need these, we can always add them back in with the **Fill tool**.

* Following Figure 8.8, **Delete** these polygons now.

With that done, we can now concentrate on the nostril again.

* Select the edges around the opening to the nostril (Figure 8.9).
* Apply a **Bevel** to add more of a crease to the opening, and remember to remove the rogue triangles that will also be created.
* Adjust the nostril shape now until you have something similar to that in Figure 8.9c.

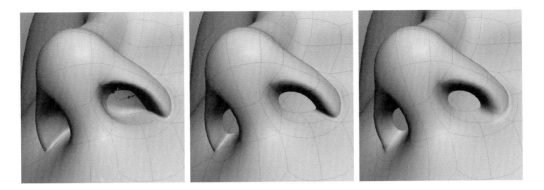

FIG. 8.8 Quickly remove the polygons on the inner nasal cavity.

FIG. 8.9 Bevel the opening of the nostril to create more of a crease.

At the front of the nostril, we have a weird problem. Although we have quads, the way the topology is formed has created sort of a pole effect.

- Select the edges at the front of the nostril (Figure 8.10a).
- **Bevel** these edges.
- Next, **Merge** the two edges highlighted in Figure 8.10c.

This leaves us with an n-gon, but we no longer have the pole type pinch at the front—easily the lesser of two evils.

- Moving on to Figure 8.11, create a **Cut** across the n-gon we just created as shown. This removes the n-gon, and gives us some more geometry to play with.

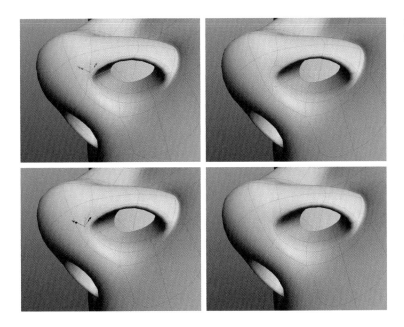

FIG. 8.10 Remove the pinch effect at the front of the nostril.

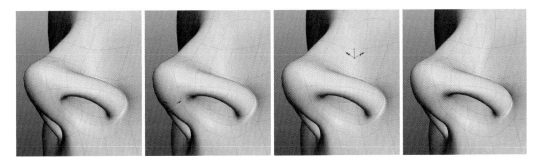

FIG. 8.11 Create a cut at the front of the nose, and a bevel up the side.

- We now need to **Bevel** the edges highlighted in Figure 8.11c. This will give us a new edge loop over the outer nostril and up the side of the nose. Again, this will help us to add more shape to the nose.

The nose is starting to take shape now, and with a little bit of tweaking yours should look like that in Figure 8.12.

Now let's move on to the mouth. We are not completely finished with the nose just yet, but as we work on other areas, we will need to revisit it to adjust the topology, or its general shape.

Mouth

As we start working on the mouth, we need to consider the topology. Yes, it needs to be clean and tidy, but now we have to think about how it could

FIG. 8.12 The current nose model.

animate. As the lips move, the surrounding area deforms according to the underlying muscle structure, and it is this structure we need to try to follow with our edge loops.

- To start, we are going to create a **Cut** running from the corner of the nose, down to the mouth area (Figure 8.13b). This will be used to define the "Smile Lines," or "Nasolabial Folds."
- Once cut, **Merge** the edge of the lower triangle, leaving us with one remaining.
- Create a second **Cut**, this time running down the outside of the existing one (Figure 8.13c).
- Finally, **Delete** the edge between the two triangles.

Now we can move on to the mouth area. As you can see from Figure 8.14, this is currently a blank canvas waiting to be worked on.

- Start by dividing the mouth area; you should aim for something similar to that shown in Figure 8.14b. Follow on the existing cuts we created for the nose down to the chin.
- Next, create a horizontal **Cut** defining where the actual mouth will be (Figure 8.14c).

FIG. 8.13 Create the geometry that will help define the smile lines.

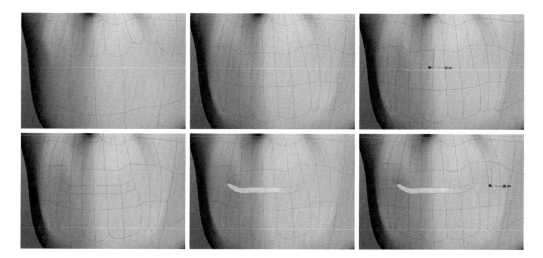

FIG. 8.14 Create the opening for the mouth.

- **Bevel** these new edges to open up the mouth (Figure 8.14d).
- If you now **Delete** the inner faces of the bevel, this gives us the opening of the mouth and a place to start building in the lips.
- This has also left us with two large n-gons on either side of the mouth, so as a final step, create two more **Cuts** (Figure 8.14f) to divide these.

We are now in a position where we can build in the lips and start to form the mouth shape.

- First, **Cut** a new edge loop flowing around the mouths opening (Figure 8.15b).
- Make sure to **Merge** the triangles at each corner of the cut next, closing the edge loop as in Figure 8.15c.
- With this extra loop in place, we can now start to form the lips (Figure 8.15d).

FIG. 8.15 Add a new edge loop around the mouth and start to form the lips.

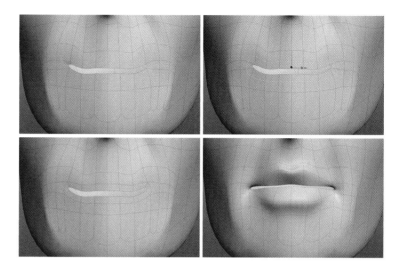

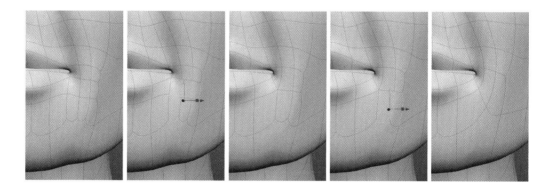

FIG. 8.16 Adjust the flow of the edges to match the muscles in this area.

With the main lips in place, we can now refer back to the muscles around the mouth. We need the edge loops to flow around the lips; now, they move down the face toward the chin.

- Select the edges shown in Figure 8.16b.
- **Merge** these to reroute the first edge loop back around the mouth, and to optimize the area slightly.
- Next, select the edges further out (Figure 8.16d).
- **Merging** these will again clean up the topology while adjusting the edge flow.

Moving on, we can continue to clean up the jaw area.

- Start by continuing the **Cuts** down from her mouth, onto her neck (Figure 8.17b).

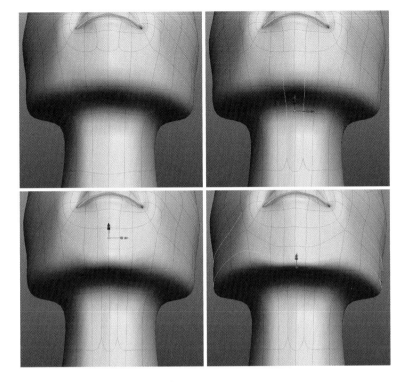

FIG. 8.17 Add More Cuts Around Her Jaw.

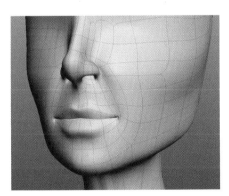

FIG. 8.18 The softened jaw line.

- Next, **Cut** across her chin, dividing the two n-gons on either side (Figure 8.17c).
- Finally, create the **Cuts** seen in Figure 8.17d. These should go around the base of her chin, and divide the n-gons on either side of her mouth.

Once done, it is time to refine her jaw line, to make it less boxy and much smoother. Try to aim for something similar to that in Figure 8.18.

(Tip: Remember to use the Smooth tool to quickly soften a large area.)

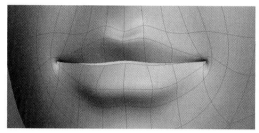
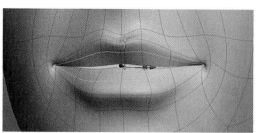
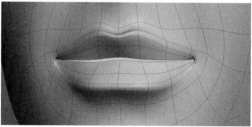

FIG. 8.19 Add more edge loops into her lips.

FIG. 8.20 The current face.

We can now return to the lips, which are looking a little flat, and build in some volume.

- First, insert an edge loop around her lips (Figure 8.19b).
- Next, select the outer edge of the lips and apply a ***Bevel*** to them (Figure 8.19c).

You can now give her lips some much-needed shape, while also filling them out.

Spend some time now working on the lower half of her face until you are satisfied with your work. When finished, your model should look like that in Figure 8.20. Do not worry if she does not look perfect; you will not be able to

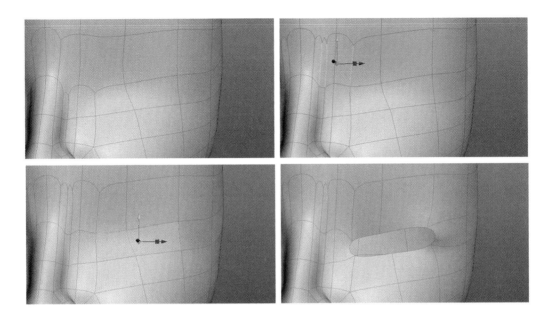

FIG. 8.21 Extend the nose before making the hole for the eyes.

get a good idea of how she will look until the head is finished. At that point, we can address the proportions and other issues.

Eyes

It's about time we gave our girl some eyes. We will approach this much like we did the mouth where we will create a hole in the model first and then work around it.

We first need to extend the nose slightly. The geometry needs to be higher so we can later work in her brow.

- To do this, create three **Cuts** continuing the nose up toward the forehead (Figure 8.21b).
- Now we can create the hole for the eye. Select the two quads around the eye position and **Delete** them, opening up the eye cavity as in Figure 8.21d.
- Just like the mouth, we now need an edge loop around the opening. Create this as shown in Figure 8.22.

We are going to leave the model for now and create a basic eyeball model. We are doing this now because it is important to have an eye in the scene to work around. As we start to shape her eye socket, and add in eyelids, it is great to have an actual eye to guide you.

You can follow Figure 8.23 for this section.

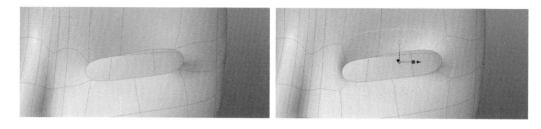

FIG. 8.22 Add an edge loop around the eye socket.

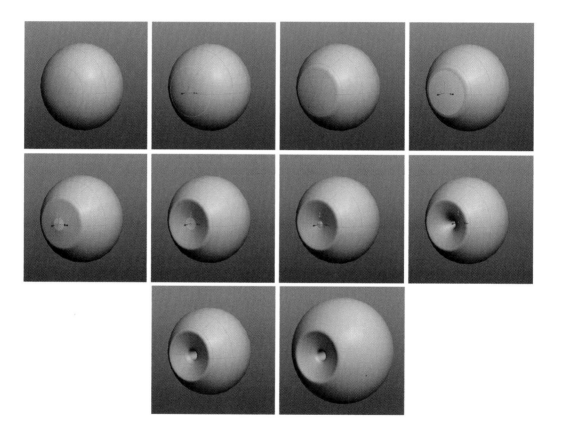

FIG. 8.23 Create a basic eyeball.

- Start with a standard sphere. It does not need to have a set number of divisions, so the default Silo sphere will do.
- Select the edges at one end of the sphere and **Bevel** these. This will give us a slight bump that we will use as the outside of the iris.
- Next, select the end faces of the eye and apply an **Extrude**.
- Scale this extrude down to the size of her pupil and move the selected faces back slightly. As you can see, this gives you a concave effect.

- With the faces still selected, apply another **Extrude**.
- This time, move the selected faces back into the eyeball. This will act as the pupil, as this area will be in shadow and will be nice and dark.
- Finally, **Bevel** the rim around the opening to the pupil to harden the edge slightly.
- Bring the eyeball into your scene and position it roughly where the eye should be. Figure 8.24 shows the eyes added into our model. Do not worry if it is not exact, as we can adjust where it sits later.
- Now adjust the shape of the eye socket to fit around the eyeball.

Now that we have the eyeball in place, and the basic eye socket ready, we can start to work more on the shape and details.

- Following Figure 8.25, first create an edge loop around the eye socket.
- Next, create two **Cuts**, the first going across the nose and the second around the side of her head, almost dividing the eye (Figure 8.25c).
- Use these new cuts to help define the eyelids a little more.

We can now see that there is too much geometry around the nose. Having your topology too dense can result in the surface looking bumpy. As a rule, we try to keep our models optimized to prevent this.

Before we continue, let's tidy up.

- We will start by removing an edge loop from her nose, so first select the two edges highlighted in Figure 8.26a. These are at the crease of the nose.

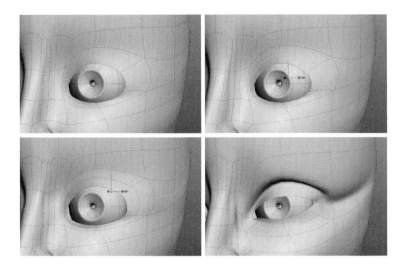

FIG. 8.25 Add new cuts around the head and eye to help define the eyelids.

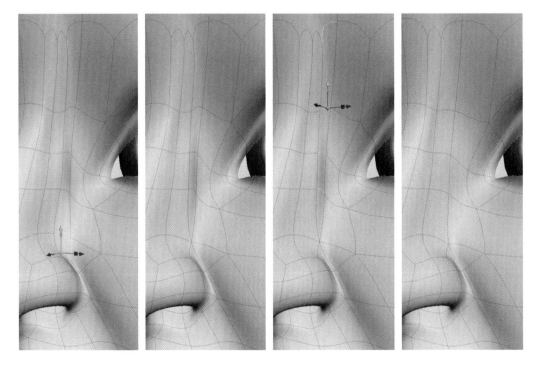

FIG. 8.26 Remove the edge ring from the nose.

- **Merge** these and then select the edge ring running up from it (Figure 8.26c).
- **Merge** again to remove the edge ring.
- Next, create a **Cut** running around the outer nostril, as seen in Figure 8.27a, to emphasis the crease here. This will end with an n-gon, but don't worry about that now.

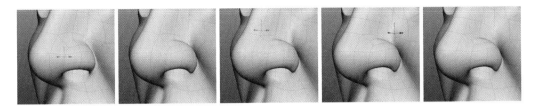

FIG. 8.27 Enhance the nostril crease.

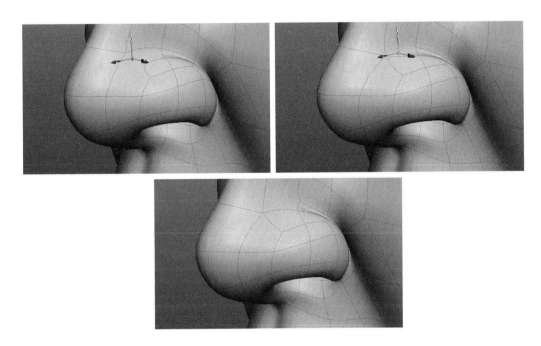

FIG. 8.28 Reposition the n-gon on the nostril eye socket.

- Collapsing the previous edge ring left us with a triangle besides the nose. To remove this, create a *Cut* from the triangle across the bridge of the nose (Figure 8.27c).
- Finally, collapse the resulting triangle shown in Figure 8.27d.

The n-gon on the nostril is not ideal. We cannot remove it without adding unwanted geometry somewhere else, so for now we will simply reposition it.

- Select the upper edge of the n-gon, and *Merge* it (Figure 8.28a).
- Next, *Delete* the upper edge of the remaining triangle. This now places the n-gon in a much better and less noticeable place.

With those tweaks and fixes out of the way, let's get back to the eyes and work on the brow area.

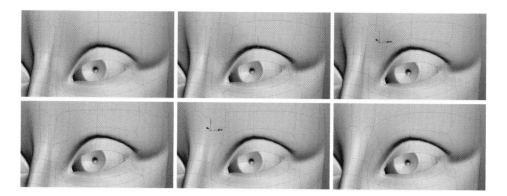

FIG. 8.29 Adjust the topology of her brow.

- We need her brow to flow from the upper nose out over her eyes. So begin by adding a **Cut** above her eye, starting at her nose (Figure 8.29b).
- This has given us a triangle, but **Merging** the upper edge of that and the edge above it will alter the edge flow moving it out onto the brow (Figure 8.29d).
- Now select the edges at the top of the nose (Figure 8.29e).
- **Merge** these to clean the topology, and reroute the upper edge loop.
- Continuing with the brow, create a new **Cut** across her forehead while also dividing the geometry at the side of her brow (Figure 8.30a).
- Next, select and **Merge** the two edges shown in Figure 8.30b. This will clean the topology and adjust the edge loop around the eye.
- Now move to the middle of her brow and divide the area, as in Figure 8.31a. Doing so gives us a series of eight quads.
- **Merge** the four upper corner edges to eliminate the n-gons, and fix the edge flow.

If we look at the head as a whole now, we can see two major problems. First is the odd shape it seems to be, and second is the overall size. Work on these now, adjusting both the size and the shape of her head until it looks more natural, and better proportioned (Figures 8.32 and 8.33).

Returning to the head, we can see a slight topology issue just under her jaw line. There is an odd quad forcing the edge flow from the neck up the side of her head.

- Select the edge ring shown in Figure 8.34a. This branches from the unwanted quad.
- **Merge** these edges.
- Now create a new **Cut** from beside the resulting triangle, down the neck to divide the n-gon further down (Figure 8.34b).
- Deleting the remaining edge gives us a quad, and as you can see, the edges flow much better, tracing the line of the jaw in a much better way. As an added bonus, the edges now also flow around her cheekbone.

FIG. 8.30 Continue to work on the geometry of her brow.

We seem to have gotten distracted and neglected the actual eyes. This tends to happen when modeling. It's better to tackle issues as you find them, rather than put them off, and as a result we have a much cleaner face.

Before we finish the eyes, there is one more issue next to her eyes. As mentioned earlier, we need the topology to mimic natural muscle lines, and this applies to around the eyes, too.

In Figure 8.35a, you will see that the edges flow from the brow and down onto her cheek, which is wrong. We need these to flow around the eye socket.

- First, create a *Cut*, making new edges that flow back around the eye (Figure 8.35b).
- Now *Merge* both of these edges.
- Finally, *Delete* the edge dividing the quad next to the eye. As you can see in Figure 8.35d, the edges now flow around the eye, which is much better.

Back to the eyes now, and the first thing we should address are the wafer-thin eyelids.

- Select the edges around the opening of the eye (Figure 8.36a).
- *Extrude* these edges backward into the eyeball. As you can see in Figure 8.36b, this gives the eyelids thickness but they now look too soft.

FIG. 8.31 Divide the middle of her brow before merging the corner edges.

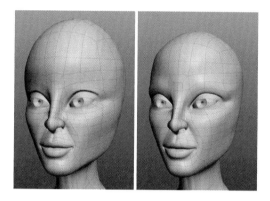

FIG. 8.32 Adjust the shape of the head to make it more natural looking.

FIG. 8.33 Also check the head's size.

FIG. 8.34 Adjust the topology on the side of her head.

FIG. 8.35 Alter the edge flow around the eye socket.

- Select the outer ring of edges again, and this time **Bevel** them. This gives us a nice crease to the front of the eyelids (Figure 8.36d).

We now want to add a little more shape to the eyes, and to help us we need some more geometry to play with.

- Select the edges shown in Figure 8.37, the ones running around the head, almost across the eyes.
- **Bevel** these to give us two edges, instead of one.

FIG. 8.36 Add thickness to the eyelids.

FIG. 8.37 Add a new bevel around the eyes.

Now work on the general shape of the eyes, and the head, until you are satisfied with the result.

Figure 8.38 shows the current head model.

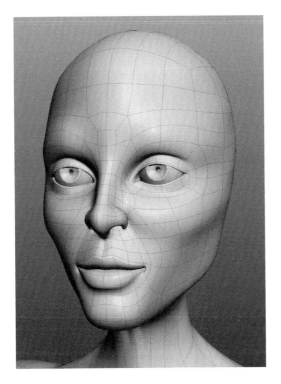

FIG. 8.38 The current head model.

Head and Jaw

We have the main areas of the face in place, so in this section we will clean up the rest of her head and optimize some areas as we go. Again, while we do this we should also keep reshaping her face to get the look and style we are after.

Let's begin with some optimization, and remove one of the edge rings around her cheekbones—sometimes less is indeed more.

We cannot select a full edge ring around her face, as we would end up destroying her current nose. Instead, we can offset the selection part way around.

- Following Figure 8.39, first select the edge ring running from behind her cheeks to just before her nose.
- Continue this selection, but drop down an edge ring, so you are selecting just above her top lip.
- **Merge** these edges.
- Because of the offset, we have a few triangles to deal with. Luckily, these can easily be removed by selecting and deleting the edges seen in Figure 8.39c.

FIG. 8.39 Optimize the cheeks.

FIG. 8.40 Divide the side of her head.

Now let's move to the side of her head, and her jaw. We have many n-gons here to deal with, and the jaw line needs more definition.

- To start, we need to create a series of ***Cuts*** down the side of her head, dividing the n-gons (Figure 8.40). We almost want to continue the current edge loops back slightly.

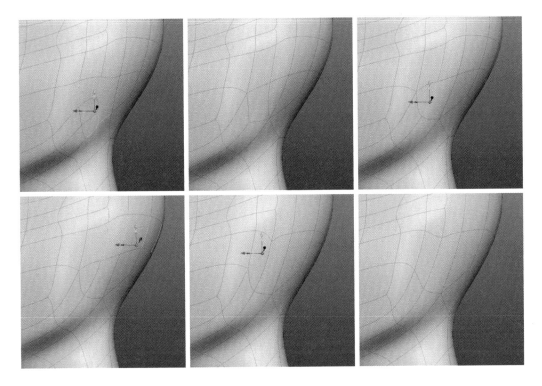

FIG. 8.41 Adjust the topology on the side of the head to define the jaw line.

We can now work with the new geometry to form the jaw line, and clean up the topology.

- First, select the edges shown in Figure 8.41a.
- **Merge** these edges to bend the edge loops around the jaw line.
- We now have a triangle (Figure 8.41b). Rather than remove this, we will simply use the **Spin Edge tool** (/) to select and turn the edge until it moves the triangle (Figure 8.41c).
- Now select and **Merge** the edge ring above the triangle, and around the back of her head (Figure 8.41d).
- Finally, **Delete** the edge dividing the two remaining triangles.
- Now adjust the shape of the jaw line to bring it out of her neck and give it more definition (Figure 8.42).

Let's now look at the upper part of her head and see if we can optimize it further.

- Following Figure 8.43, first create a **Cut** running down and around the base of her head.
- Create two **Cuts** either side of the new triangles (Figure 8.43b), **Deleting** the crossing edges after.

FIG. 8.42 Work on the overall shape of her jaw.

Next, we will create a hole in the side of her head to mark where we are going to add the ear. If we do this now, it will give us an idea of how the topology will be, meaning we can continue to fix the head knowing it will not be drastically altered by the ear.

- Select and **Delete** the four quads around the area where the ear will be (Figure 8.43c).
- Next, create a **Cut** around this hole containing it inside a new edge loop (Figure 8.43d).

With that done, we can continue to adjust the topology on the head.

- Select the two edges on the upper head (Figure 8.43e) and **Merge** them.
- Next, select the edges shown in Figure 8.43f and **Merge** these. What we have done is reroute the edge loops back toward the ear.
- Finally, **Delete** the edge dividing the two remaining triangles (Figure 8.43g).

The head is tweaked and optimized, and we have made some early preparations for the ear. With all these topology changes your model might look slightly odd, so smooth out the side of her head and work on the overall shape.

Figure 8.44 shows the current head model.

Neck

Just two more areas to work on before the detailed base mesh is complete. First, we will finish the neck area and then build her ears.

Turn to the back of the head. On her upper shoulders, we have an n-gon left over from when we worked on her spine. We can now continue these cuts, and remove the n-gon.

- Start by creating a vertical **Cut** from the inner edge, up onto the back of her head, as shown in Figure 8.45b.

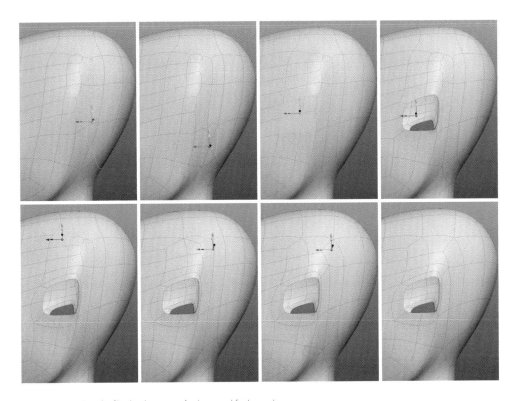

FIG. 8.43 Rework the side of her head to prepare for the ear and fix the topology.

FIG. 8.44 The current head model.

- Also **Cut** across this to the middle of the model.
- Now **Merge** the upper vertices to the ones on either side, turning the four n-gons into four quads and looping the edge loop (Figure 8.45c).

Now let's concentrate on the front and side of her neck, and add in some subtle muscles like the *Sternocleidomastoideus,* which runs from the clavicle to just below the ear.

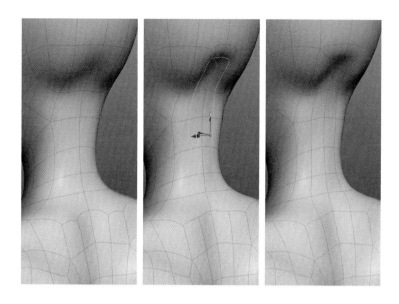

FIG. 8.45 Continue the cut from her shoulders to the back of her head.

FIG. 8.46 Begin by adjusting the neck's topology.

We are going to cut this muscle into the model, but to do this we will need to rework the whole neck topology.

- Start by dividing the polygons running up the side of her neck (Figure 8.46b).
- Now turn these triangles back into quads, but delete the horizontal edges this time, meaning the quads run up her neck rather than around it (Figure 8.46d).
- Move to the front of the neck now and continue the cuts, which ran from the head. **Cut** all the way down to her clavicle.
- When done, add another **Cut**, this time across the middle of the model (Figure 8.47a).
- Next, **Merge** the lower vertices of these cuts to the ones on either side to complete the edge loop (Figure 8.47b).

FIG. 8.47 Continue to rework the neck's topology.

- We now have two triangles further up the neck. Create a **Cut** as seen in Figure 8.47c, dividing the quad between these two triangles.
- **Merge** this new cut to bring the triangles together, and turn them into quads (Figure 8.47d).

Looking at the clavicle, we can see two more triangles at the base of the neck. We can remove these and add some more geometry around the clavicle area, allowing us to work in a little more detail.

- Still on Figure 8.47, create a **Cut** from the center of one triangle to the middle of the model (Figure 8.47e).
- **Merging** the two outer triangles now will remove the triangles and n-gons, giving us a much cleaner clavicle to work with.

Turn back to the side of the neck so we can address the triangles here, and rework more of the topology.

- Following Figure 8.48, first divide the neck as we did initially. This time, split the polygons parallel to the ones defining the *Sternocleidomastoideus* neck muscle (Figure 8.48a).
- With these cuts in place, you can now **Delete** the edges we no longer need—the main ones dividing the quads (Figure 8.48b).
- Next, **Merge** the upper edge on the top triangle (Figure 8.48c).
- As a final step, we can divide the polygons of the upper n-gon and across the back of her neck (Figure 8.49).

Time to do some tidying up and fix the remaining triangles and n-gons that are lying on her shoulders. Luckily, we can remove them in one move.

- Create a **Cut** running from the triangle on the base of her neck, around to cross the n-gon on her back (Figure 8.50b).

FIG. 8.48 Add another cut to help define the neck muscles.

FIG. 8.49 Divide the back of her neck to remove the remaining n-gon.

- *Merge* the two edges of the resulting triangles to complete this step (Figure 8.50c).

If you rotate your model now and examine her shoulders, you might see a slight issue. If you look from the front, the Trapezium muscle has a slight dip in it. This is the muscle on the upper back that arcs from the neck to the shoulder.

We can adjust the topology next to deal with this, and smooth out the edge flow.

- Following Figure 8.51, first divide the edge that is causing the problem.
- Now *Merge* the second cut.
- Finally, *Delete* the remaining edge shown in Figure 8.51c.

As you can see, we no longer have the edge across the base of the neck; instead, the edges flow nicely from the neck to the shoulder.

Before we let you loose to tweak, reshape, and adjust the head further, we can optimize one more place. We can remove an edge ring from the nose and the brow to help smooth out the area. These edges are not really needed, so it makes sense to remove them.

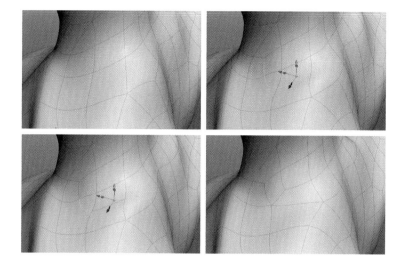

FIG. 8.50 Remove the n-gon and triangle left on her shoulder.

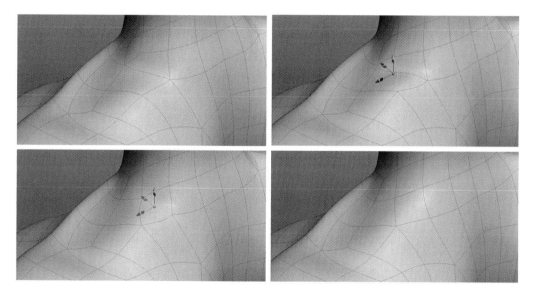

FIG. 8.51 Adjust the topology on the shoulder to smooth out the Trapezium muscle.

- Switch to Figure 8.52 and select the edges running from the n-gon on her nostril, up and over her brow.
- **_Merge_** these edges to give you a smoother head just like the one in Figure 8.52b.

(Tip: The denser your geometry, the more issues you will have. Try to use the least amount of polygons as you can to prevent unwanted bumps, lumps, and pinching.)

FIG. 8.52 Remove the unused edges on the nose and brow.

FIG. 8.53 Remove the triangles from the middle of her brow.

- This should leave you with a series of triangles in the middle of her head (Figure 8.53). **Merge** the center edges now to remove these triangles.
- Finally, turn to the back of her head and select the edge ring next to the triangle (Figure 8.54a).
- **Merge** these, and then **Delete** the remaining edge.

FIG. 8.54 Remove the triangle from the back of her head.

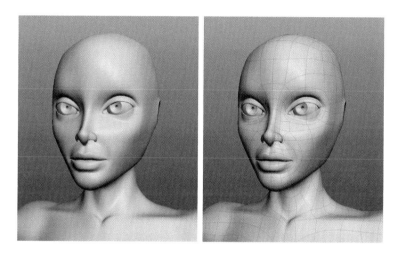

FIG. 8.55 The finished head model.

We are pretty much done with the head and neck now, so feel free to work away on it as much as you like. There are plenty of areas where you can adjust the topology to make the edges flow better and the model look much nicer.

Figure 8.55 shows the finished head model, and as you can see, we have added a few more details. Try to copy these now if you like before we continue.

In the final section, we will give her an ear, but for now, save your work and take a break.

(You can find the Silo scene created in this section in Chapter08/Files/08_ Head.sib.)

Ear

All this girl needs now is an ear. Once we have built it, we will have a fully modeled base mesh for you to play with and use on many different projects, so let's jump right in.

(Tip: We recommend finding some reference material of an ear for this section. The ear can look quite complicated and be tricky to model from memory, so Google an image of an ear now to help. We have included Figure 8.56 as a guide, to help as you model.)

- Begin by loading the scene **Chapter08/Files/08_Head.sib**.
- **Subdivide** the model and navigate to the hole we created as a start point for the ear.
- Select the edge ring around the hole and perform an **Extrude**, scaling it outward (Figure 8.57b).
- Next, create a second **Extrude**; this time, simply move it out to the right as this will give the ear its thickness (Figure 8.57c).
- Now create a final **Extrude**, but this time **Merge** the edges. This will close the hole, giving you a basic ear shape (Figure 8.57d).

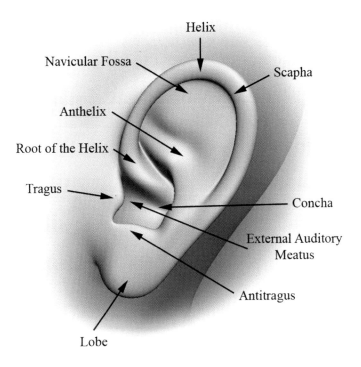

FIG. 8.56 The external ear.

- Now we have a base to work on, so adjust the shape so it looks like a basic ear. You should now have something like that in Figure 8.58.

We can now begin to build in some details. In this case, it is better to work your way from the outside of the ear, in.

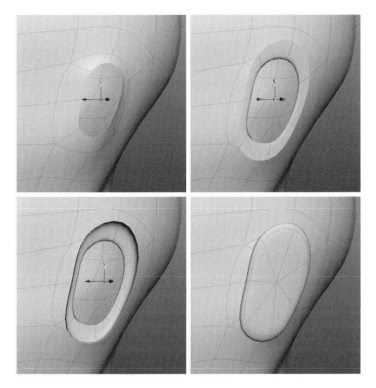

FIG. 8.57 Create the basic ear shape.

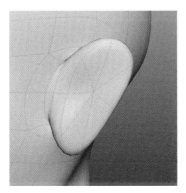

FIG. 8.58 Adjust the shape of the ear.

Following Figure 8.59, start by creating two **Cuts** around the inner ear. These should follow the main outer ring, or *Helix* as its known, and end pointing inside the ear at the *Concha*.

- With the ear cut, adjust the shape to create the creases and folds, as seen in Figure 8.59c.
- Now create two more **Cuts** around the middle of the ear to enhance this area a little more (Figure 8.59d).
- Now focus on the lower part of the ear and create the **Cuts** shown in Figure 8.60. These will help us to build in the *Antitragus* and *Tragus* areas.

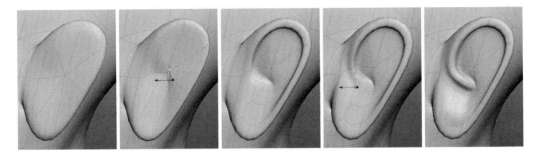

FIG. 8.59 Start to build in the main shapes of the ear.

FIG. 8.60 Divide the lower ear.

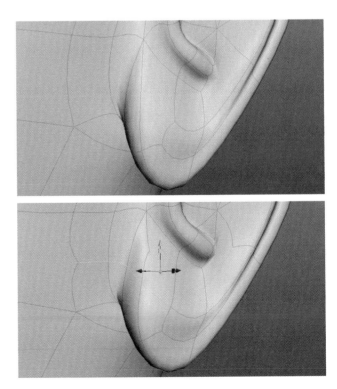

We now need to divide this area further so we can add the ear cavity. What we ideally need are two quads, which we can extrude into the model. However, this will cause a few problems, so we need to prepare the area first.

- Create a long **Cut** around the lower ear, up across where the *Tragus* would be and onto the side of her head (Figure 8.61b).
- Now select and **Merge** the edge highlighted in Figure 8.61c.
- Finally, **Delete** the edge that now sits between the two remaining triangles (Figure 8.61d).

This now gives us two clean quads, which when extruded into the model will not leave us with nasty poles or ugly geometry.

- You can see the cavity being created in Figure 8.62. Simply **Extrude** the two quads, scale them, and then push them into the ear to form the cavity.

Now that we have the cavity, the *Tragus* is looking very thin. We also need to address the topology in this area to make it flow more naturally.

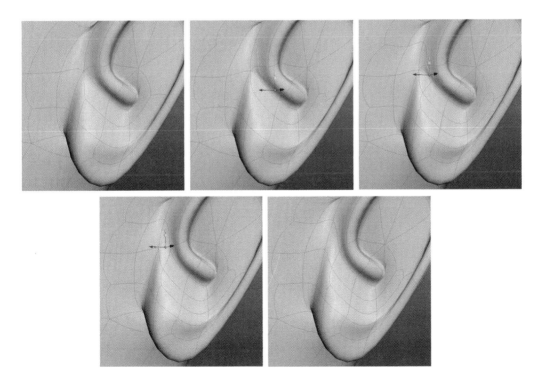

FIG. 8.61 Prepare the lower ear for the cavity.

FIG. 8.62 Create the ear's cavity.

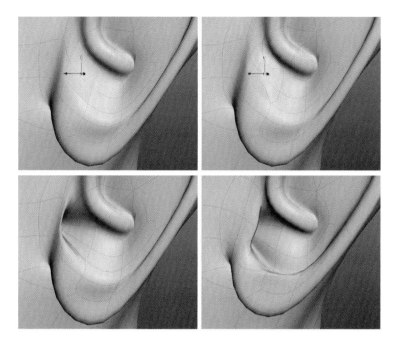

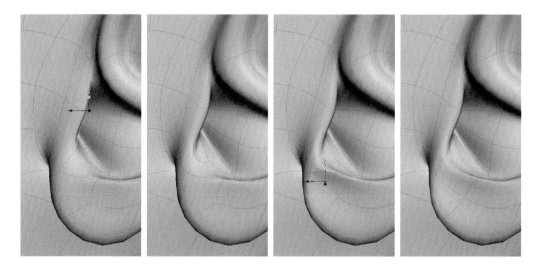

FIG. 8.63 Give the Tragus some thickness.

- Select the two edges at the front of the *Tragus* (Figure 6.63a).
- **Bevel** these to give the area some thickness.
- Next, divide the geometry at the front of the *Antitragus* to adjust the flow of the geometry (Figure 6.63c).
- Finally, **Delete** the edge dividing the quad.

FIG. 8.64 Divide the n-gon at the start of the Helix.

FIG. 8.65 Merge the edges between the Helix and the Tragus.

If we look at the upper ear, we can see that we have an n-gon around the start of the *Helix*.

- Create a **Cut** following the flow of the *Helix*, as shown in Figure 8.64, dividing the n-gon.
- Now select the edges shown in Figure 8.65 and **Merge** them.

Let's look at the upper ear now, and the *Anthelix* area. Here we need more of a crease around the *Helix*.

- First, divide the n-gon at the base of the *Helix*, making a quad. You can see this **Cut** in Figure 8.66b.
- Next, create the series of **Cuts** shown in Figure 8.66c. We need to continue the cut around the inside of the ear, and remove some of the existing triangles.

FIG. 8.66 Add the crease into the
lower Helix.

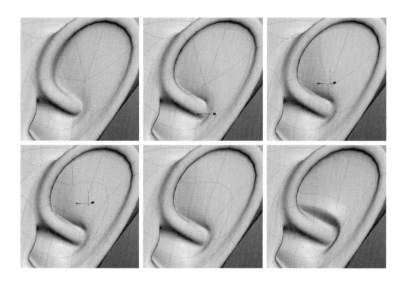

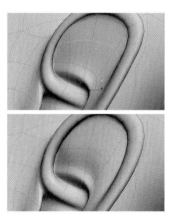

FIG. 8.67 Cut the upper ear so we can add the Navicular Fossa.

- With these cuts in place, we can now **Delete** the dividing edges of the
 triangles, turning them into quads.
- Now adjust the area to take full advantage of the new topology
 (Figure 8.66f).
- Now we can safely adjust the upper ear to add in the *Navicular Fossa*. To
 do this, simply **Cut** across the upper ear as shown in Figure 8.67. Take this
 cut right onto her head if needed.

We now have a slight issue to address. The topology of the ear around the
end of the *Helix* is not correct. We need the *Antitragus* area to blend into the
Anthelix but now in blends into the *Helix*.

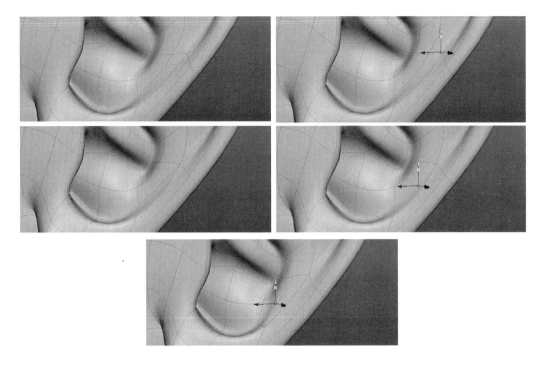

FIG. 8.68 Start to rework the topology to blend the lower ear correctly.

- Start by selecting and **Merging** an edge in front of the *Helix* (Figures 8.68b, and 8.68c). This should be at the bottom of an n-gon so the upper ear will be fine—it will, however, give us a triangle.
- Select the outer edge of this triangle (Figure 8.68d) and **Spin** it until it is like that in Figure 8.68e.
- Now focus on the inner ear and create a new **Cut** running from beside the triangle on the *Anthelix* down to the triangle on the *Lobe* (Figure 8.69b).
- Now **Delete** the edge between the triangles, and **Merge** the lower triangle to clean up the area.

Feel free to play around with the shape of the ear until you are satisfied. As it stands, we can leave the ear as it is; as you can see from Figure 8.70 it is working quite well.

As always, you are welcome to add in a little more detail if you want. Figure 8.71 shows our final ear, after a few more tweaks and adjustments to the shape and topology, but do not feel you need to copy these if you are happy to move on.

(You can find the Silo scene created in this section in Chapter08/Files/08_Ear.sib.)

FIG. 8.69 Divide the lower ear to remove the triangles.

FIG. 8.70 The current ear model.

FIG. 8.71 Our tweaked ear model.

Final Tweaks

Your detailed base mesh is now complete, well done!

Over the last few chapters, you have given Silo's modeling tools a good workout, and now you should be able to confidently model anything that is thrown at you.

As far as organic polygon modeling goes, we are now finished, but we still have lots to explore. In the next chapter, we will give our female model clothing, but rather than model them we will open up Silo's sculpting tools to quickly create the complex creases and folds needed.

For now, sit back and polish your model. This would also be a good time to open up the concept artwork and make sure her proportions and general shape are correct.

The good thing about this model is you can now reuse it on many projects. Why not adjust her so she looks more realistic and save a separate version?

Figure 8.72 shows the final detailed base model.

(You can find the Silo scene created in this section in Chapter08/Files/08_Final.sib.)

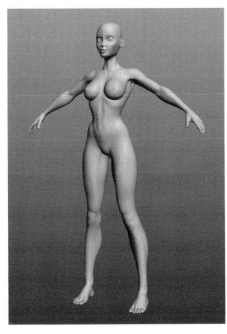 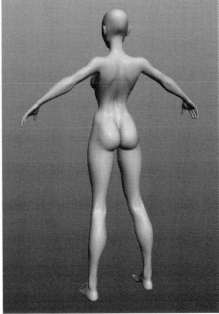

FIG. 8.72 The finished detailed base mesh.

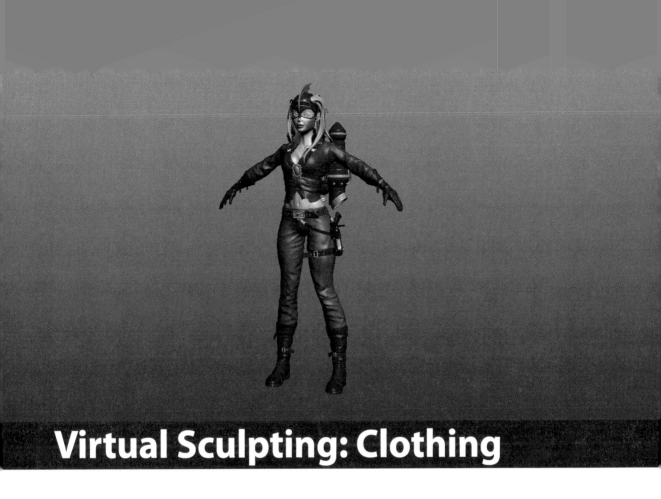

Virtual Sculpting: Clothing

During the first section of the book, you created a basic base mesh and a detailed base mesh. These can both easily be applied to numerous projects, but for us it has given us the perfect start in creating our Rocket Girl, Jade Raven. In this chapter, we will dress her up, much like a doll, using the detailed base mesh to guide us.

We have covered Silo's main modeling tools in the previous chapters, so here we will look at another of its tools, the Paint Displacement tools.

(Note: You will find the files used for this section in the downloaded tutorial files inside Chapter 9/Files.)

Essential Tools

Sculpting or digital painting in any application can be tricky with a mouse. Using a pen is a much more intuitive way to work. It allows for smoother, more natural movement and strokes, which makes your life easier and dramatically improves your work.

If you are considering a future in digital art, or digital sculpting, seriously consider investing in a graphics tablet. This might seem a scary prospect

3D Modeling in Silo. DOI: 10.1016/B978-0-240-81481-0.00009-1
© 2011 Elsevier Inc. All rights reserved.

initially, and we are not suggesting you splash out $500 on one now. There are many different varieties and brands available with prices ranging from $50 up to well over $1,000, so start small, and if you find you are using it more and more, you can always upgrade at a later date.

Once of the main brands used around the world is Wacom (www.wacom .com). They have a huge selection of quality tablets with some great features, but they can be a little pricey, so research exactly what you need from a tablet before you spend your hard-earned cash.

Trust (www.trust.com) also has a good range of tablets, and are much cheaper than Wacom, so feel free to try these first.

Starting Blocks

Like any artists, we cannot sculpt thin air; we need something to work on top of, to pull and push into shape. Before we begin sculpting, we need to generate basic models representing the clothing. These just need to be plain models, much like our initial character base mesh, which we will then sculpt details into

Don't worry, we will not be spending the next 20 pages building each model in detail—by now, you are fully capable of generating these models on your own. We will, however, take a crafty shortcut.

Luckily, we already have a great model that can start us off with the clothing, with a few tweaks.

• Begin by loading the scene *Chapter09/Files/09_BasicBaseMesh.sib*

Yes, this model is perfect for us to use. We initially built this model as a starting point for digital sculpting, and it is already roughly the correct proportions so it would be silly not to use it.

• Take this model and strip it down, dividing it into the key clothing elements—jacket, trousers, and gloves. Your edited model should look like that in Figure 9.1b.

(Note: We will not use the feet for the boots at this stage; it would be easier to build them from scratch, as you will see later in the chapter.)

• Now save this edited mesh as *09_ClothingBase.sib*.

This has given us the bare bones of the clothing, which for this chapter is all we need. We cannot, however, just use these as they are; they will need a bit of work before we can sculpt onto them.

• Now load the scene *Chapter09/Files/09_DetailedBaseMesh.sib*.

We are going to import the basic clothing into this scene, but before we do, we need to make a slight adjustment to the model. Now, her breasts sit naturally as they would if she were naked, which is not how we need them.

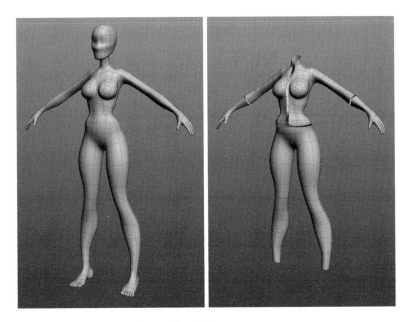

FIG. 9.1 Convert the basic base mesh into our basic clothing.

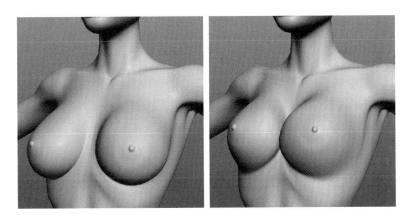

FIG. 9.2 Adjust her breasts so they look as they would if held by her clothing.

- Edit the model so her chest is pushed up, and together, as if it were held by invisible underwear (Figure 9.2). It looks a little unnatural now, but it will look better once she has her jacket on.

(Tip: Use the **Soft Selection** tool to help you adjust her chest.)

- With that done, import the scene **09_ClothingBase.sib** by going to **File > Load Into Scene**.
- As you can see in Figure 9.3, the models will clash, so adjust the clothing meshes to sit outside the main character model.

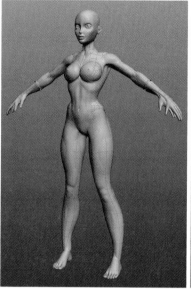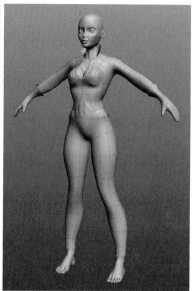

FIG. 9.3 Import and adjust the base clothing models.

All that is obviously missing at this point are her boots, but as mentioned before, we will come to those later. For now, let's move on and start to edit these base models to make them more suited to sculpting.

Jacket

We can concentrate on the jacket and hide the other bits of clothing for now. As mentioned earlier, what follows is not a detailed tutorial on what we need to do to these models. Instead, we will supply a general overview of what you will need.

The rest is up to you!

What we ideally want is a basic, flat model representing the jacket in a final state. This includes giving it thickness, and making sure the topology is correct before we can proceed. What we are not looking for at this stage are any details, just the main shape.

(Note: It is important to have the topology in its final state before you begin sculpting, as any dramatic changes can destroy all your hard work.)

(Tip: Be sure to add extra edge loops into areas that will need lots of detail. Try to keep the topology even where possible, with nice square quads.)

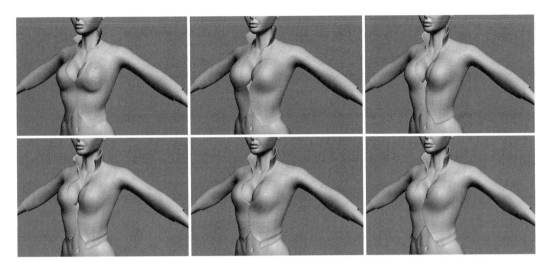

FIG. 9.4 Adjust the jacket, building in the main areas.

Figure 9.4 illustrates the main changes we need to make to the jacket; these are also detailed in the following steps.

- First, we need to address the topology around her chest. We no longer need the circular edge loops that formed her breasts, so first flatten this area out, returning the topology to the default grid shape in Figure 9.4b.
- Next, we want to give the jacket some depth and thickness, so **Extrude** the edges around the outside of the jacket and collar, moving them toward the body.
- Because we will be able to see the inside of the collar, it is important to now build this area, extending the polygons down to her neck.

(Tip: Do not waste time building areas you will not see; only add them if they are needed to help the topology.)

- The edges around the opening of the jacket will now appear soft when subdivided (Figure 9.4c), which is not what we want. **Bevel** these edges now to give it a harder looking edge as in Figure 9.4d.
- Up to now, you have probably been working with symmetry enabled. Turn this off so we can start to make each side of the jacket unique. Begin by folding the left side over the right slightly, as if it were fastened (Figure 9.4e).
- Finally, add a few more edge loops around the arms. The polygons are currently too long, and ideally, we want them to be square, so adding more geometry will help us when we sculpt in the details.

The base for the jacket is completed; save your work now before we move on to her trousers.

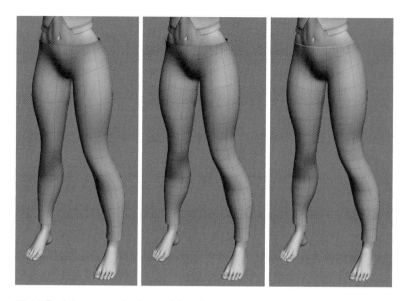

FIG. 9.5 Tweak the trousers making them ready for sculpting.

Trousers

The trousers are much easier to work with, as we already have the main shapes we need. We could try to build in the pockets or her fly, but those could easily be achieved by sculpting them in.

- First, add more edge loops around her legs, to even out the topology (Figure 9.5b).
- Next, adjust the top of her trousers, giving them some depth and adjusting them to fit her hips better (Figure 9.5c).

Again, this is all we need to do to the trousers at this point because we did most of the work earlier in the book.

Gloves

Like the trousers, her gloves need just a small alteration because we pretty much have the model we need. For now, simply add some depth around the opening, while building the internal faces, as we will be able to see the inside of the cuff (Figure 9.6).

(Note: If the fingers will eventually be bent, add an extra edge loop around the knuckles. This will make posing the hand much easier as it will retain the shape of the fingers.)

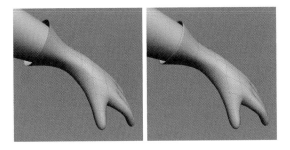

FIG. 9.6 Add a seam around the opening of the glove.

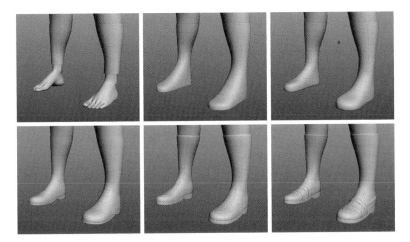

FIG. 9.7 Build Jade's boots.

Boots

Earlier we chose not to use the feet from the base mesh as the starting point for our boots. Instead, we are going to build the boots from scratch. This is the easiest option, as the boots only need to be basic; if we edited the feet, we would be making more work for ourselves as we adjusted the topology.

What we can do is use the lower section of the trousers as a starting point.

The following steps can be seen in Figure 9.7.

- Begin by selecting the bottom four rows of her trousers, and use the **Break** tool to separate them, effectively detaching the polygons to give us the upper part of her boots.
- Next, **Extrude** the bottom of these, extending them down first and then out to cover her feet and toes (Figure 9.7b).

- Use the **Bridge** tool to seal the bottom of the boots, so her feet are completely hidden.
- Now that we have the main boot shape, we can start to add in some of the main details, like the sole and the straps seen in Figures 9.7d–f.

(Note: Always refer to the concept artwork when building.)

There we have it, our base boots ready to be sculpted onto.

Accessories

We now have the main clothing elements in place, and ready for us to start sculpting on to. Before we do, it is a good idea to build in the main straps that cling to her body and hold her various accessories in place.

We need to do this because the straps and her belt will have an effect on how her clothing is creased, and where the folds are. As an example, the main straps for her rocket pack will pull on her jacket and sink into it, meaning we will need to show this in the fabric.

Your next step is to build in these accessories, but do not go overboard. We do not need them to be highly detailed; instead, we just need to know where they will be, as we will upgrade them in the next chapter.

- For now, begin with a simple cube and extend it until it wraps around Jade`s thigh to act as the strap for her holster.
- Once done, copy this and adjust it to fit around the gloves and the boots.
- Build more straps next to act as the ones from her rocket pack.
- Finally, adjust a cylinder to fit the general shape of the buckle at the front of her chest.

Use simple cylinders and cubes, extruded, scaled, and adjusted until they fit over the figure.

This is all we need for now, but as an extra step, and to help us start to visualize the finished model, why not apply some basic colors? Refer to Chapter 3 if you need a reminder on creating new materials.

Figure 9.8 shows the character with the main accessories added. You can also see what a difference having basic colors applied has made to the look and feel of the model.

Figure 9.9 illustrates the **Material Editor** once the new materials have been created, to show you what has been added.

Notice that the body beneath the clothing is starting to pop through in areas. Rather than try to adjust the clothing to hide this, it would be more economical to now remove the areas we cannot see.

- For this model, delete everything except her head, neck, and the front of her torso; the rest is covered with clothing anyway so is never seen.

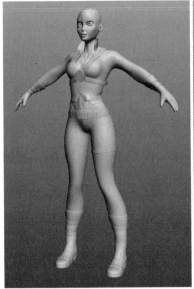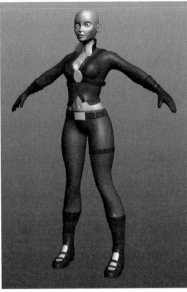

FIG. 9.8 Add in the main accessories that will affect the clothing, and why not add a splash of color?

FIG. 9.9 The Material Editor with the new colors added.

Once done, all you should have are the areas shown in Figure 9.10b.

This might seem a waste as we spent lots of time building her limbs. However, remember the detailed base mesh was created to be useable on many other projects, not just this one.

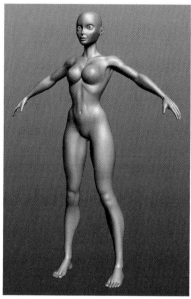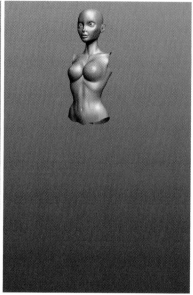

FIG. 9.10 Delete the unseen parts of her body.

All the preparation work is now complete and we are ready to start working in the cloth details.

(You can find the Silo scene created in this section in *Chapter09/Files/09_ ClothingPreSculpt.sib*.)

Sculpting Details

As explained in Chapter 3, digital sculpting is exactly what the name suggests. You push, pull, pinch, and tweak your model as if it were a lump of clay. This is what we will be doing in the following sections to add creases and folds to our clothing.

(Tip: Remember that even at a higher subdivision level you can still tweak the lower resolution cage to edit the overall shape of the model.)

As a reminder, Figure 9.11 shows you the main **Brush Editor**, which we will be using in this section.

(Note: To access the Brush Editor, go to **Editors/Options** > **Brush Editor**.)

Before we begin, it is important to add that we will not be covering each brush stroke in detail, as this would be tedious to follow. Besides, sculpting is meant to be fun and organic, so it is better to give you a rough guide, and encourage you to follow your own artistic path.

Figure 9.12 shows the basic process we will be following for adding the cloth detail.

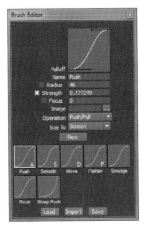

FIG. 9.11 The Brush Editor.

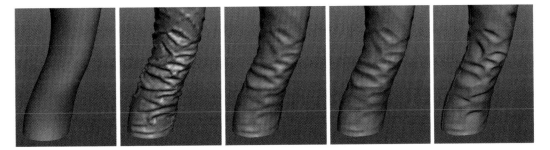

FIG. 9.12 The basic sculpting process.

- First, using the **Sharp Push** brush, carve in the main folds of cloth. As you can see in Figure 9.12b, this will look messy to begin with, but bear with us.
- Next, use the **Smooth** brush to soften the cloth (Figure 9.12c).
- With the main creases and folds in place, we can now use the **Pinch** brush to help define and sharpen some of the folds (Figure 9.12d).
- Finally, we can use the **Smudge** brush to push the details around, making some areas sag more while adding depth to others (Figure 9.12e).
- For extra details like the seams, just use the **Push** brush and paint these in with an even, long stroke.

With this process fresh in your mind, let's dive in.

Jacket

So, let's start sculpting!

(Tip: At this stage, it is extremely important you download some clothing reference to work with. Unless you completely understand how cloth is

affected by gravity, it is difficult to get it to look correct. A quick search online for jeans, trousers, and flight jackets will give you all the reference you need.)

- To make life easier, hide everything except the upper body before you begin.
- The best approach to sculpting is to take things a subdivision at a time. This way, you gradually build in the details starting with the larger areas, and finishing with the finer areas.

So, the process for the jacket is as follows.

- Start by pressing **C** to add a subdivision, and then block in the main, large details. Focus on the big folds around her arms, as shown in Figure 9.13b.
- When you are happy, apply another subdivision, and, with a smaller brush, work in some more creases. Create some slightly smaller folds, and start to define the seam around her shoulders (Figure 9.13c).
- Continue, adding more subdivisions and more details until you are satisfied. Remember that the straps pull around her chest, so try to add this into the model.

Figure 9.13 shows the full progress of the jacket.

(Note: Do not go overboard with your subdivisions; we recommend four or five subdivisions maximum. Any more and Silo might start to struggle once the rest of the sculpted geometry is in the scene. Of course, this does depend on your system.)

(Tip: Think ahead to what details will be seen when the character is eventually rendered; if it will not be seen, do not bother adding it in!)

Trousers

Let's continue with her trousers next.

- Hide the jacket, and make the trousers and associated accessories visible again.
- Follow the same process as with the jacket, adding in the folds and creases around the legs, taking things a subdivision at a time.
- Make sure you take into account the strap around her thigh; this will cause the fabric to bunch up above it.
- As a final pass, why not sculpt in the seams down the sides of her legs, and her fly and pockets?

As you work, remember to follow the process outlined earlier.

1. Sharp Push—Block in main details
2. Smooth—Soften the harsh strokes

FIG. 9.13 Sculpt details into the jacket.

3. Pinch—Crease and sharpen the folds
4. Smudge—Deepen the recesses of the cloth
5. Push—Paint in fabric seams and other details

Figure 9.14 illustrates the steps taken to add the details to the trousers.

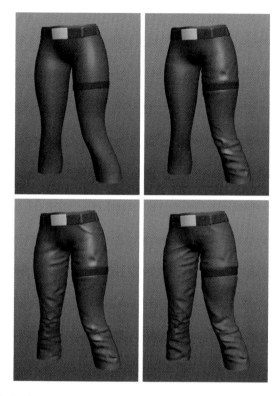

FIG. 9.14 Sculpt details into the trousers.

Boots

Moving on from the trousers, now we will look at the boots.

(Note: You might find that the scenes are running a little slow, so at this stage you could divide her into separate files to make editing easier.)

Again, follow the same procedure adding subdivisions and details. If you are feeling more confident, why not experiment with some other details rather than wrinkles?

Figure 9.15 shows the boot model as it's being worked on. As you can see, we have added a few circular details that are not in the concept, so feel free to play around and have some fun.

At this stage, you might want to attempt to add some tread into the soles of the boots. Sculpting this detail in would be tricky with the current version of Silo, so we suggest building the tread in as a separate model.

An easy option is to create the separate tread segments and position them below the existing sole, something similar to that shown in Figure 9.16.

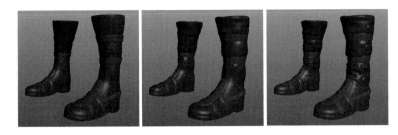

FIG. 9.15 Sculpt details into the boots.

FIG. 9.16 Add sections below the sole to add the tread.

FIG. 9.17 Create a completely new sole for the boot if you require a better solution.

If you looking for a superior effect, why not create a new sole model, like the one shown in Figure 9.17?

Bring this into your scene and replace your existing sole. As demonstrated in Figure 9.18, you will be safe deleting the base sole from the boot, but you will not be able to combine the new sole, as the dramatic change in topology would destroy all your sculpting work. This will not matter, as the sole needs to look separate anyway.

(You can find the boot sole model in the downloaded tutorial files Chapter09/Files/09_BootSole.sib.)

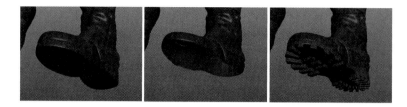

FIG. 9.18 Replace the basic sole with your new, improved version.

FIG. 9.19 The sculpted boot complete with a new sole.

Adding tread to the boot will give it a new look and feel (Figure 9.19).

Gloves

Onto the final section now with the gloves. By now, you should be able to perform the detail pass with no major problems.

- Before you start sculpting, create a seam around the gloves. You can do this with the help of a simple **Bevel** operation (Figure 9.20).
- Next, using what you have learned so far, work your way around the model, adding in the details a subdivision at a time, as illustrated in Figure 9.21.

Final Review

The main areas of the model are now complete, and in the next chapter we can explore Hard Surface Modeling as we finish the accessories while building Jade's helmet and rocket pack.

Bring all your model's elements into the scene now and explore the model as a whole. The great thing about digital sculpting is that we can continue

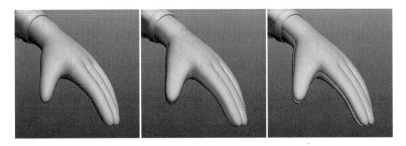

FIG. 9.20 Create a seam around the gloves.

FIG. 9.21 Sculpt details into the gloves.

to work on the model as we move forward, tweaking her as we go, so don't worry if she isn't perfect now.

Figure 9.22 shows the model before and after the sculpting pass to illustrate how much detail we have added to its surface.

(You can find the Silo scene created in this section in Chapter09/Files/09_ ClothingSculpt.sib.)

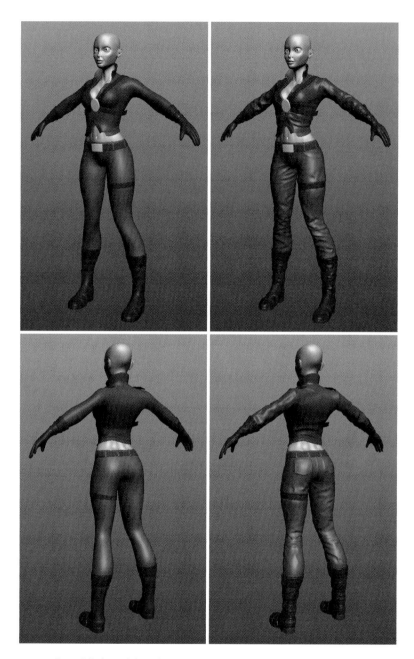

FIG. 9.22 The model before and after sculpting.

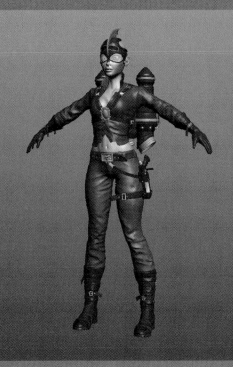

Hard Surface Modeling

Jade Raven is really starting to come together. By now, you should be capable of generating any organic-based model. In this chapter, we focus more on the hard surface elements of our character as we build her rocket pack, helmet, and a pistol. With those in place, we can move on and finish her accessories, replacing the basic geometry we created while sculpting with more detailed elements .

(You will find the files used for this section in the downloaded tutorial files inside Chapter 10/Files.)

Rocket Pack

We are going to take a break from our main character now as we turn our attention to her rocket pack. To make things easier to follow, this is divided into three sections covering the main rockets, the central body, and the backrest.

Rockets

The rockets are the major feature of the rocket pack, so let's start here.

3D Modeling in Silo. DOI: 10.1016/B978-0-240-81481-0.00010-8

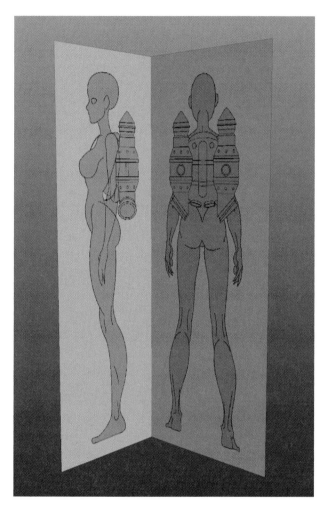

FIG. 10.1 We start with the concept images in a new scene.

- Begin by loading the scene **_Chapter10/Files/10_ViewportPolys.sib_**.

As you can see in Figure 10.1, this brings in a similar scene to the one we started with, the only difference being that what was the front image now shows the character's back. So, we can see what the rocket pack should look like and how big it needs to be.

- Begin by creating the basic shape of one of the rockets. A cylinder is a great starting point, which is then molded into the main shape (Figure 10.2). As with the body, we can generate one side, and mirror it to create the opposite side.

Now we have the main shape; if we apply a subdivision to it, you will see that it loses its form as the model is softened (Figure 10.3b).

FIG. 10.2 Begin by creating the basic shape of her rocket pack.

FIG. 10.3 Crease, or Bevel, the edges to retain the form when subdividing.

What we need is a way to keep certain edges from being softened when a subdivision is applied.

- Select the horizontal edges shown in Figure 10.3c.
- Now go to **Subdivision** > **Crease Edges**.

We just told Silo that these edges shouldn't be fully affected by the subdivision operation. Instead, they are, as the name suggests, creased to stay rigid. You can see the creased edges in Figure 10.3d, highlighted in blue.

This is a great way to add hard edges into a model, making Silo a great Hard Surface modeling package and an organic one.

This is a matter of personal choice, but in some areas, the creased edges seem a little too harsh, so there is another option.

- Following Figure 10.3e, apply a small **Bevel** to the edges, rather than a crease.

FIG. 10.4 Create a basic bolt/rivet.

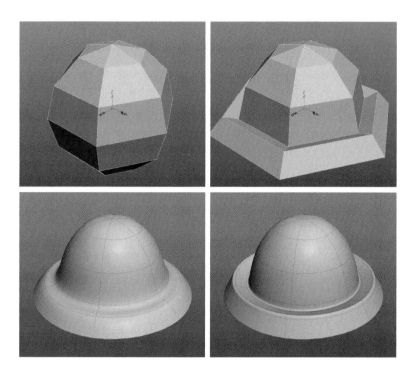

This works just like the crease, but it gives us nice rounded edges that will catch the light in a much more interesting way.

- Once the edges are creased, or Beveled, you will just need to go in and adjust the rocket's scale. As you can see, it will now be slightly slimmer.

Moving on, we can start to build in some more detail. The round bolts or rivets, for example, can be created quite easily, as illustrated in Figure 10.4.

- We begin with a basic sphere primitive, which is then halved.
- The lower edges can then be extruded and adjusted to form the surrounding details.

Once you have one rivet, you can place it on the model as indicated in the reference and duplicate it to create the others for use around the model.

- Once the first rivet is in position, switch to the top view and reset the object's axis by going to **Selection > Reset Object Axis**.
- Press **M** to enter **Manipulator Edit Mode** and move the manipulator to the center of the rocket (Figure 10.5b).
- With the pivot in place, press **M** again to return to normal editing.
- Now, duplicate the rivet, and in the **Numerical Editor** rotate it by −45 units (Figure 10.5c).
- Repeat until you have all eight rivets in place (Figure 10.5d).

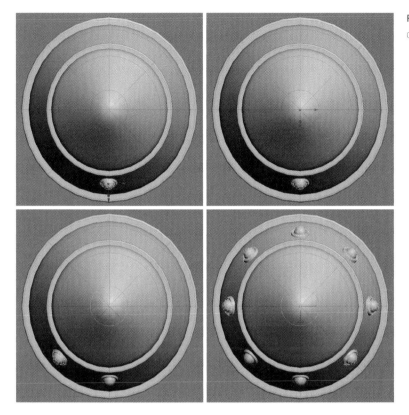

FIG. 10.5 Duplicate this rivet to create more around the rocket.

- You can now start to work in more details, like adding the bands around the rocket that will eventually hold it in place (Figure 10.6). These are simple cylinders with beveled edges.

Now we will focus on the base of the rocket, where we need to add the exhausts and a lip around the end to make it feel more solid.

- To create the lip, first **Extrude** the end edges inward, and then again back up into the model (Figure 10.7).
- **Bevel** the lower edges next to harden the appearance of the surface.
- To create the exhausts, which are built from three sections, simply modify a cylinder making it into a tapered tube shape, and duplicate it to create the lower two (Figure 10.7e).
- Remember to edit the final exhaust, creating internal polygons so you can't see through the model (Figure 10.7f).
- The main rocket is in place, so why not work on it a little more to add in some more details. As you can see in Figure 10.8, we also added some pipes and bolts around the rims to make it a little more interesting.
- When you are satisfied, use the **Mirror Geometry tool** to generate the rocket for the opposite side.

271

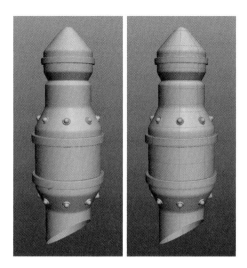

FIG. 10.6 Add the bands around the rocket.

FIG. 10.7 Work on the base of the rocket, adding the exhausts.

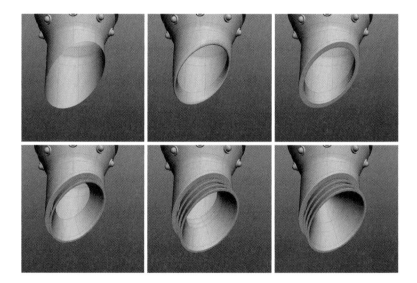

Central Body

Now let's connect the rockets by building the main body of the rocket pack.

- First, hide the current rocket geometry.
- This time, start with a cube and adjust it, so once subdivided, it fits the general shape of the central part of the rocket pack. As shown in Figure 10.9, first work from the front, and then following Figure 10.10, work from the side.
- With the rest of the rocket visible again, start to work in some of the major details, like the panel seen in Figure 10.11b. This shape began life as a sphere, but was stretched and edited to fit.

FIG. 10.8 Work in some more of your own details.

FIG. 10.9 Use a cube as the base for the central part of the rocket pack.

- Next, create the bands across the central panel, making sure they line up with the bands already on the rockets (Figure 10.11c).

What we can do now is connect the bands that go around each rocket to the ones that go across the main body. This will make the model feel less like it is made of separate elements, and more like the bands are holding it all in place.

273

FIG. 10.10 Make sure to adjust it from the side.

FIG. 10.11 Add in some of the major details next, like the panel in the middle of the model.

- Following Figure 10.12, first hide everything but the bands and combine them into a single object.
- Next, delete the polygons behind the central bands to open up the outer loops (Figure 10.12b).
- Using the **Merge tool**, connect the vertices of the inner bands with the outer bands at the front of the model (Figure 10.12c).
- Move to the back now and use the **Bridge tool** to close the rear loops.
- Finally, bring the hidden geometry back and adjust the bands to make sure they still fit around the main model.

The first two main elements of the rocket pack are complete, but as illustrated in Figure 10.13, you can do more.

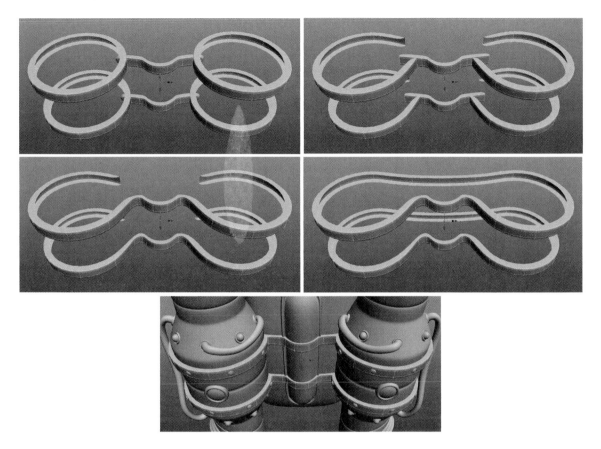

FIG. 10.12 Make the bands a single, continuous loop holding the rockets in place.

FIG. 10.13 Continue to add more details, like bolts and the extra boosters.

FIG. 10.14 Import the jacket model into the scene.

- Using techniques you have learned so far, continue to add some more details to the rocket pack, like more bolts and the two extra boosters.

Backrest

On to the final section of the rocket pack—the area that will sit between the character and the pack itself. In the concept drawings, it looks like a cushion of sorts, so that is what we will base it on.

To help us in this section, it would be a good idea to use the actual character model as reference, but rather than import the whole thing, we will just use a lower resolution version of her jacket.

- Begin by loading the scene **Chapter10/Files/10_JacketBase.sib** into the rocket scene. You should now see something similar to Figure 10.14.
- Your rocket pack might be sitting a little too far forward, or even facing backward, so adjust its position and orientation so it is sitting away from the jacket.
- Hide the rocket pack now and create the model seen in Figure 10.15a. Start with a cube and divide it, adjusting it to fit the curve of the jacket.
- **Delete** the rear faces next and **Bevel** the edges around the front to help retain the shape once subdivided (Figure 10.15b).
- Hide the jacket now and divide up the backrest by adding in separate sections to give it the cushion effect (Figure 10.16).
- Now make just the central section of the rocket pack and the jacket visible again. Adjust the backrest to sit nicely between the two (Figure 10.17).

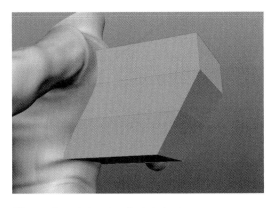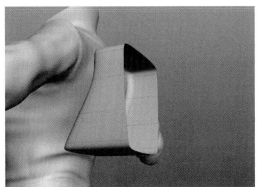

FIG. 10.15 Create the base shape for the backrest.

FIG. 10.16 Add the ridges into the model to give it a cushion effect.

FIG. 10.17 Adjust the position of the backrest so it sits well between the jacket and rocket pack.

FIG. 10.18 The finished rocket pack.

- When satisfied with your work, delete the jacket model, leaving you with just the completed rocket pack in the scene.

Your model should look like that in Figure 10.18.

(You can find the Silo scene created in this section in Chapter10/Files/10_RocketPack.sib.)

Further Details

With what you have learned in the book so far, why stop here? You could use your newfound sculpting knowledge to add in some bumps and scratches across the rocket's surface.

Admittedly, these could be added with the help of a bump map once textures are applied, so it comes down to personal choice, and how your system will handle the extra data.

If you imagine the character, plus the rocket pack, all with tiny details added in one scene, you get our point. If your system isn't up to it, you could be in for a headache just trying to navigate around the scene.

For now we will rely on textures for damage detail, but if you are curious, Figure 10.19 shows what you could sculpt into the rockets.

Helmet

To create the helmet, we will need a sphere. However, just as we did earlier in the book, we want this one to be constructed completely from quads to eliminate any pinching.

- Start by loading the file **Chapter10/Files/10_HeadBase.sib**. We can use this to help us form the shape of the helmet.

FIG. 10.19 The finished rocket pack with added details.

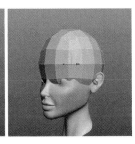

FIG. 10.20 Form a sphere from a cube.

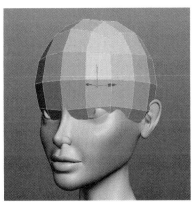
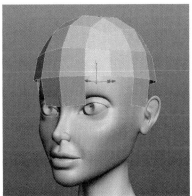

FIG. 10.21 Remove the areas of the sphere we don't need.

- As illustrated in Figure 10.20, next create a cube and apply a single subdivision to it, (press **C**).
- Next, go to **Subdivision > Refine Control Mesh** (or press **Shift1C**) to bake this into the model.
- Now delete the lower areas of the sphere we don't need (Figure 10.21).
- You can now start to shape the helmet and give it some depth and thickness, while using the **Bevel** tool to harden the edges.

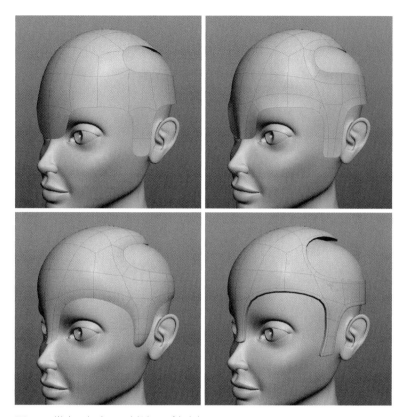

FIG. 10.22 Work on the shape and thickness of the helmet.

- You will also want to open up the helmet at the back, as per the concept artwork (Figure 10.22).

(Tip: Refer to the concept artwork to make sure it looks the same.)

With the main shape of the helmet created, let's next build the fin, which will sit on top.

- To form the fin, start with a simple cube and **Extrude** the top edge, rotating each extra section to match the outer surface of the helmet (Figure 10.23b).
- When done, add three divisions around the surface using the Split Loop, or **Cut** tool . This will allow you to shape the rear into the spikes as shown in Figure 10.23c.

(Note: We have added a recess around the helmet, but will eventually remove it later in the chapter. Feel free to play around with different ways to make the model a little more interesting to look at. If you change your mind, it is easy enough to remove them again.)

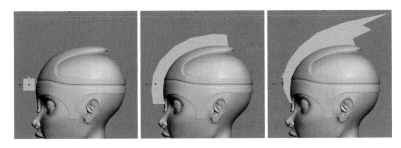

FIG. 10.23 Start work on the helmet's fin, forming it from a cube.

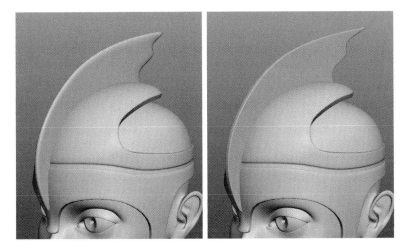

FIG. 10.24 Harden the outer edges of the fin.

- Finally, **Bevel** the outer edges of the fin to sharpen its overall shape. You can see the difference this makes in Figure 10.24.

We have one main area to look at before we can move on. She needs some sort of visor to protect her eyes as she flies. The concept art doesn't tell us how this should look in too much detail, apart from a piece of glass over her eyes, so let's take a chance and create a rim for the glass to sit in.

- Following Figure 10.25, start by **Beveling** the edges on either side of her face. These are on the nose plate, and the area near her ear.
- Select the inner faces of these and **Extrude** them, pulling the geometry toward her cheek (Figure 10.25c).
- Next, create a **Bridge** between these to complete the loop.
- As a final step, **Bevel** the edge loops closest to the helmet. The areas where this new rim joins the helmet are too soft so we need to harden them slightly (Figure 10.25e).

FIG. 10.25 Create a rim around her eyes.

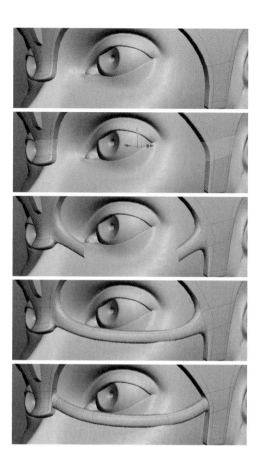

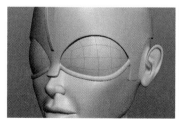
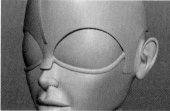
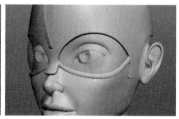

FIG. 10.26 Add in the glass to form the lenses.

- Now that we have the rim, we can fill it with glass. Do not use a sphere as the starting point for this, as it will result in pinching at the front of the lens. Instead, use a smoothed cube, as we did when we began work on the helmet. If the glass is quad based, as in Figure 10.26, the surface will be much smoother.

(Tip: If you want the glass to be transparent, set its display mode to **Ghost Shaded**.)

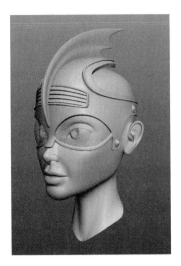

FIG. 10.27 The final helmet.

You now have the main helmet model, so use your imagination and add some details.

Figure 10.27 shows the completed helmet with a few adjustments, and details like a vent and a few caps added.

(You can find the Silo scene created in this section in Chapter10/Files/10_Helmet.sib.)

Accessories

The rocket pack and helmet are complete, so now let's turn our attention to the various straps and buckles that hold everything in place. We initially created placeholder geometry for these to help as we sculpted, so let's now look at upgrading these elements.

Rocket Pack Straps

Rather than physically try to edit the placeholder straps for the rocket pack, we will build new ones to replace them. The easiest way to do this is to create a single strap and re-use it for the others.

(Tip: As always, having some reference material at hand is a great idea.)

We need a strap with a clip she would unclasp to take the rocket pack off, so let's start work.

- Following Figure 10.28, begin with a simple cube, **Extruding** the ends to form the bend at one end.

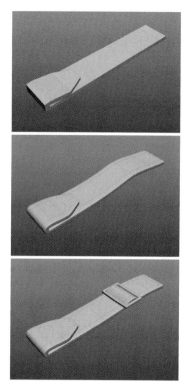

FIG. 10.28 Start work on the first part of the strap.

- When this is subdivided, it will be too soft, so **Bevel** the outer edges.
- Finally, create the buckle you can see in Figure 10.28c. This again is formed from a cube.

The upper part of the strap is complete, so now let's create the clip, which will sit between the two parts. We don't need to create a fully working clip, as it will not be seen open, so don't worry about creating all the internal workings for now.

- As a starting point, duplicate the buckle you created earlier and place it at the upper end of the clip.
- With that in place, create a cube and adjust it to form the basic shape of the lower end of the clip (Figure 10.29a). The cube was scaled to the general size before being adjusted with extra edge loops to help form the shape.
- Again, once this is subdivided it will appear too soft, so **Bevel** all the outer edges so it retains its shape (Figure 10.29b).
- We now need to create a recess on either side to give the illusion that the clip is hollow. To do this, simply select the polygons and **Extrude** them, pushing them into the model.

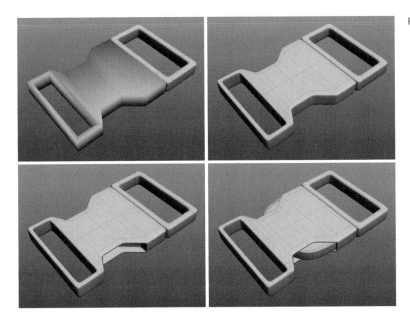

FIG. 10.29 Create the main clip.

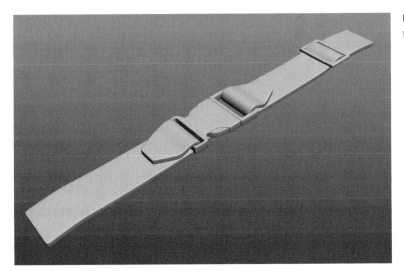

FIG. 10.30 Bring all the elements of the strap together.

- This extrude will also probably appear too rounded, so either Crease or Bevel the inner edges to switch it back to a rectangular shape (Figure 10.29c).
- Finally, create two clasps that will sit inside these recesses (Figure 10.29d).
- Now add this clip to the section of the strap you created earlier, duplicating the upper section of the strap and rotating it to create the lower part (Figure 10.30).

(You can find the Silo scene created in this section in Chapter10/Files/ 10_NewStrap.sib.)

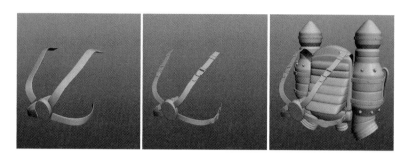

FIG. 10.31 Replace the basic straps with the new ones and attach them to the rocket pack.

Now we have a strap we can use, so we can start to replace the basic geometry we currently have.

- Go to **File** > **Load Into Scene**... and select the file **Chapter10/Files/ 10_StrapsBase.sib**. This has the basic geometry you created in the previous chapter.
- Now, using this as a guide, replace each strap with the new one (Figure 10.31).
- When you have the main straps in place, bring the rocket pack into the scene so you can connect the straps to it. For this, you can add a few extra pieces of geometry, or simply extend the straps back.

(You can find the Silo scene created in this section in Chapter10/Files/10_ RocketWithStraps.sib.)

Rocket Pack Buckle

The only area left to tackle is the buckle at the front. Currently, it is a bland-looking oval shape, but luckily, we have the concept artwork to show us how it should look.

Figure 10.32 is a reminder of the rocket pack concept art. You can see the buckle in the top-left hand corner.

- Focus on the buckle now and, as illustrated in Figure 10.33, use the **Extrude tool** to create the dome in the center.
- When done, duplicate four of the rivets created for the main rocket pack and add them to the front of the buckle as shown.

Now move on to the four clips around the buckle; these will be where the straps will fasten onto it.

- Start with a cube and adjust the general shape to fit that of one of the clips (Figure 10.34a).
- Subdividing this will soften the appearance too much, so apply a **Bevel** to all the edges of the cube (Figure 10.34b).
- To create the recessed section in the middle, simply apply two **Extrude** operations and adjust the shape to suit your needs (Figure 10.34c).
- Finally, duplicate this clip three times, and position the duplicates to finish the design.
- Now, all we have to do is adjust the straps so they feed into the actual clips.

FIG. 10.32 The rocket pack concept art.

FIG. 10.33 Add the dome to the front of the buckle.

FIG. 10.34 Build the clips for the buckle.

FIG. 10.35 The finished buckle.

Your finished buckle should look like the one in Figure 10.35, with the completed rocket pack looking similar to the one in Figure 10.36.

(You can find the Silo scene created in this section in Chapter10/Files/10_RocketPackFull.sib.)

Belt and Gun Holster Details

We will take a slightly different approach with the buckle. This time, we can use the existing temporary geometry we initially created and enhance it, adding in the detail we need. There is no point in rebuilding the belt, buckle, and belt loops from scratch, as the ones we have are good enough.

You can see the following steps in Figure 10.37.

- We first need an end to the belt. This needs to come out from behind the buckle and hang outward. For this, rework a cube, or duplicate a piece of the current belt and adjust it to achieve the correct shape (Figure 10.37b).

FIG. 10.36 The completed rocket pack with straps and buckle.

FIG. 10.37 Using the temporary model, create a detailed belt and buckle model.

- For the belt holes, create a simple cylinder shape with a hole in the center, adding an edge loop around the middle to pull out to form the bump.
- Next, turn your attention to the belt buckle and create a recess in the center. This is where the main design will sit (Figure 10.37c).
- Time to use your imagination and modeling skills to create a design for her buckle. Here we created a simple rocket, but feel free add whatever you like (Figure 10.37d).
- Finally, add some more shape to the belt and belt loops to make it more interesting. To achieve the look in Figure 10.37e, we simple added a few edge loops to the models and adjusted the new geometry to create the raised areas.

(You can find the Silo scene created in this section in Chapter10/Files/10_Belt.sib.)

Now we can generate the main holster, which sits below the belt, on her thigh. For this, we can again use the strap we created earlier, and adjust it to suit our needs.

- First, make sure the basic strap for the thigh is in the same scene as the belt model, so you are looking at something like Figure 10.38a.
- Now bring into the scene the strap you created earlier and edit it to hang from the belt (Figure 10.38b).

FIG. 10.38 Generate the holster straps.

- While you are here, you can also start to rework the thigh strap to make it appear more like a belt. Again, reuse pieces from the main strap model you created.
- Continue the main strap so it hangs down onto the thigh and ends back up at the rear of the belt. It would be useful to have the trouser model in the scene, so we don't end up with the strap sitting inside the model (Figure 10.38c).
- Before creating the holster, add in some more details onto the thigh strap to make it look more like a belt (Figure 10.38d).

Take a break now and create the actual gun holster. As you can see in Figure 10.39, the holster is a simple shape.

- Start with a cube and adjust it to create the basic holster shape (Figure 10.39a).
- Next, create the hole where the gun will sit in the top and then **Bevel** the edges so the holster keeps its shape when subdivided (Figure 10.39b).
- Finally, add some details in the form of a small strap and studs, something similar to Figure 10.39c.

Bring the holster into the same scene as your belt, making sure you delete the trousers if they are still in the scene. You should now have something like Figure 10.40.

(You can find the Silo scene created in this section in Chapter10/Files/10_ BeltAndHolster.sib.)

Glove and Boot Details

To complete the main clothing details, we will adjust the glove and boot straps, turning them into belts. You have done this already with the belt and holster, so these steps will be familiar to you.

FIG. 10.39 Create the main gun holster.

FIG. 10.40 The completed belt and gun holster.

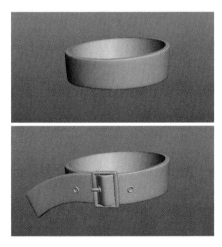

FIG. 10.41 Turn the basic glove and belt straps into belts.

- Work your way around the remaining four straps—two on the glove and two on the boot—transforming them into more of a belt shape (Figure 10.41).

The resulting models should be similar to those shown in Figures 10.42 and 10.43, with the basic straps looking much nicer.

The main torso, clothing, and accessories are now complete, meaning Jade should be looking almost finished, if a little bald.

Figure 10.44 shows the full character, with all elements in the same scene.

(Note: You might notice when comparing this to the concept artwork that the kneepads are missing. We decided to leave these from the model, as they no longer fit the style of the character. If needed, they could always be added later in the texture.

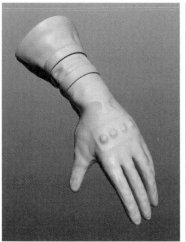
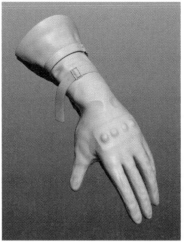

FIG. 10.42 Enhance the straps on the gloves.

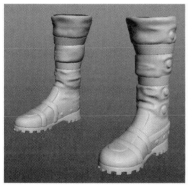

FIG. 10.43 Enhance the straps on the boots.

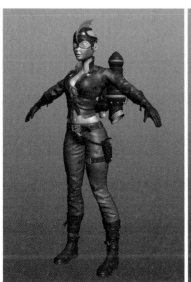
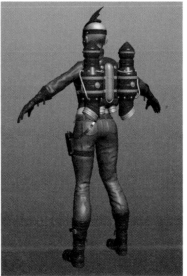

FIG. 10.44 The current rocket girl.

(You can find the Silo scene created in this section in Chapter10/Files/ 10_FullCharacter.sib.)

Pistol

You will notice in the following chapter that our Rocket Girl now has a pistol. This is something we added as a bonus item, and a free bonus download chapter.

You can download the chapter containing full instructions on its creation from the Focal Press website mentioned earlier in the book.

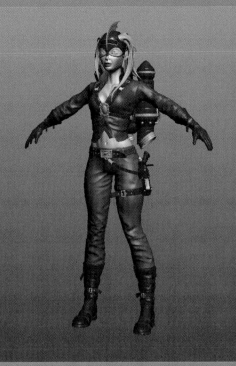

Adding Hair

We are almost done building our Rocket Girl, Jade. The model is detailed and working well. In this chapter, we will finally give her some hair to complete her look.

(Note: You will find the files used for this section in the downloaded tutorial files inside Chapter 11/Files.)

Hair

Building the hair would come more under organic modeling; the problem we had earlier is we needed to have the head and helmet in place before we could create it. Now all the other elements are done, and we can finally focus on her hair.

There are many ways to approach hair; some people use basic polygon strips, others like to sculpt every last detail and delicate wave. What we will do is block out the main shape before adding extra waves and strands to give it more detail.

- Begin by loading the scene Chapter11/Files/11_FullCharacterWithGun.sib.
- Hide everything except the helmet model.

3D Modeling in Silo. DOI: 10.1016/B978-0-240-81481-0.00011-X

FIG. 11.1 Use the helmet to create the starting point for the hair.

FIG. 11.2 Create the lower section of hair before attaching it to the top.

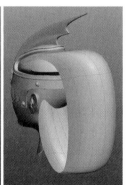

Because the hair comes out from beneath the helmet, we need to make sure the model sits neatly around the outside, so it makes sense for us to use the helmet as a starting point.

- Begin by filling the hole on the top of her helmet (Figure 11.1a). Use whatever method you like for this, but we recommend the **Bridge tool**.
- Next, select the new polygons and **Break** them away from the helmet.
- Finally, add a new division across the new geometry to round off the shape (Figure 11.1b).
- Now that we have the starting point for the upper section of her hair, bring back the head model.
- Create the lower section now (Figure 11.2a). This hair section can be a relatively plain model. Give it eight divisions across so we can match it with the upper section.
- **Extrude** the upper section now, deleting the new middle polygons so you are left with the outer geometry pointing out.
- **Combine** the two elements of the hair and then **Extrude** the lower and upper edges.
- Bend these around so they join, and **Merge** the vertices so you end up with something similar to that in Figure 11.2b.

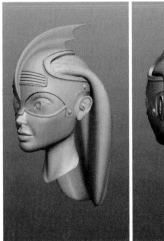
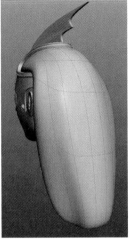
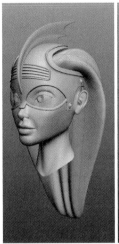
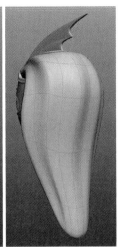

FIG. 11.3 With the upper and lower parts combined, go in and fill in the holes at fither side.

FIG. 11.4 Reshape the base hair model to give it more of a hair feel.

You might notice a series of black lines on your model. This is simply because the geometry normals (the direction the faces and vertices point) don't match up. Select the model and go to *Modify* > *Unify Normals* to fix this.

- With the main shape in place, go in and start to fill in the holes around the sides. You should aim for a model similar to the one shown in Figure 11.3, giving us the main bulk of the hair.
- Now that you have the main section of the hair ready, reshape it slightly to give it a more natural appearance (Figure 11.4).

Now the fun begins. We need to give this flat model some life and make it feel more like free-flowing hair.

- Following Figure 11.5, start at the top of the hair and *Extrude* a single polygon out.
- Extent this, adding another *Extrude* while bending and shaping the model, tapering it toward the end. Doing this has given us a wavy strand of hair coming out above her fringe.
- Continue on, *Extruding* more strands of hair out of the model as shown. Be careful not to go too overboard, as it could begin to look messy.

Now turn to the back of the model. Although we could use the same process to add detail here, it could start to look unnatural, so instead, we will leave her hair flat but add more of a wave to the shape.

- As illustrated in Figure 11.6, create a series of cuts down the back of her hair. Don't cut all the way to the top or around the bottom at this point.
- Now adjust the new geometry to create dips in the hair, adding more detail to the shape.

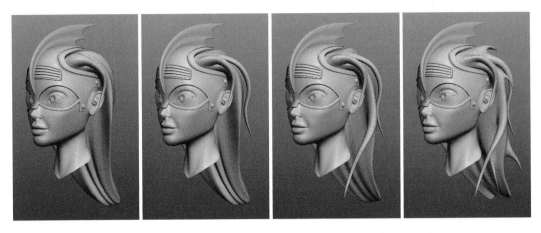

FIG. 11.5 Extrude geometry out of the model to literally pull strands of hair out of the geometry.

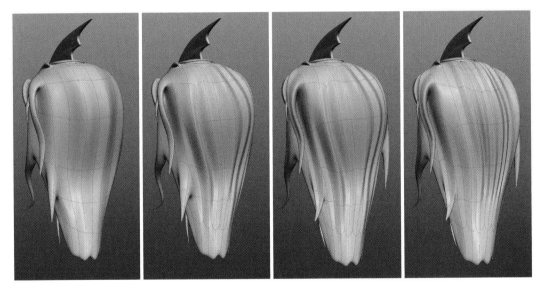

FIG. 11.6 Add more detail to the back of her hair with simple cuts in the geometry.

Let's leave the main hair for now and focus on the area around her ears. At present, the area is completely bald, so we need some hair here that will fall from under her helmet and onto her face.

- Start with a basic shape, following the helmet and moving up over her ear (Figure 11.7b).
- Extend this model down, tapering it to form the strand of hair (Figure 11.7c).
- Finally, **Extrude** a smaller strand in front of the ear to give the hair some variety (Figure 11.7d).
- Now, bring the main hair model back and revisit it as a whole, tweaking the shape until you are satisfied.

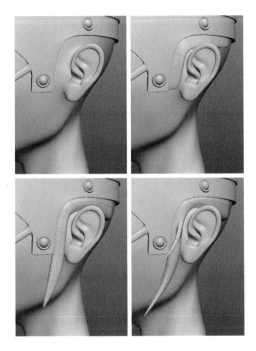

FIG. 11.7 Build the hair needed to fill the gap above her ear.

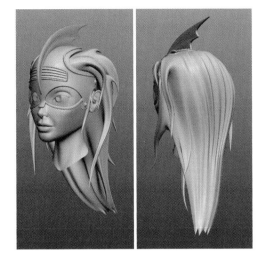

FIG. 11.8 The current hair model, almost complete.

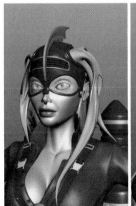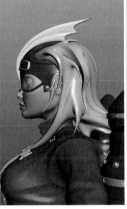

FIG. 11.9 Adjust the hair to sit nicely over her body and accessories.

Figure 11.8 shows the hair model at this stage.

(You can find the Silo scene created in this section in Chapter11/Files/
11_Hair.sib.)

All we need to do now is adjust this hair model to sit nicely over the
character's shoulders and her rocket pack.

You should end up with something resembling the hair seen in Figure 11.9.

FIG. 11.10 The finished Rocket Girl model.

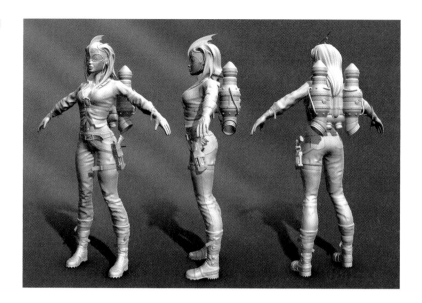

We could build in eyebrows and eyelashes, perhaps even teeth, but at this stage, you should be experienced and skilled enough to tackle those without direction.

So, well done. Give yourself a pat on the back and relax. Jade Raven aka Rocket Girl is complete (Figure 11.10).

Don't rest for too long, though; in the next chapter we will investigate Silo's UV tools as we apply UV mapping before putting her into her final pose.

You can find the Silo scene created in this section in Chapter11/Files/ 11_FullHairAndBody.sib.

UV Mapping in Silo

Besides being a great modeling package, Silo also offers a host of UV editing tools. If you would like to learn more, and see these tools in action as we apply UV mapping data to the main areas of our character please visit the Focal Press website referred to earlier in the book, where along with the tutorial files you will be able to download this bonus chapter.

Alternatively, if you would like a brief introduction to UVs and how they work in Silo, refer to Chapter 3.

3D Modeling in Silo. DOI: 10.1016/B978-0-240-81481-0.00012-1

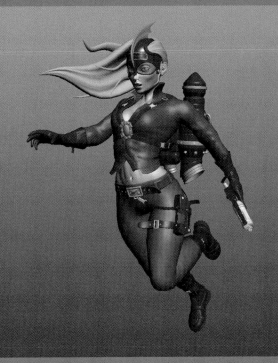

Final Pose

We now have a fully realized character complete with a basic set of UVs (for details on UV mapping please refer back to chapter 3, or the bonus, downloadable chapter 12.). The client loves her, so all that is left to do is to put her into her final pose so she can be colored and rendered.

(Note: You will find the files used for this section in the downloaded tutorial files inside Chapter 13/Files.)

Preparation

Anyone experienced in 3D will be expecting us to build some sort of skeleton, so we can easily manipulate and pose our character. For now at least, Silo doesn't have these tools, but this doesn't mean we can't bend her into shape. What we can do is enlist some of Silo's basic tools to help us.

* Load the scene ***Chapter13/Files/13_13_FinalUnposed.sib***.

This is the character as we previously left her, complete with just a few key areas UV mapped.

When loaded, Silo will automatically switch our sculpted areas to the highest subdivision level; for now, though, we need her in her base state.

3D Modeling in Silo. DOI: 10.1016/B978-0-240-81481-0.00013-3

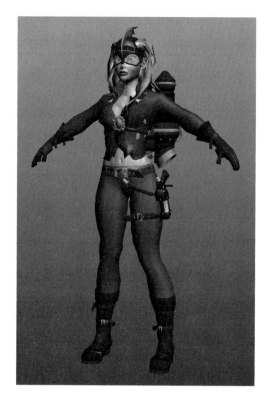

FIG. 13.1 Load your character and drop her down to the lowest subdivision level.

- Go to **Subdivision** > **Toggle Current Subdivision (Alt + V)** to instantly drop, or Press **V** until the character has dropped to the base subdivision level (Figure 13.1).

Before we begin posing, we need to do two things to make our lives so much easier.

- First, combine all the un-sculpted elements so they are a single object by selecting them and then using **Right Click** > **Combine Objects**. This includes the straps, rocket pack, helmet, and body, and will make the next step easier to perform.

(Note: Combining sculpted objects will result in all your sculpting data on the higher subdivision levels being lost, so it is best to leave these as separate elements.)

- Next. go to **Editors/Options** > **Object Properties**.

This will open up the window shown in Figure 13.2. When you have an object selected, this will show what properties are currently active.

- Work your way through each object in the scene and make sure **Symmetry** is **disabled**.

FIG. 13.2 The Object Properties window.

You can see now why we combined the nonsculpted models; modifying each separate piece could take a while.

While building Jade we have been switching between symmetry modes, depending on what model we have been editing. If symmetry remains enabled and we bend her left leg, for example, her right leg would follow, making it impossible to pose her correctly.

Making sure this is disabled on a per-object basis is important, as using the *Modify* > *Mirroring* > *Symmetry Mode Toggle* menu item (or hotkey) will simply toggle the tool. Physically turning symmetry off now eliminates any future issues.

With the scene ready, we can now start to pose our character.

Posing

To pose Jade, we will be using tools you have already experienced in this book. Our approach is simple: select the area we want to pose, reposition the manipulator so it is at the correct pivot point, and then rotate the body part.

Let's see this in action.

- With nothing selected in the scene, press *A* to enter vertex selection mode. Having nothing selected will allow you to work on all the vertices at once, not just on the selected object.
- Following Figure 13.3, select the lower, left leg including the boot and straps.
- Press *M* to enter *Manipulator Edit mode* and move the manipulator to the knee.
- Now simply rotate the lower leg to pose it (Figure 13.3d).

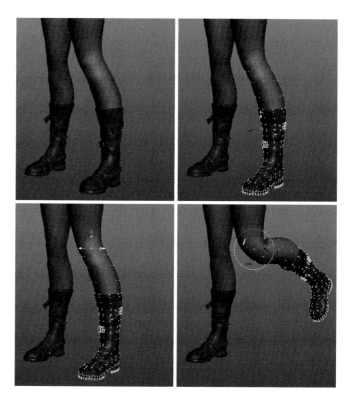

FIG. 13.3 Rotate the lower leg, moving the manipulator to the knee so it rotates correctly.

That was relatively painless, wasn't it? Let's move up to the hip next.

- Here we have an element that needs to remain solid. We don't want to bend the gun or the holster, so first select and move these away from the thigh (Figure 13.4).
- Now select the lower leg and press the + key to increase the selection, moving it up to her thigh.
- We want to bend the leg and influence the hip area slightly as we do it, so turn on **Soft Selection**. You should see the upper vertices now being affected as in Figure 13.5a.

This is fine, but if we rotate the leg now, the straps around her thigh and further up her leg won't follow it. We could add those vertices to the selection, which would be fine for the lower strap, but the upper strap only needs to be influenced by our rotation.

- Go to the **Soft Selection** options window and switch **Type** to **Spherical** (Figure 13.6).

As you can see in Figure 13.5b, the selection will influence the vertices on other elements around the currently selected vertices.

FIG. 13.4 Move the gun and holster away from the hip.

FIG. 13.5 Select the vertices on the left leg and enable Soft Selection.

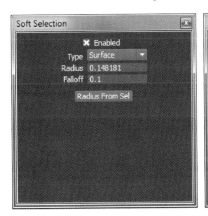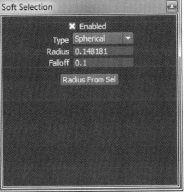

FIG. 13.6 Switch the Soft Selection type to Spherical to affect other objects .

- Now we can move the manipulator up to the hip (Figure 13.7) and rotate the leg, which will also affect the straps.

(Note: With any direct posing, there will be areas you need to go in and edit directly afterward—like the strap, for example. As we rotated the leg, some of the strap pushed into the leg so this will need fixing.

FIG. 13.7 Reposition the manipulator and rotate the leg.

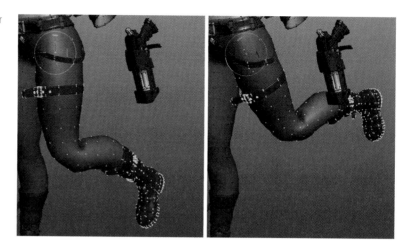

That is the basic process we need to follow to pose Jade. Now that you know what to do, start to work your way around the model and put her into position; remember to select the vertices, position the manipulator, and then rotate.

As a reminder, Figure 13.8 shows the initial concept image the client supplied, but feel free to use this as a basic guide and make small adjustments if you feel they will make the model look better.

At this stage, you might be wondering about the hair. You could try to pose the hair model you have, which could work but also might cause problems. For something as organic as this you might want to rebuild to get the exact look you want.

Figure 13.9 shows the posed Rocket Girl with new hair. As you can see, we also placed the gun in her hand. It seemed a waste to have it hidden in the holster, and it makes the pose feel more dynamic.

Cloth Touchup

We have now adjusted the model to achieve the pose we want, but in the process, we have probably caused the creases and folds we sculpted earlier to no longer look natural. Initially, we sculpted her clothing to look correct as she was standing, but now we have bent knees, a twisted torso, and posed arms, which affects the way her body interacts with her clothing.

As a final step, work your way around the clothing, touching up any badly deformed areas with the *Paint Displacement tool*.

FIG. 13.8 The original pose concept.

FIG. 13.9 The posed Rocket Girl.

FIG. 13.10 Resculpt the clothing to fix any bent areas.

Figure 13.10 shows the trousers. As you can see, bending the left knee left the clothing badly deformed, but with a bit of work we can return it to a more natural state.

You have now reached the end of the modeling chapters in this book, and you should have the knowledge and skills needed to create any character from scratch, using Silo.

FIG. 13.11 The Cover Girl.

Well done! We hope you learned something from this book, and in the process had some fun.

In the following chapter, you will be shown some of the other tools Silo has to offer, but for now sit back and admire your hard work.

(You can find the Silo scene created in this section in Chapter13/Files/13_ FinalPosed.)

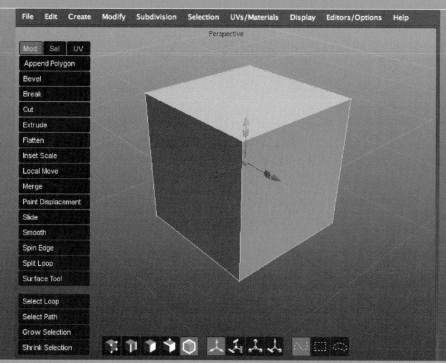

Silo Efficiency

So far, we have covered everything you need to know to model in Silo, and like an expatriate who has picked up all the phrases necessary to navigate in a foreign country, it might be easy to stop there. However, Silo also includes many additional tools and settings to improve your modeling efficiency, and once you start incorporating them into your workflow, you will quickly see how valuable they are.

For the professional modeler who uses Silo, often these efficiency tools set the program apart. It is not uncommon to hear pros remark that they can model at twice the speed in Silo as in any other program. For further details regarding five key areas where Silo tools and settings can improve efficiency—context sensitivity, sticky keys, customization, advanced selection tools, and advanced polygon creation tools—please visit the Focal Press website referred to earlier in the book, where along with the tutorial files you will be able to download this bonus chapter.

3D Modeling in Silo. DOI: 10.1016/B978-0-240-81481-0.00014-5

Resources

Here is a list of websites, tutorials, and people you can visit or follow online to learn more about Silo and 3D in general.

Help and Tutorials

Your first port of call should be www.nevercenter.com/silo/. Here you will find links to a wealth of tutorials and videos to help you get more from Silo. You will also find the Silo forums where you can post your work and get great, constructive feedback from the community.

Next, pay a visit to www.southerngfx.co.uk. This is the home of artist and Silo user Glen Southern, who has created a series of great Silo tutorials and some very useful cool Silo Interface designs.

Then, you can go to www.ant-online.co.uk to find out more about me and my work. In addition, I have a tutorials section where I frequently upload work in progress threads covering how I create my models.

Twitter and Facebook

It seems everyone has Twitter and Facebook accounts these days, and we are no exception. Following are the details needed to follow us online, see what we are up to, and get regular tips on 3D and Silo.

Silo Facebook Page—http://www.facebook.com/Silo3D
Silo on Twitter—http://twitter.com/silo3d
Antony Ward Facebook Page—http://www.facebook.com/AntWardsArt
Antony Ward on Twitter—http://www.twitter.com/ant_ward

Reference

Time for some general artist reference links—all great places to grab anatomical images to use for character modeling. If you look hard enough, you can find free, average-quality images to suit your needs. However, sometimes it is a good idea to spend a little cash on some great, high-quality photo references—and here is a list of places to find them.

http://3d.sk is an excellent first stop for reference images, and a fantastic place to grab pretty much anything you need. They currently hold over 200,000 royalty-free, high-resolution photos to download, and add more daily. All this does come at a cost, but it is well worth the money.

http://www.ballisticpublishing.com/dvds/ultimate_series is a series of DVDs made in conjunction with 3d.sk. These are, again, high-quality reference images perfect for any character artist.

Following are a few more sites well worth a browse—and they offer free images.

http://fineart.sk
http://www.the-blueprints.com
http://www.characterdesign.com/ (Under Photosets)
http://www.deviantart.com

For more links to reference images, and general tips and tricks, visit the Silo Wiki, which is updated regularly.

http://www.nevercenter.com/wiki/index.php?title=Nevercenter_3D_Modeling_Wiki

Further Reading

So, what next? You have your high-resolution model, but now you want to learn how to texture her in Photoshop, or perhaps convert her into a game model. I could not move past this point without mentioning my previous two books, both of which focus on the creation of characters strictly for games: *Game Character Development in Maya*, and *Game Character Development*. Search for them on Amazon.

If you would like to see where I took the Jade Raven model after this book, a brief tutorial in Issue 18 of *3DArtist Magazine* details my rendering and post-production process. You can find more information and order back issues at http://3dartistonline.com.

Focal Press also has a host of technical manuals, which will help you move ahead in digital artistry. See more of these at: www.focalpress.com.

Index